MANGA
FOR THE BEGINNER
Shoujo

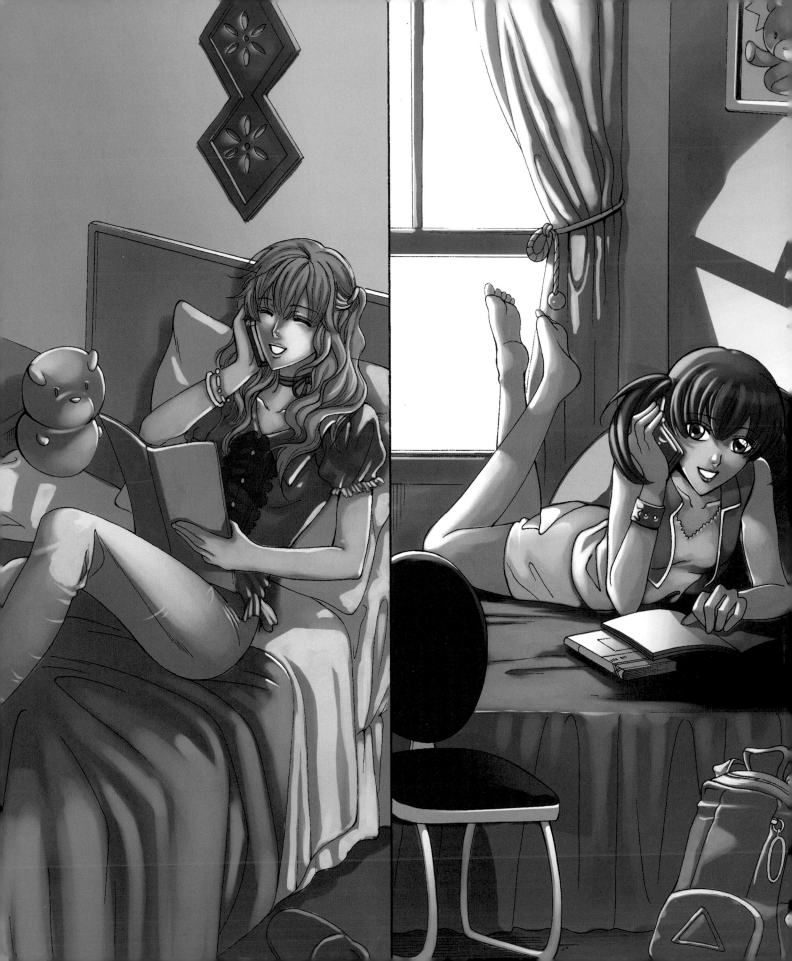

MANGA
FOR THE BEGINNER
Shoujo

**Everything You Need to Start Drawing
the Most Popular Style of Japanese Comics**

CHRISTOPHER HART

Watson-Guptill Publications/New York

Contributing Artists:

Christopher Hart Laichro

Rhea Silvan Adetyar Rakhman

Tabby Kink Tina Francisco

Roberta Pares Erica Awano

Design adapted by woolypear

Library of Congress Cataloging-in-Publication Data
Hart, Christopher.
 Manga for the beginner shoujo : everything you need to start drawing the most
popular style of Japanese comics / Christopher Hart. — 1st ed.
 p. cm.
 Includes index.
 ISBN 978-0-8230-3329-4 (pbk.)
 1. Comic books, strips, etc.—Japan—Technique. 2. Cartooning—Technique.
 3. Comic strip characters. I. Title.
 NC1764.5.J3H369285 2010
 741.5'1—dc22
 2009050997

Printed in China

First Edition

10 9 8 7 6 5 4 3 2 1

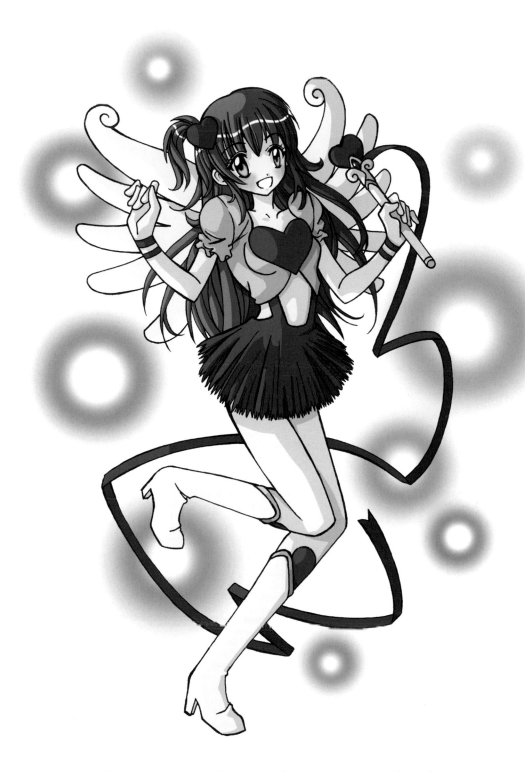

If you can dream it, you can be it.

CHRISTOPHER HART

Contents

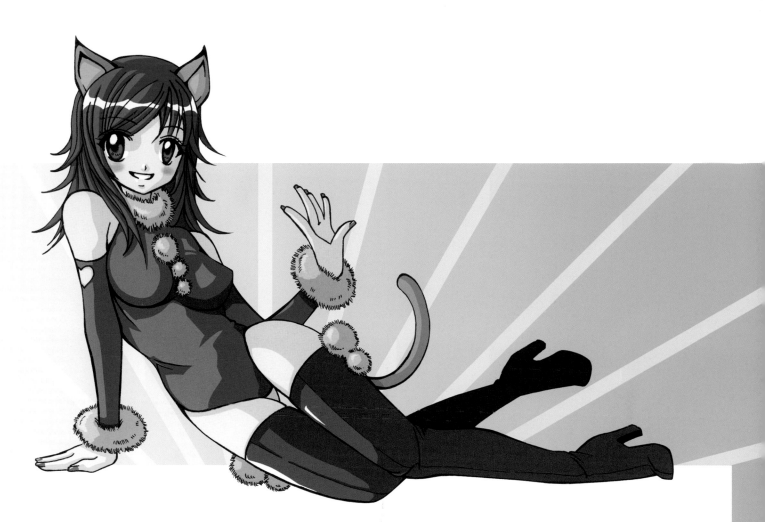

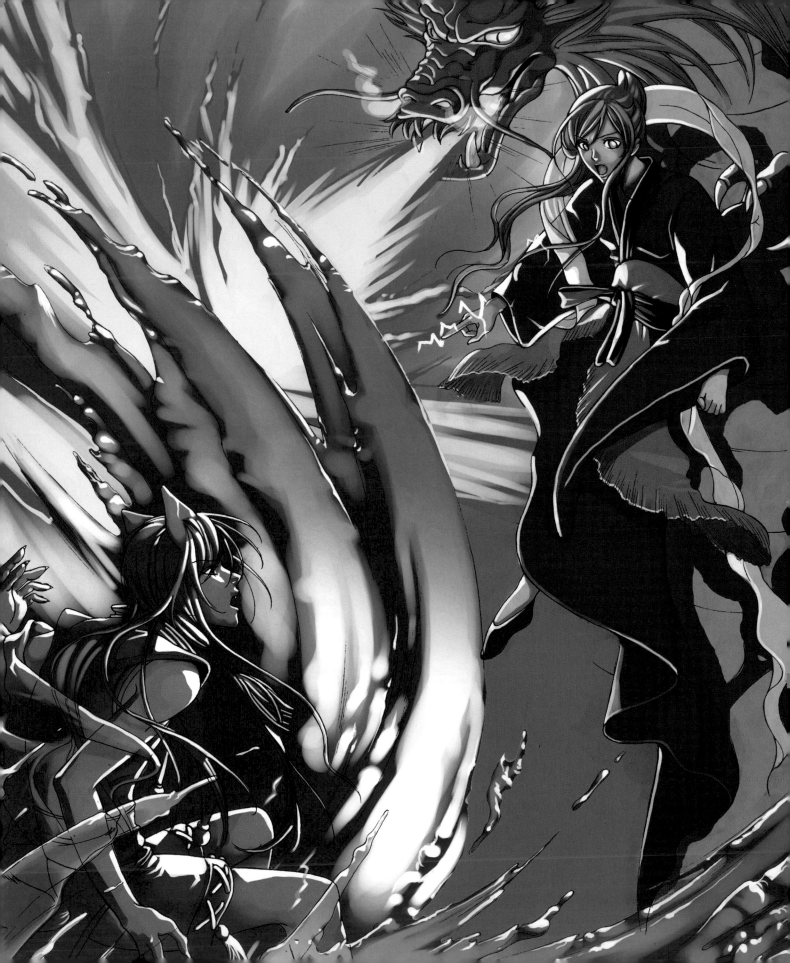

Introduction

HERE'S A SPECIAL BOOK for those interested in drawing the *shoujo* (pronounced show-joe) style of manga. Shoujo is the style of manga that's aimed at teenage girls but that also has garnered a strong male following. Also spelled *shojo,* it's the most popular style of manga in the known universe—and this is the first book specifically designed to teach *beginners* how to draw it. Maybe you've had some experience with other forms of art but your manga needs a little help. Or maybe you've been sort of faking your manga and want to kick it up to the next level. Either way, this book is designed for you.

Manga for the Beginner Shoujo adds additional steps to the normal step-by-step format to make sure you can follow the tutorials at every point along the way. It also features a comprehensive amount of art principles to lay a foundation for your manga as you continue through this book and beyond. Your favorite characters are included, from magical girls to handsome teen boys to cat-girls, Goth boys, demon gals, and more. You'll also learn the secrets of how to draw the wildly popular elegant, older-male teenage shoujo character. This famous manga figure from Japan is experiencing an unprecedented wave of popularity in graphic novels in America today, and he's featured here in an in-depth chapter complete with lots of step-by-step breakdowns and special drawing hints. In other words, you'll be learning the basics on the most outrageously cool characters in shoujo. No boring mannequins for you to copy here. This is the real deal: authentic manga, drawn in the latest style Tokyo has to offer. Why settle for anything less? The text is also particularly helpful to beginning artists, as it explains the lessons in a breezy manner. Extra tips and insights are offered on everything from coloring to character development. This book has got your back every step of the way. You may start off as an *otaku* (a manga fan), but you'll end up a *mangaka* (a manga artist)!

THE Shoujo Face

THE SHOUJO LOOK REQUIRES special elements and proportions: big, glistening eyes; a small mouth; and a tiny nose. Often, I see beginners taking great care to draw elaborate eyes. They intuitively understand what a big role this feature plays in a character's design. But what they don't always realize is that for a character to have big eyes, it also has to have a huge forehead. To counterbalance this, the character has a small mouth area. This is the very definition of the "cute" head type and is one of the reasons they shoujo head is so appealing. So remember: No feature exists all by itself. It must coexist within a framework that accommodates its unique size and shape.

MANGA STYLES

What is the *shoujo* style? Shoujo is the most widely read genre of Japanese comics. It features teen characters and leans more toward stories aimed at young female readers, though boys read it avidly, as well. The girls are drawn pretty and cute. The boys have youthful good looks. Older-male teens are drawn as dashing, mature leading men. (We'll cover the various male characters starting on page 108.)

We'll concentrate on the female characters for now, because they're the stars of the genre (and also the main audience). Age range is important: As the age range of the characters changes, the genre changes. So it's important to keep your shoujo girls between ages twelve and seventeen. If you go lower or higher than that, you start to enter into genres other than shoujo, as you'll see here.

CHIBI
Ages 5–8

KODOMO
Ages 8–11

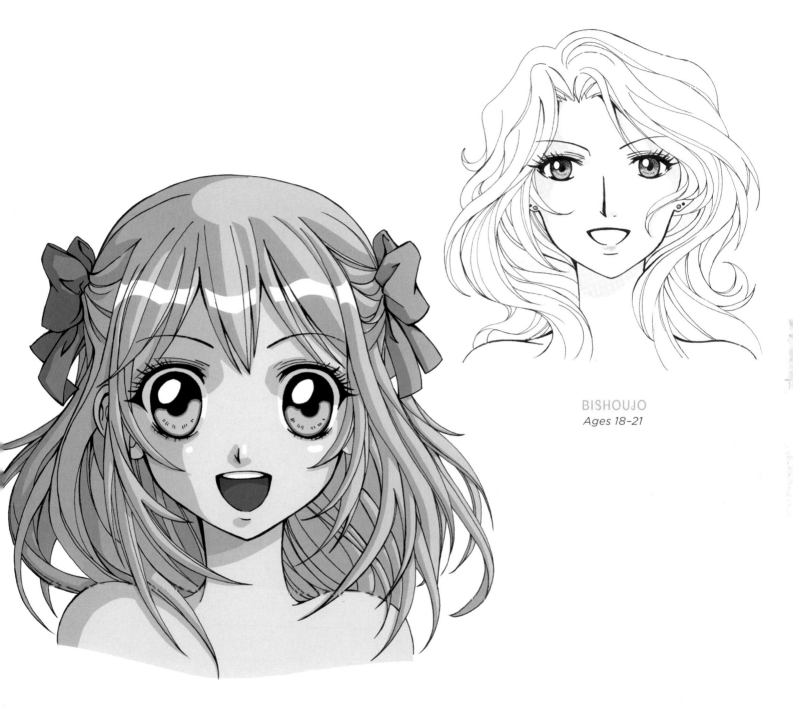

BISHOUJO
Ages 18–21

SHOUJO
Ages 12–17

REGULAR EYES VS. SHOUJO EYES

Because shoujo is famous for its glamorous eyes, we'll spend a little extra time on this feature.

The left column shows how a beginner might draw manga eyes. They're quite plain and all starkly black and white. The eyes in the right column are done like a professional manga artist would draw shoujo eyes: with a lighter touch and "feathered" to give a softer, glistening look. The lashes, too, are thicker and more profuse. Try copying some of these. You don't have to get them perfect the first time. It takes a few tries. Don't be too critical of yourself. Remember, it's just the start of the book.

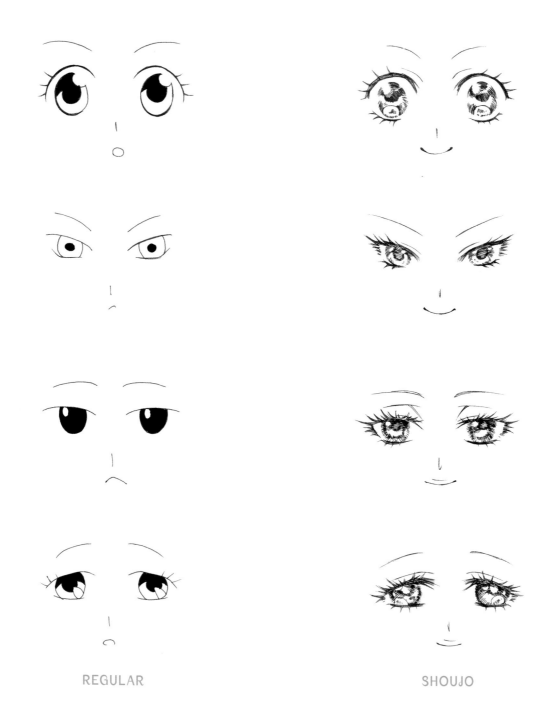

REGULAR SHOUJO

Glossary of Manga Eyes

There's no single right way to draw manga eyes. If you don't like one style, there are many others from which to choose. Use this glossary of examples to find one that suits your taste. You can pick from what's here or improvise to make it your own. Notice that it's not just the shading that makes the eyes unique but the shape of the eye itself. Some eyes will feature long lashes, some short, and some none at all. Some eyelids press down on the eyeball, and some arch above the eye, leaving a space between eyelid and eyeball. But in every case, the eye is large and round, with plenty of shines.

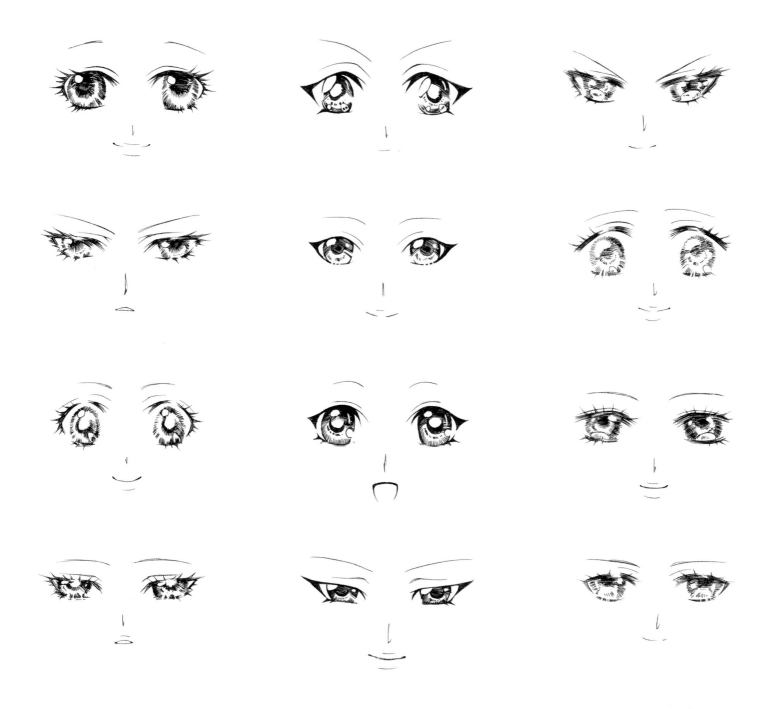

THE FACE: FRONT VIEW

We'll start with the front view, because everything is perfectly symmetrical at this angle, and everything lines up evenly: two eyes, two eyebrows, two ears, all at the same level.

Notice that the eyes are left blank in the early steps. That's because you first want to focus on getting all the features in the right place before adding the details. It's at this beginning stage that you do the most erasing and correcting. Don't be afraid to make mistakes. That's how you learn. All professional artists use erasers—and lots of them!

Girls

When drawing the shoujo girl's head, remember this axiom: big forehead, small mouth area. This rule will result in a modified egg shape. It's easy to draw, and it works. Make sure that the forehead is big enough to fit in those enormous eyes. But also, a big forehead is the typical look of young adolescent characters. As a character ages, the eyes move higher up on the head, which makes the forehead look smaller.

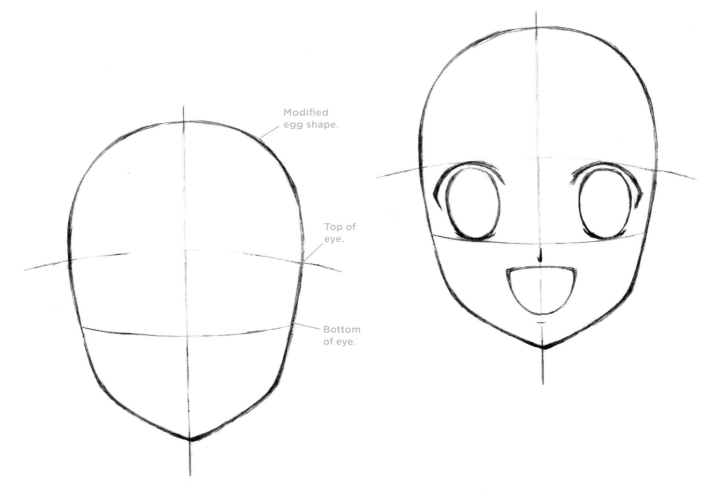

Modified egg shape.

Top of eye.

Bottom of eye.

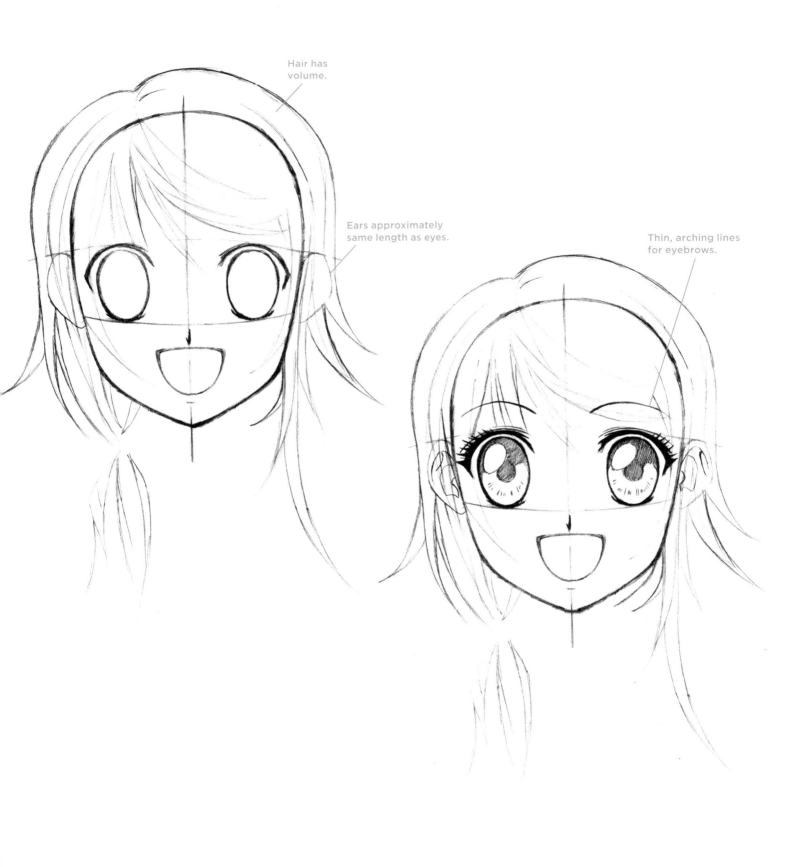

Hair has volume.

Ears approximately same length as eyes.

Thin, arching lines for eyebrows.

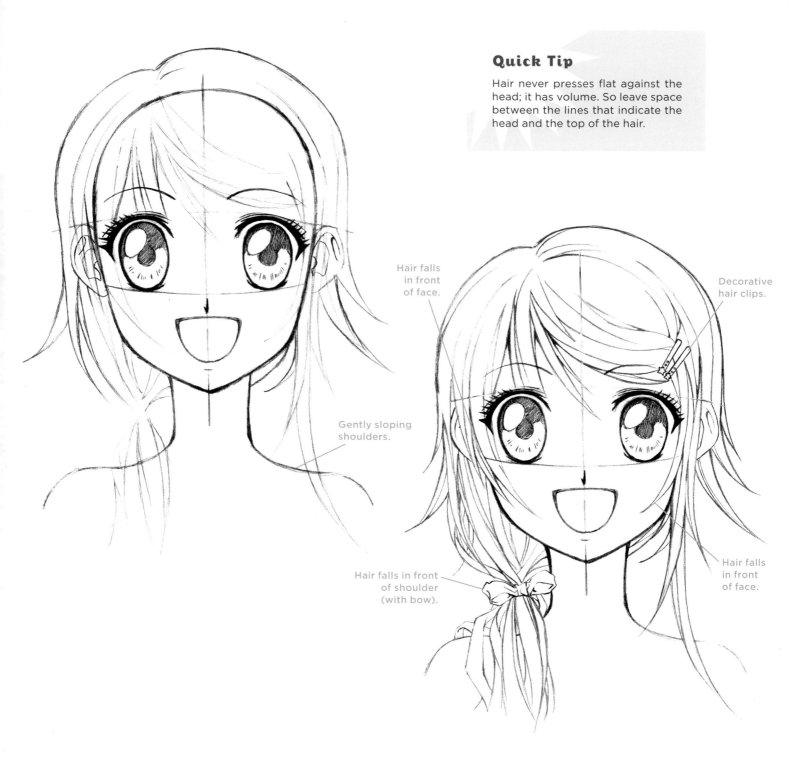

Quick Tip

Hair never presses flat against the head; it has volume. So leave space between the lines that indicate the head and the top of the hair.

Hair falls in front of face.

Decorative hair clips.

Gently sloping shoulders.

Hair falls in front of shoulder (with bow).

Hair falls in front of face.

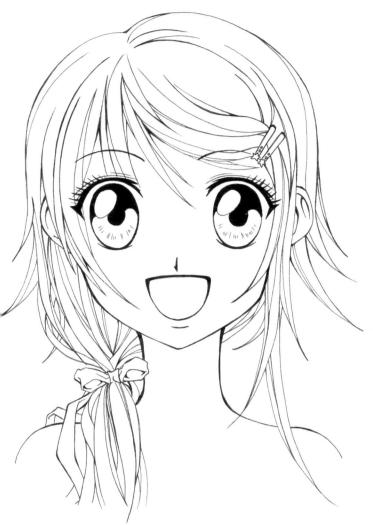

INKED VERSION

Note how the artist varies the thickness of the lines, especially around the eyes.

COLOR SUGGESTION

Note the jagged shine that goes across the hair. This is used to give the hair its youthful luster.

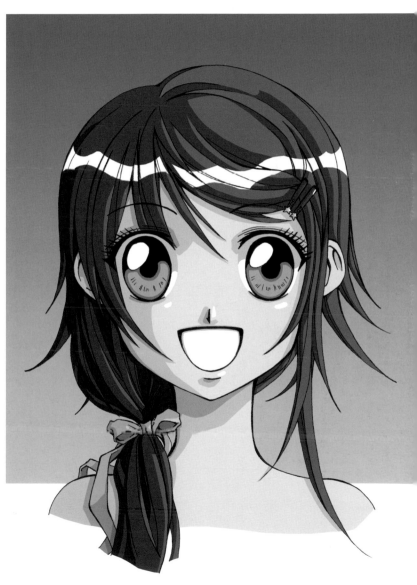

Boys

Male characters that are in their upper-teenage years are quite popular in shoujo. Younger teenage boys also make an appearance, as we'll see later, but they're not quite as popular as these Romeos.

Like the shoujo girl, the teen boy's head is also a modified egg shape, only his is much more slender and has a sculpted chin. Since he's older looking than the female character, his forehead isn't as large as hers. It's more in proportion to his face. The eyes are narrow and elegant and somewhat feminized, making him more of an androgynous character. Because he's a male, his eyebrows are fuller than those of the shoujo girl, and he typically has a long, straight bridge of the nose.

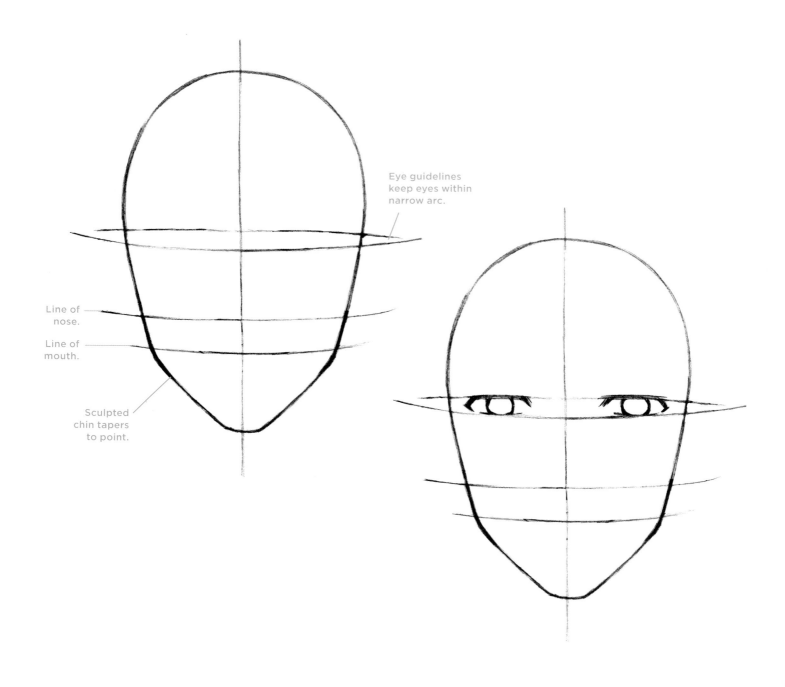

Eye guidelines keep eyes within narrow arc.

Line of nose.

Line of mouth.

Sculpted chin tapers to point.

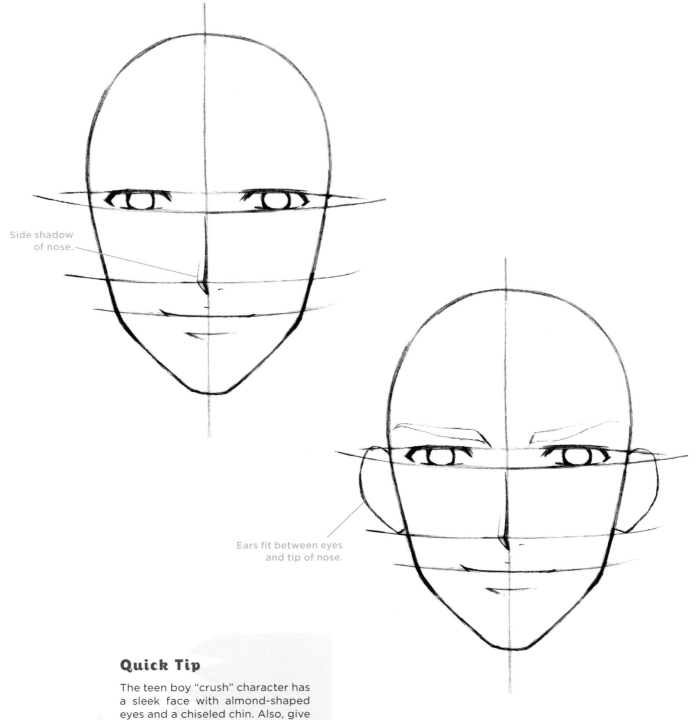

Side shadow of nose.

Ears fit between eyes and tip of nose.

Quick Tip

The teen boy "crush" character has a sleek face with almond-shaped eyes and a chiseled chin. Also, give him thick eyebrows.

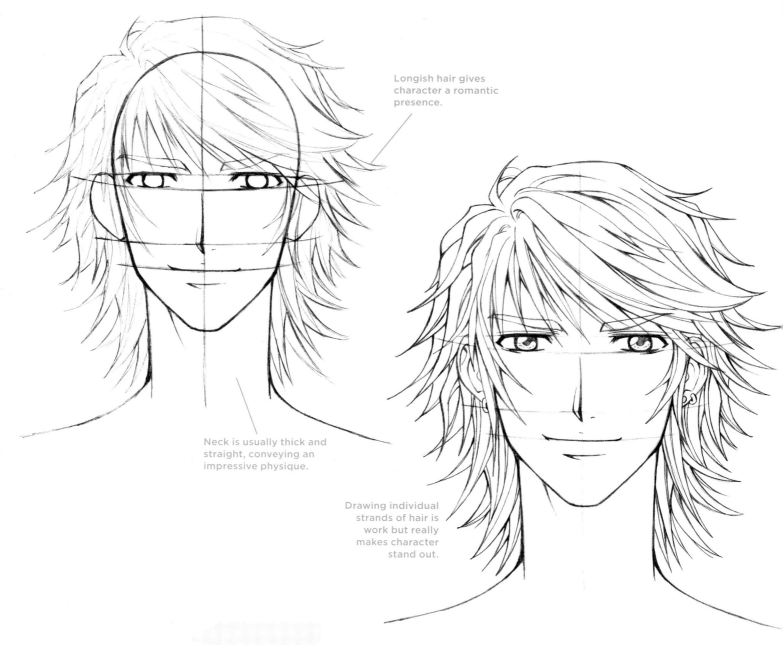

Longish hair gives character a romantic presence.

Neck is usually thick and straight, conveying an impressive physique.

Drawing individual strands of hair is work but really makes character stand out.

Quick Tip

Many hairstyles are possible, but longer hair is the most popular.

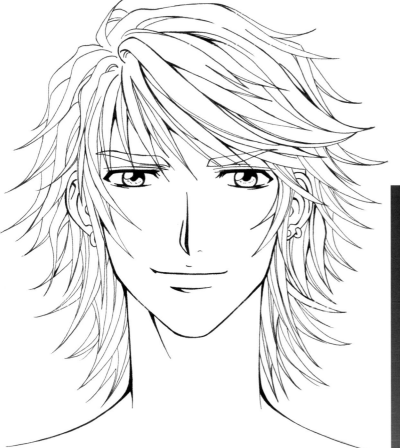

COLOR SUGGESTION
Note that the hair has slight variations of different shades of brown in it, otherwise it would look flat.

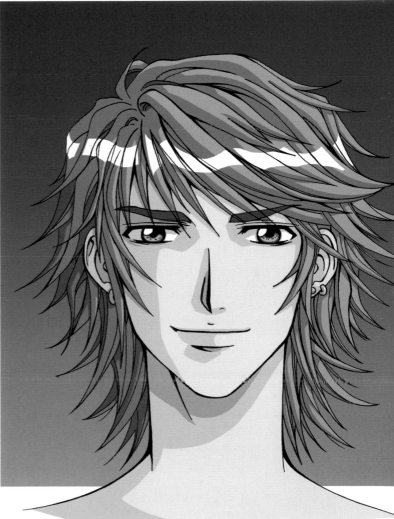

INKED VERSION
The eyelids are always inked with the heaviest line of any feature of the face.

THE FACE: PROFILE

In the side view, start out with a flat front of the face. Then sculpt it out to indicate the features. The back of the head remains rounded and takes up considerable mass behind the ear.

Where the side view gets tricky is in two places: (1) the eye; if it's too high or too low, the character will look unappealing. Oftentimes, a beginner will think the eye itself is drawn incorrectly, when actually it is just slightly out of place. Erase and reposition it slightly, and the result will often pleasantly surprise you. And (2) the mouth; sometimes, beginners don't recognize that the entire face from the tip of the nose to the tip of the chin is receding at a slight diagonal. You can see that in the second step. It's not a straight line down. If the mouth doesn't look right, be sure that the lower part of the face is receding.

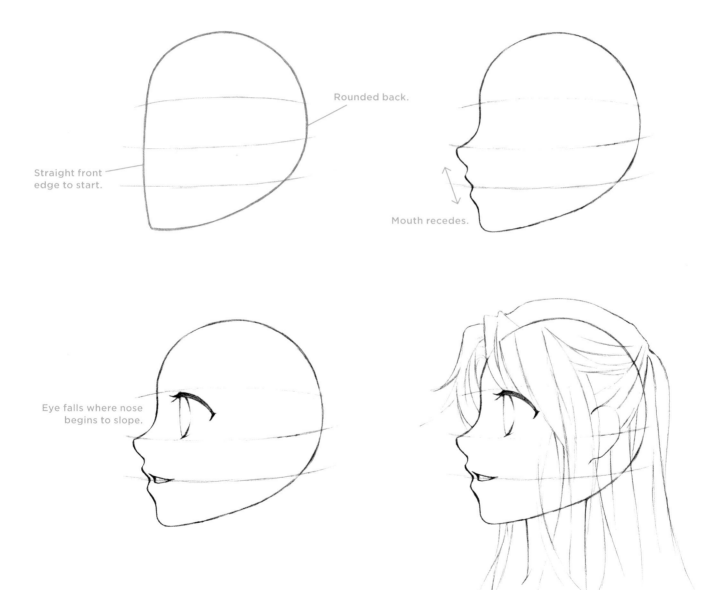

Rounded back.

Straight front edge to start.

Mouth recedes.

Eye falls where nose begins to slope.

Girls

When drawing the female in profile, think "soft curves." Don't get too pointy—unless she's an evil beauty. And never give her a thick or pronounced brow. Smooth it up.

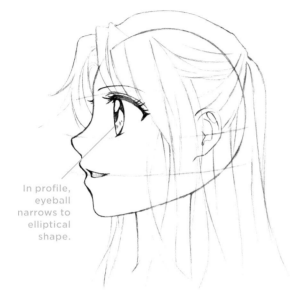

In profile, eyeball narrows to elliptical shape.

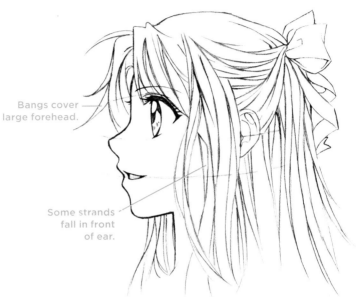

Bangs cover large forehead.

Some strands fall in front of ear.

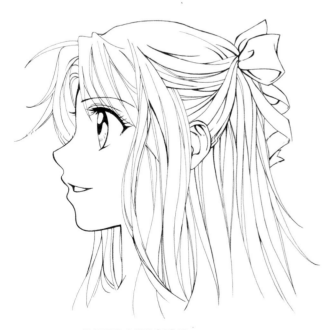

INKED VERSION
Note how thicker lines are interwoven with ultra-thin ones.

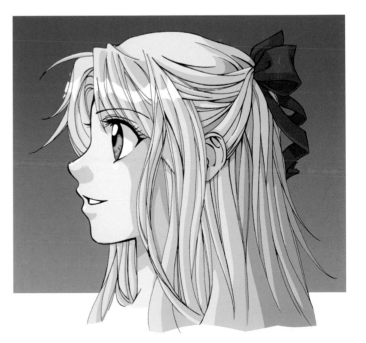

COLOR SUGGESTION
Fantasy colors are lively and appealing for hair; even blue and pink can be used.

Boys

Being slightly older and more mature looking than his female counterpart, the shoujo boy has sharper features, which are more pronounced in the side view. The long bridge of the nose is accentuated, as is the chiseled chin. He sports a slight overbite, in that his upper lip overlaps his lower lip. His neck is broad and athletic, and his wild hair gives him a rebellious appearance.

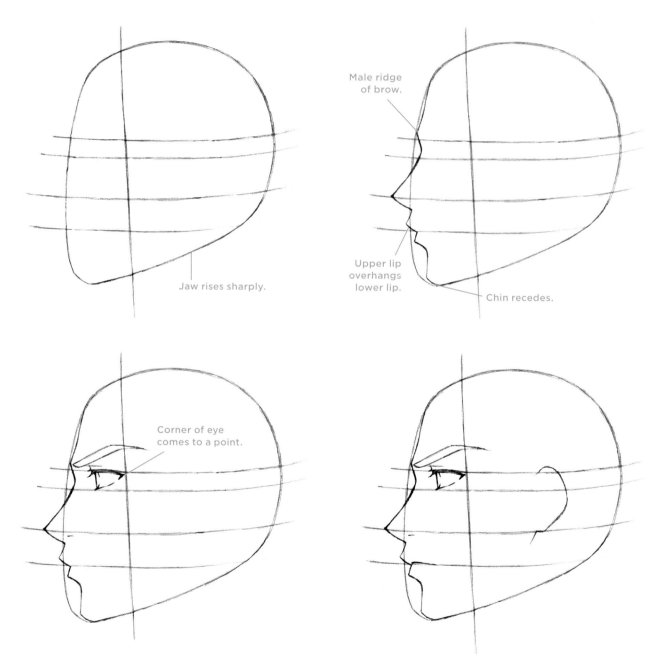

Jaw rises sharply.

Male ridge of brow.

Upper lip overhangs lower lip.

Chin recedes.

Corner of eye comes to a point.

Hair extends beyond head and flops down in front of forehead.

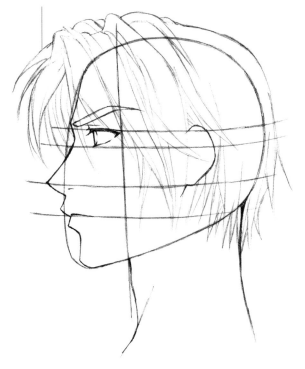

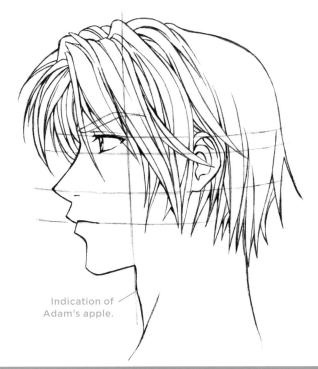

Indication of Adam's apple.

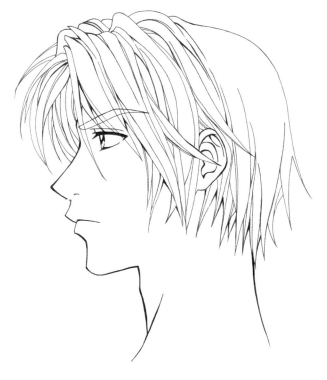

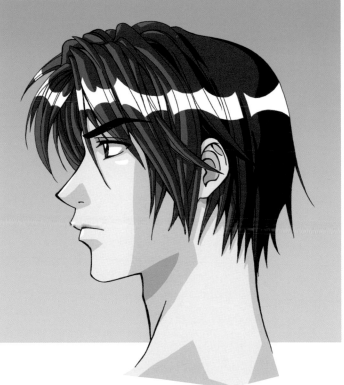

INKED VERSION

The lightest lines are found on the top of the head, where natural lighting would be hitting the form.

COLOR SUGGESTION

Black hair is fine in black-and-white comics. But in color comics, it tends to look overly saturated. So, many artists prefer to use gray so that they can use a variety of shades.

THE FACE: 3/4 VIEW

When drawing the 3/4 view, it's important to make use of the *center line*, which divides the face vertically. In the front view, this would fall in the center, but in the 3/4 view the face is now affected by the laws of perspective and, as you can see, things are no longer perfectly symmetrical. The center line falls closer to the far side of the face and is curved to show the roundness of the form. The eyes and eyebrows are no longer the same size. And you can only see one ear. In addition, the mouth and nose have moved over toward the far side of the face. The center line remains your anchor, dividing the face in two vertically and keeping all of the features where they should be.

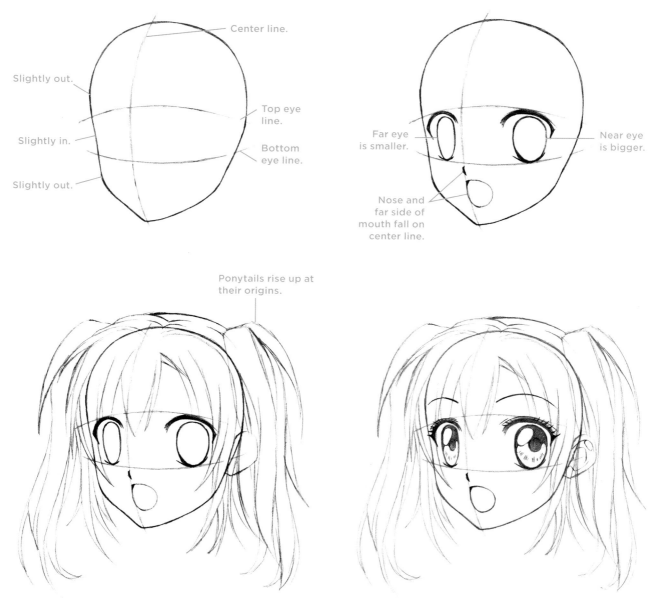

Center line.

Slightly out.

Slightly in.

Slightly out.

Top eye line.

Bottom eye line.

Far eye is smaller.

Near eye is bigger.

Nose and far side of mouth fall on center line.

Ponytails rise up at their origins.

Girls

Many drawing styles leave out the bridge of the nose on women to emphasize the character's femininity. But only in manga is the bridge left out regularly in the 3/4 view, too. In manga, noses are so petite that you can get away with using the smallest of dots to indicate only the tip of the nose. See how feminine that looks?

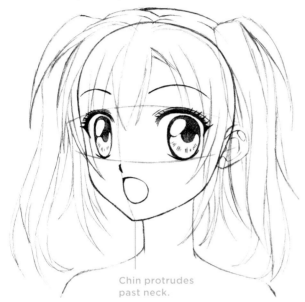

Chin protrudes past neck.

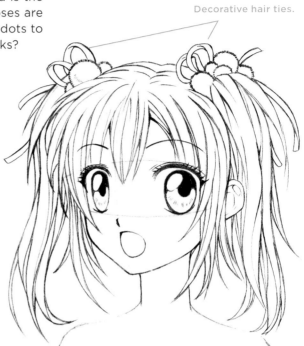

Decorative hair ties.

INKED VERSION

Inking takes a very slow and steady hand. In drawing, the wrist is loose and quick. When inking, the wrist is stiff and the whole arm moves.

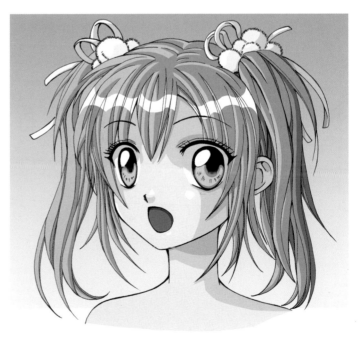

COLOR SUGGESTION

Note that the background color is chosen specifically because it complements the hair color: Light pink goes well with powder blue.

Boys

Note that on the male character the eyebrows don't arch as high off the eyes as they do on the female character. They stay closer to the eyes. Again, due to perspective, the far eye is shortened, and the near eye is of normal length. And here's a trick you should learn that's in evidence on this character: As the bridge of the nose continues up the face toward the eye, it turns into the eyebrow. It's the natural flow of the same line. In addition, note that the eyes on male characters are narrow and horizontal, while on females they're taller and rounder.

It's also good practice to show the hair on the far side of the face in the 3/4 view. This helps to "book-end" the image, giving it depth by creating three layers: the foreground (front of hair), middle ground (face), and background (far side of hair).

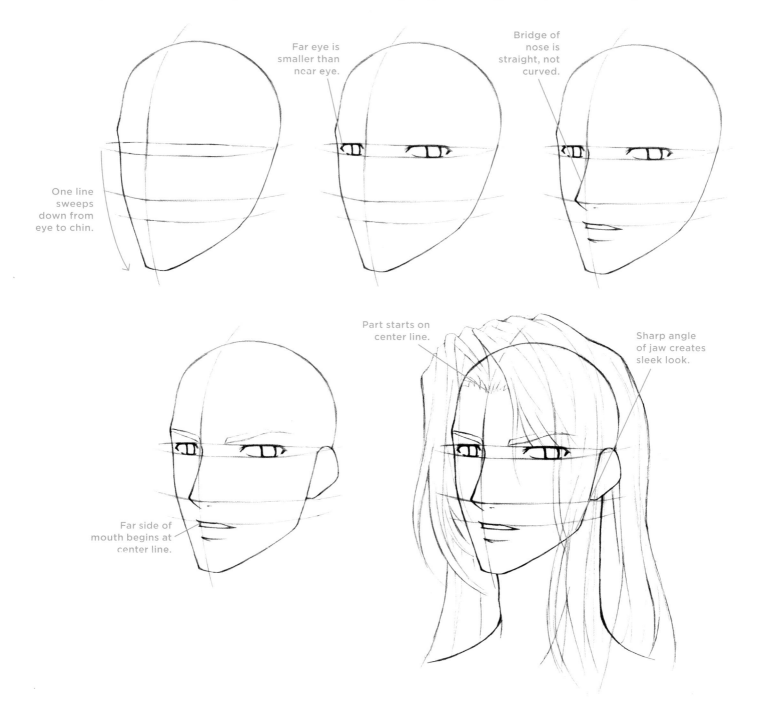

Far eye is smaller than near eye.

Bridge of nose is straight, not curved.

One line sweeps down from eye to chin.

Part starts on center line.

Sharp angle of jaw creates sleek look.

Far side of mouth begins at center line.

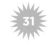

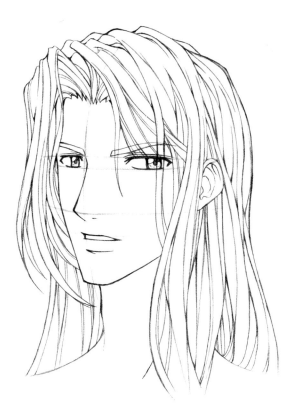

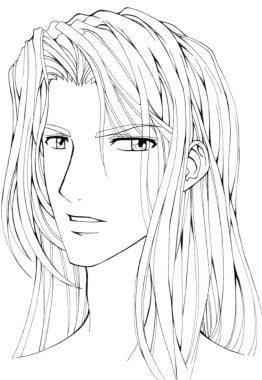

INKED VERSION
Even if you make a mistake when inking, it's not a fatal flaw. You can "patch" the area with another piece of paper and ink over it on that. There are also special white paints that mask inking mistakes.

COLOR SUGGESTION
Make sure that your background color is more muted than the hair color. You never want the background color popping off the page and overpowering your character.

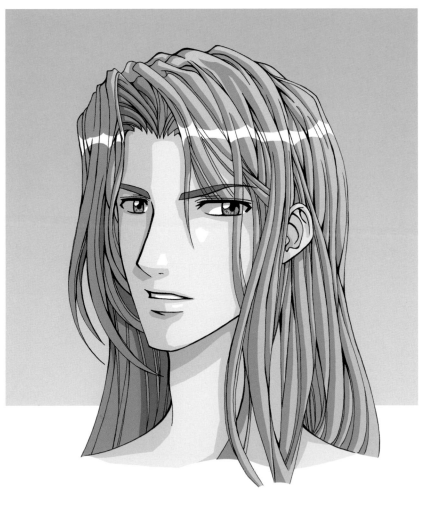

EXPRESSIONS

Now we bring the features into the act! This section offers a wealth of shoujo-specific expressions, along with the corresponding facial constructions. This not only allows you to understand how to create attitudes but also teaches you how to draw the head in all positions so that you don't feel restricted to the basic three angles (front, profile, and 3/4). And we'll also squeeze in a little shoulder action when we can.

Girls

Of course, the eyes, eyebrows, and mouth are the primary movers in creating expressions. But for shoujo girls, there's more: Pay special attention to the shape of the eyelashes, elongating them on sultry or sad expressions. The hair also moves about, reflecting the state of emotions, flailing about in a stormy manner when the character is angry.

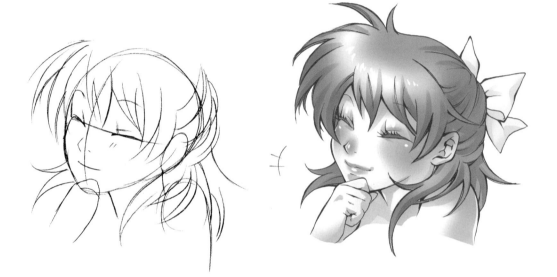

PLEASED

Closed eyes show extreme pleasure. The expression, therefore, relies more on the eyes than on the mouth.

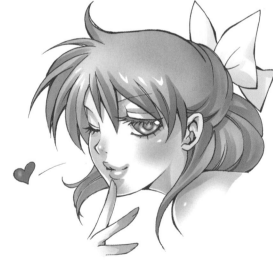

FLIRTATIOUS

In a flirting expression, you always want to keep it playful and light.

EMOTIONAL
Characters who feel their emotions deeply are fan favorites in manga, because young readers relate to their sense of vulnerability.

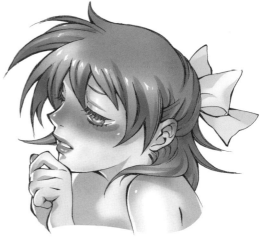

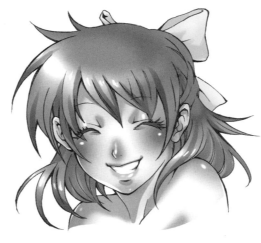

CHUCKLING
Never draw individual teeth. Meld them together for a brilliant look. (Note the high, arching eyebrows in expressions of laughter.)

UPSET
Keep your female characters pretty, even when they're outraged. Concentrate on their beautiful eyes.

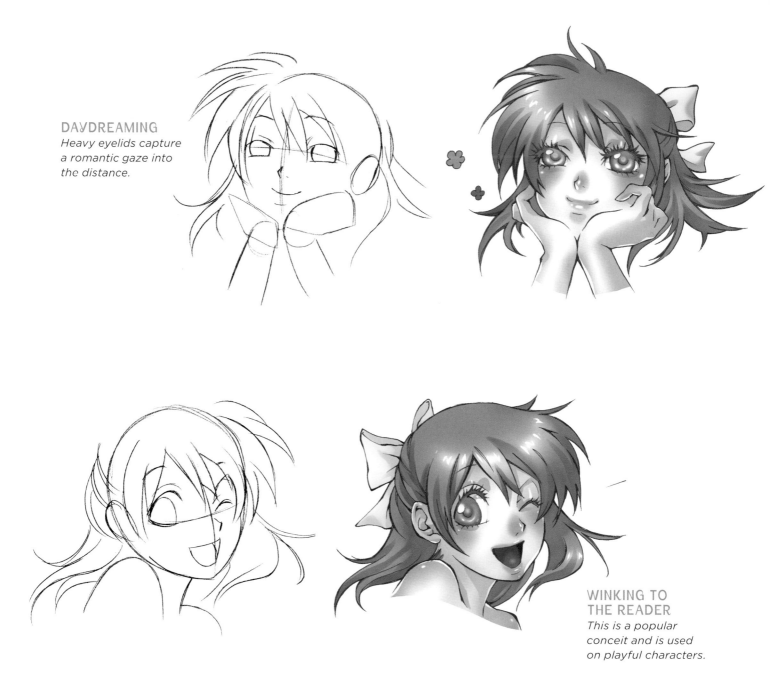

DAYDREAMING
*Heavy eyelids capture
a romantic gaze into
the distance.*

**WINKING TO
THE READER**
*This is a popular
conceit and is used
on playful characters.*

FRIGHTENED
As the eyes and mouth open wide, the face stretches to accommodate them. Notice that the hair flies about, reflecting the mood of the moment.

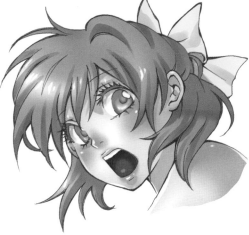

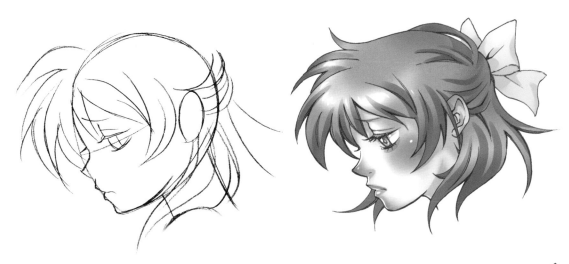

SAD
Looks of unhappiness usually have the eyes cast downward. Hopeful looks often have the eyes and head looking upward.

LONELY
Shoulders rise up, as if trying to comfort her like a blanket.

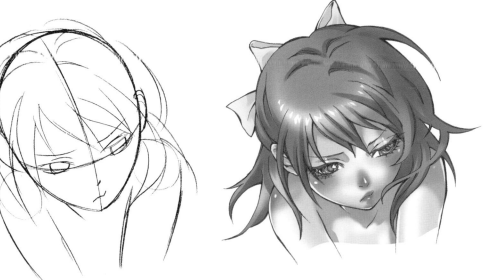

Boys

Boys can have expressions that are just as lyrical as those of girls, but their expressions can also become fierce, evil, and pretty intense. Because the older teen boys don't have the huge, glistening eyes of the girl characters, you need to have the eyebrows do a little more work. The eyebrows are sharper and point downward toward the bridge of the nose. In addition, look for a tilt of the head to assist in creating an expression, instead of only using what's going on in the face itself.

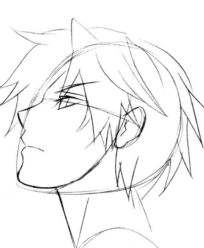

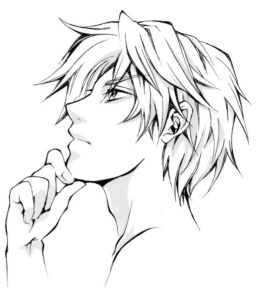

THINKING
Thinking is always indicated with a look off into the distance and with eyebrows that press down on the eyes.

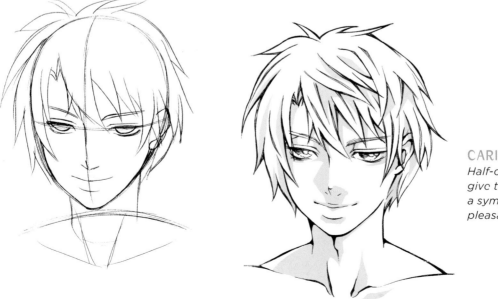

CARING SMILE
Half-closed eyes give this character a sympathetic, pleasant expression.

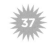

SUSPICIOUS
A suspicious character may tilt his head down and scratch his chin as he figures out whom to believe.

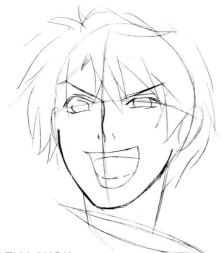

CRAZY LAUGH
The one eyebrow is raised, while the other crushes down, creating a dynamic expression.

REFLECTIVE SMILE

A downward head tilt adds a little spice to front-view poses. Don't make the eyebrows frown too much or he'll look evil. Just a small downward angle does the trick. Shadow adds an element of mood to the expression.

MISCHIEVOUS SMILE

With the right attitude, you can almost tell what a character is thinking—perhaps not the exact thought, but whether his intentions are good or bad.

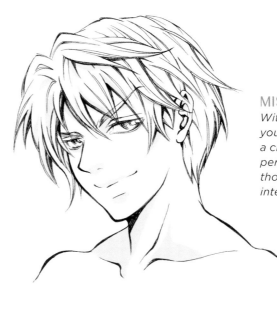

PAINED

Eyebrows that push down toward the bridge of the nose, combined with slightly gritted teeth, convey emotional turmoil.

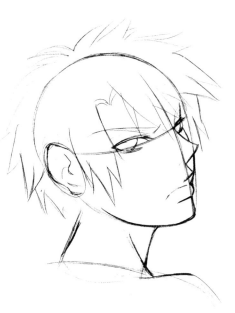

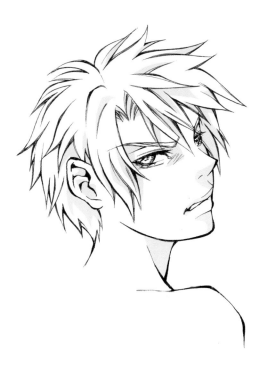

FLASH OF ANGER

Notice how one of the teeth becomes a fang to add an accent to the angry expression. The hair is an important element in communicating a wild edge to the image.

FEMALE HAIR DYNAMICS

Instead of thinking of hair as inert, just lying there on the head like a hat, think of it as strands traveling purposefully in a direction. This gives it a dynamic quality. Every good hairstyle has a direction to it. If it doesn't have a direction, it looks subdued. (Also see page 32 for tips on hair.)

Plus, have you ever noticed that manga hair on female characters often seems to blow in the wind or move gracefully in a swirling action? This flourish adds charisma and is an eye-catcher for the reader. So take a look at the forces exerted on manga hairstyles that give them their famous flow of action.

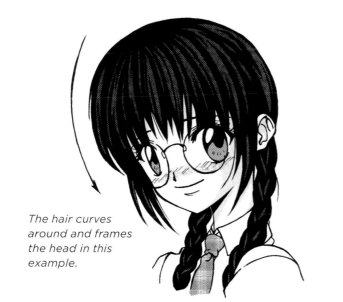

The hair curves around and frames the head in this example.

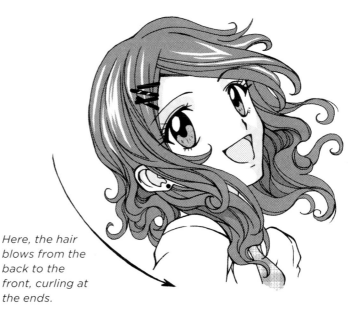

Here, the hair blows from the back to the front, curling at the ends.

Hair that hangs straight is good for bobs with long bangs.

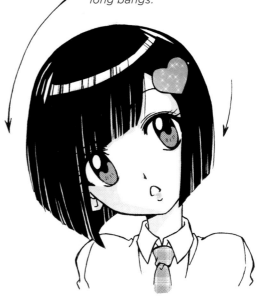

These are magical girl–style ponytails that swirl and twirl.

This hair is bunching and curling—and also moves from one side to the other.

Note the flowing action line this single ponytail makes.

Cropped ponytails—or ponytails that aren't pulled completely through the elastic band—are a very cute look!

Windblown hair moves both in front of and behind the head. Note that individual strands are drawn, which makes the hairstyle more elegant and appealing.

GIRLS WITH HATS

To add a jazzy look to your characters, you can't beat stylish, colorful hats. These fashion divas of shoujo shown here wear the most popular styles from Tokyo so that you can select the latest trends for your characters. Be as bold and colorful as you can, and don't worry that being flashy will detract from the character—it only adds to the vitality of the character's overall design. And don't forget to make use of patterns, bows, ribbons, flowers, pompoms, and brooches.

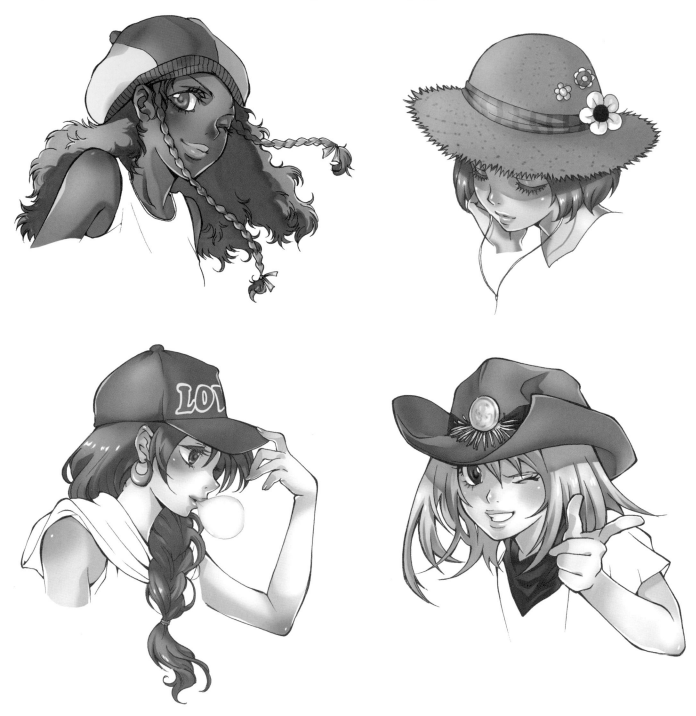

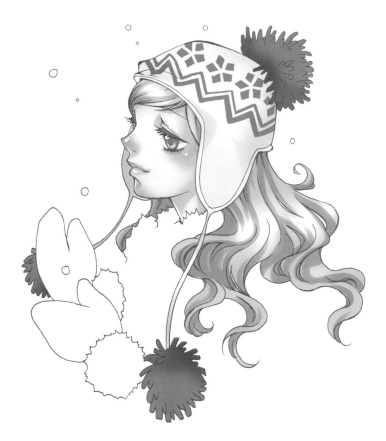

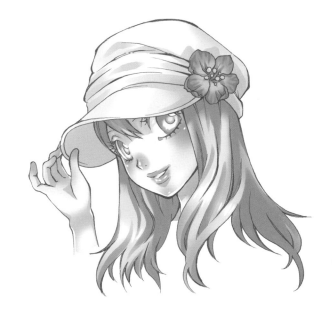

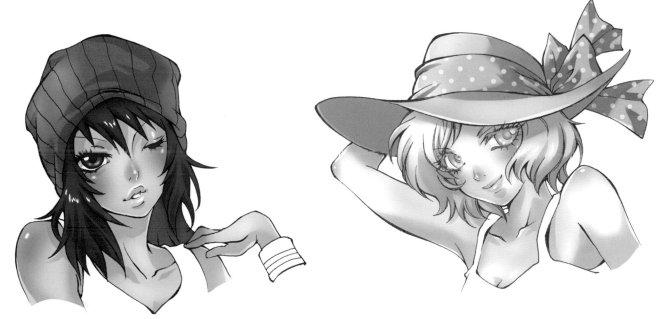

TEEN BOY HAIRSTYLES

Good-looking guys can be so vain; it takes a lot of effort to make your hair look this natural and care-free. So here's a complete collection of the most popular hairstyles for the fifteen-to-nineteen-year-old set. Long hair is very popular. But even when the hair is short, long strands of it should fall in front of the face. Don't draw the hair perfectly combed and in place; this makes the character look too restrained. Add a little action to it, as if it's slightly in motion. This gives the boy dramatic, movie-star looks.

SHORT

LONG

MEDIUM

EXTRA-LONG

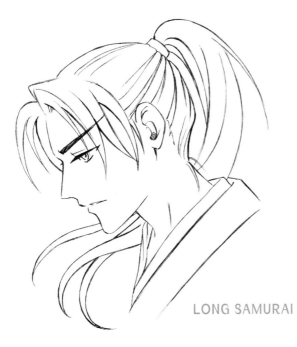

LONG SAMURAI

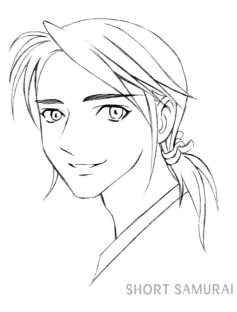

SHORT SAMURAI

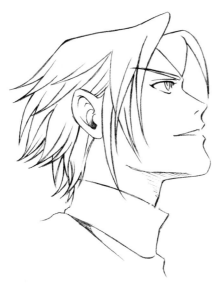

SOPHISTICATED

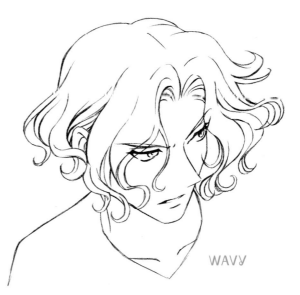

WAVY

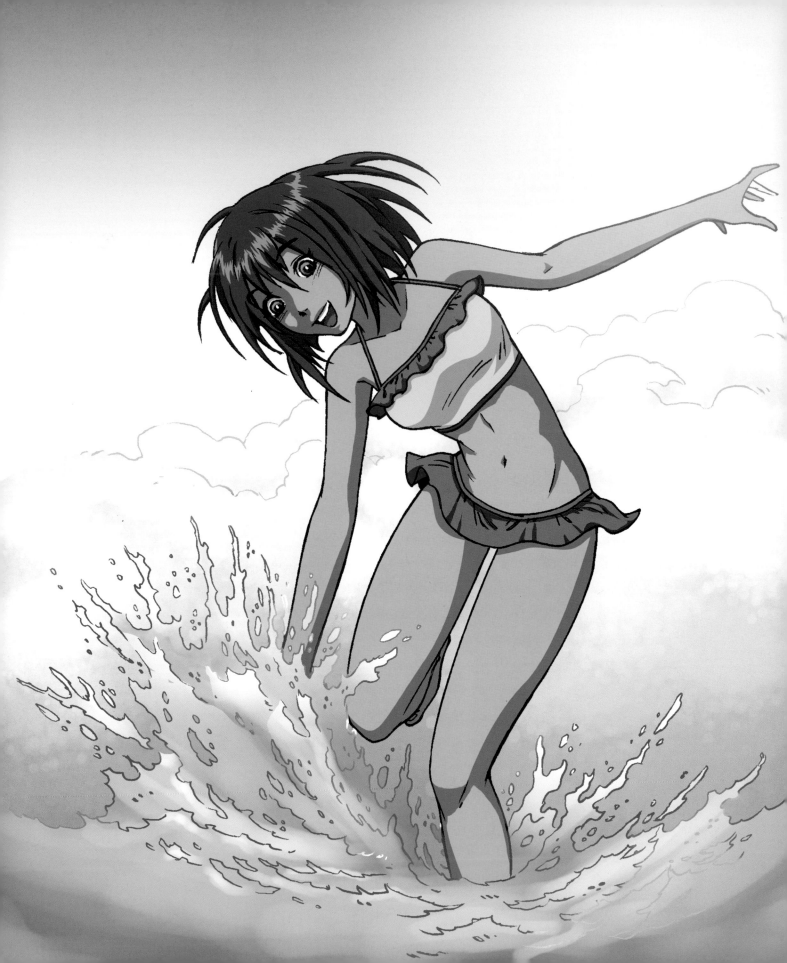

Female Bodies & Motion

NOW WE ADVANCE FROM drawing faces to drawing bodies. Since female characters are such a strong presence in shoujo, and since it's so important to get the age right, we're going to focus just on them in this chapter. We'll get to the boys later on. Just like faces, manga bodies are categorized in different genres according to the age of the character. We're interested in shoujo, so again, we have to be careful to keep our characters within a strict age bracket or their body types and movements will propel them completely out of this genre. As the female body matures, it goes through several stages of development, incorporating a youthful-cute quality and then a flirty-pretty quality. Let's take a look!

FEMALE BODY TYPES

Bishoujo characters (fully mature young women) are mostly found in the fantasy, sci-fi, action, and occult genres. The *shoujo* type is a young teen who retains the cute, perky, and pretty look of adolescence. The *kodomo* characters are younger still, with no real muscle tone or distinct female body shape. They star in adventure-type comedies. And *chibis* are the famous minipeople of manga who are small, chunky, and adorable. They can show up in any genre for comic relief.

CHIBI
(5–8)

KODOMO
(8–11)

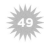

SHOUJO
(12-17)

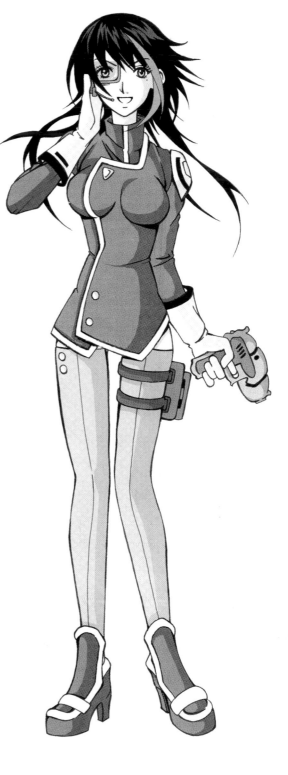

BISHOUJO
(18–21)

SIMPLIFIED FEMALE BODY

The proportions of a character are based on its overall height. Note that the wrist and crotch appear halfway between the ankle and the head. By taking note of the halfway mark, you can prevent common errors, such as drawing the legs too long or too short. In manga, however, there's also a little room for artistic license, and often a little extra height is added to the body to get idealized (i.e., taller) proportions. A small chest and narrow hips keep her looking young. Older, more mature characters will fill out more.

Front

Indicate the major joints by drawing circles on the shoulders, elbows, and knees. Why do artists typically do this? It serves to remind them that the joint is important and has its own shape. It is solid and cannot be squashed like the rest of the limb. It must maintain its shape and form.

Top of head.

Collarbones are as wide as hips.

Hips.

Halfway point.

Circles indicate joints.

Ankle.

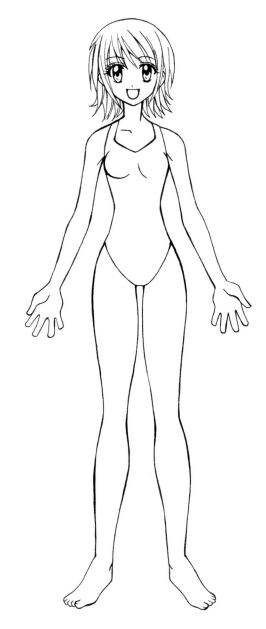

Side

Straight lines aren't as pleasing as curved lines. This is especially important when drawing the body. Even on areas where you might assume the lines would be straight, such as the legs, they're still slightly curved. Notice the subtle rounding of the leg muscles. This principle is even more pronounced on the back, which shows a significant curve at the shoulders and, again, just above the hips. Notice how long the neck is (long necks are an attractive feature on female characters). Also take note that when the arms are in a relaxed position, they will naturally fall so that the fingers are just about midthigh level.

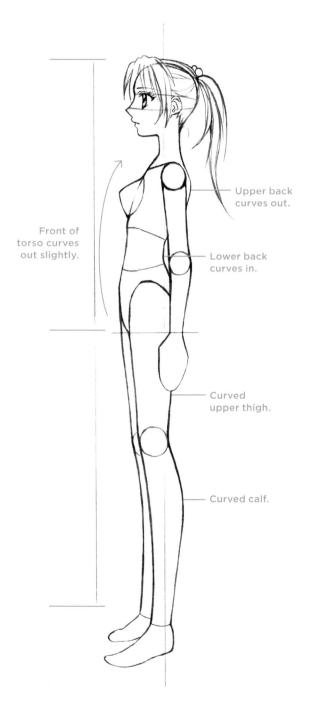

Front of torso curves out slightly.

Upper back curves out.

Lower back curves in.

Curved upper thigh.

Curved calf.

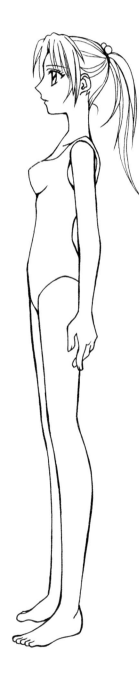

Back

On female characters, the back is quite narrow, and the hips are wide—but not too wide! And the shoulder muscles are mildly developed. Don't let the shoulders droop. Notice how the proportions remain the same, no matter the view—front, side, or back. That's the secret of drawing a character over and over again in different poses while keeping her recognizable: It's all about maintaining the proportions.

So here, the elbows should be positioned just a little higher than the waistline. Check landmarks like this from one view to the next to make sure these checkpoints line up; and if they don't, simply erase and adjust them. If you can keep a few of these proportions in mind (for example, "elbows just above the waistline"), then you'll start drawing your characters in proportion each time.

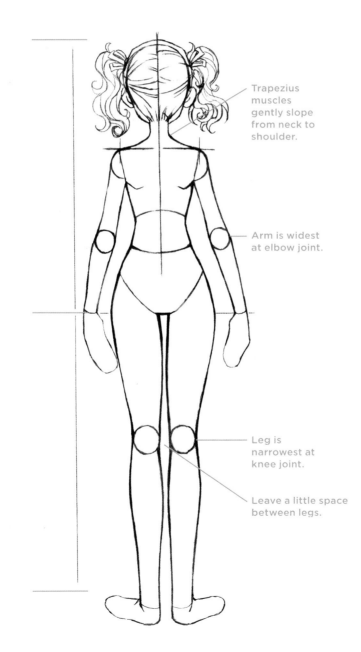

Trapezius muscles gently slope from neck to shoulder.

Arm is widest at elbow joint.

Leg is narrowest at knee joint.

Leave a little space between legs.

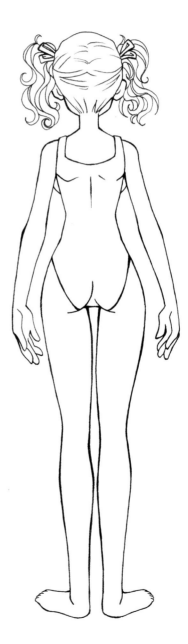

SILHOUETTES

Silhouettes are used throughout manga to add variety to a routine series of sequential images. Drawn correctly, the silhouette is dramatic and eye-catching. It can also show off the human figure in a very appealing way. A strong silhouette is usually based on a strong pose.

To draw silhouettes, it's most useful to first roughly sketch in the entire figure. Yes, that means the interior as well as the outline. Believe me, the time you spend working on the interior will result in a better outline for the silhouette. Simply starting off by drawing the outline won't work.

Silhouettes, by nature, should be "extroverted" poses, not "inward-looking" poses. By this, I mean keep the arms and legs *away* from the trunk of the body as much as possible. If they overlap the figure, they'll meld with black areas of the body and become hidden from view.

BAD WALKING
None of the limbs in this image are positioned away from the body; therefore, the figure is one undefined mass. Showing a person walking in a front view is a bad choice for a silhouette. It's "introverted." We want "extroverted" poses.

GOOD WALKING
Drawing the figure in a side view is the first order of business for a walking silhouette. Now you can see those graceful, long legs in action and the arms swinging in tandem.

BAD STANDING

This silhouette is very symmetrical. The two arms are doing the same exact thing. The legs are both standing the same way. Nothing about the pose is dynamic. Plus, the hair is hiding the figure.

GOOD STANDING

The legs are now positioned asymmetrically. The body stretches dynamically. The hair separates more from the torso. Even though she's still just standing, this is a much more active pose.

BAD SITTING

This pose is not at all designed for a silhouette. All of the limbs meld together into the body. There would be no reason for creating a silhouette out of a pose like this.

GOOD SITTING

Compare this sitting silhouette with the previous one. By moving the limbs away from the trunk of the body, you feminize the figure and give her some body language, too.

BAD FLYING
It works, but the body is stiff, and the hair and arms blend into the body and become indistinct.

GOOD FLYING
The pose is now quite dynamic. The arms, legs, and hair are all away from the body and clear and easy to see. The pose is also more attractive.

BAD PUNCHING

The lack of upper body movement makes this punch stiff and lacking in force. The hair blends into the shoulder and arm.

GOOD PUNCHING

The body now moves into the punch, and the legs bend, too. The hair flies up, reacting to the action. Compared to the first pose, you can feel the movement.

DRAWING POSES WITH MOVEMENT

The human body was built to move. And things that move, bend, and twist are more interesting to view than stationary objects; therefore, it follows that you've got to find a way to make your figures move in whatever pose they're in—even if they're just standing still. But how do you do that? The female form, being curvier than that of the male, can strike poses that are more flexible. In the same way that female eyes communicate a wide range of expressions while still maintaining femininity as a constant undercurrent, so, too, should the gestures of the female body convey a sense of femininity in tandem with whatever other emotions are on display in the overall pose.

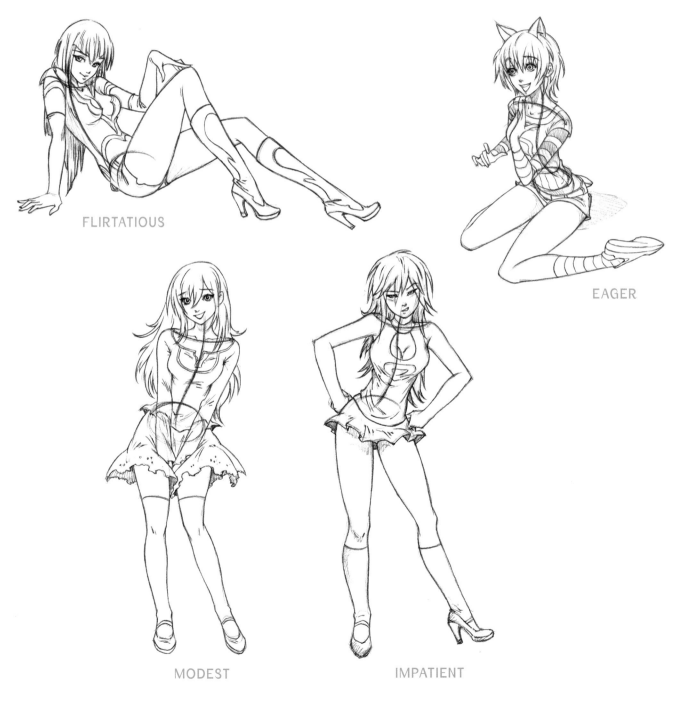

FLIRTATIOUS

EAGER

MODEST

IMPATIENT

The Line of the Spine

You've probably heard of the *line of action.* It's a long line (typically running through the entire drawing) that animators sketch in at the rough stage of the drawing to emphasize the fluidity of the pose. Well, we're going to use a similar device, only not so elaborate. We don't need to be elaborate. The *line of the spine* serves the same purpose, and it's shorter.

Whichever way the spine is curving or bending is the same way the body generally moves. So use the line of the spine (indicated in red in the drawings here) to indicate this flow of action. It's simple and built right into the body. When you sketch the line of the spine in your rough drawings, try to emphasize its curviness, and you'll avoid making a stiff drawing.

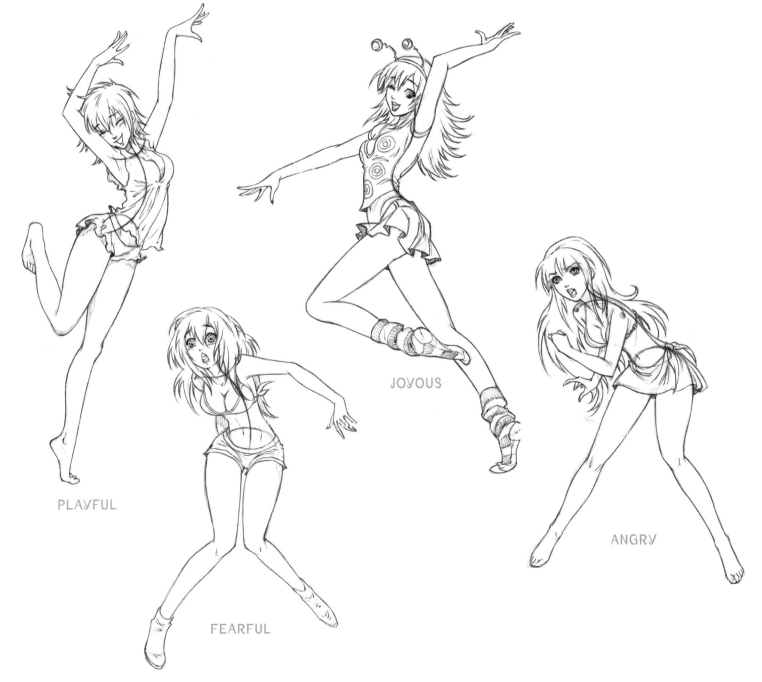

PLAYFUL

JOYOUS

FEARFUL

ANGRY

EXPRESSIVE POSES

Your character doesn't have to be throwing a punch to convey a sense of movement. The best demonstration of this is a standing pose that makes effective use of the line of the spine. If you can make a standing pose dynamic, then using the line of the spine must be effective. Take a look: By simply curving that line slightly, the pose takes on an appealing look. You don't have to settle for stiff poses now that you know this secret. So here are some expressive poses for shoujo girl characters that you can copy. They also show the body from different angles, so copying them will raise your skill level.

Standing

This somewhat flirty stance is far more appealing than simply standing with the hands at the sides. It's playful and bubbly, and this comes from giving the torso a little twist to one side. Just a small amount of movement goes a long way in communicating attitude.

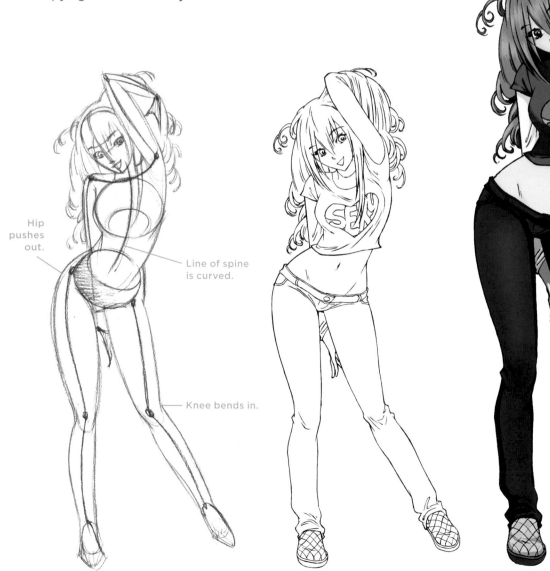

Hip pushes out.

Line of spine is curved.

Knee bends in.

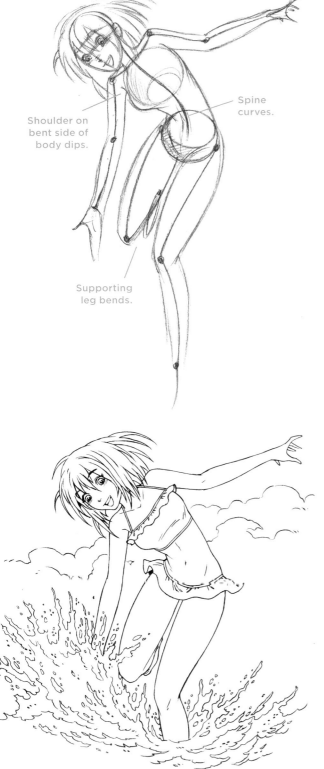

Shoulder on bent side of body dips.

Spine curves.

Supporting leg bends.

Bending

Believe it or not, bending while standing is one of the harder poses to make look natural. Often, beginners draw it with a stiff upper body and locked legs, making it appear as if the upper body and lower body are not connected. That's a no-no. The legs should be slightly bent, with a bending spine, in order to look natural.

Also, instead of showing the figure from the side, which has a tendency to look stiff, turn the body to the 3/4 view, as has been done here. The 3/4 view is actually a lot easier to draw in a bending pose than the side view, but beginners often don't think about using it. It will save you some agony, however, so give it a try!

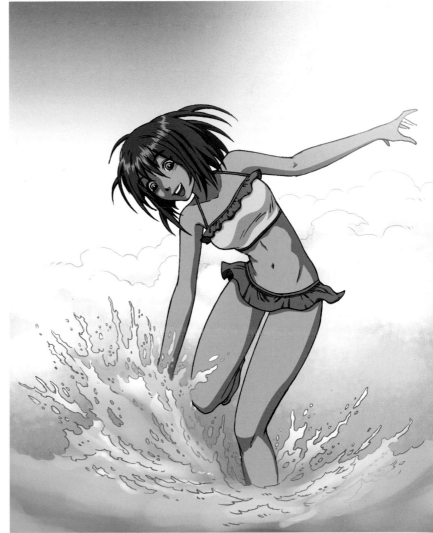

Sitting, Straight Back

Here's a classic sitting pose. The curve in the small of her back pushes the torso forward. Adding a curved back to a sitting position isn't what you'd call a huge detail, and it's not going to rock someone's world when looking at this picture. But it *will* make a difference in the viewer's overall impression. The drawing will appear more lifelike. It's these little hints (which in and of themselves might not make or break a drawing) that create a look of solid professionalism that's unmistakable when you add them all together. Your friends who try drawing manga without knowing these principles won't have any idea why your drawings look so good and theirs look so plain!

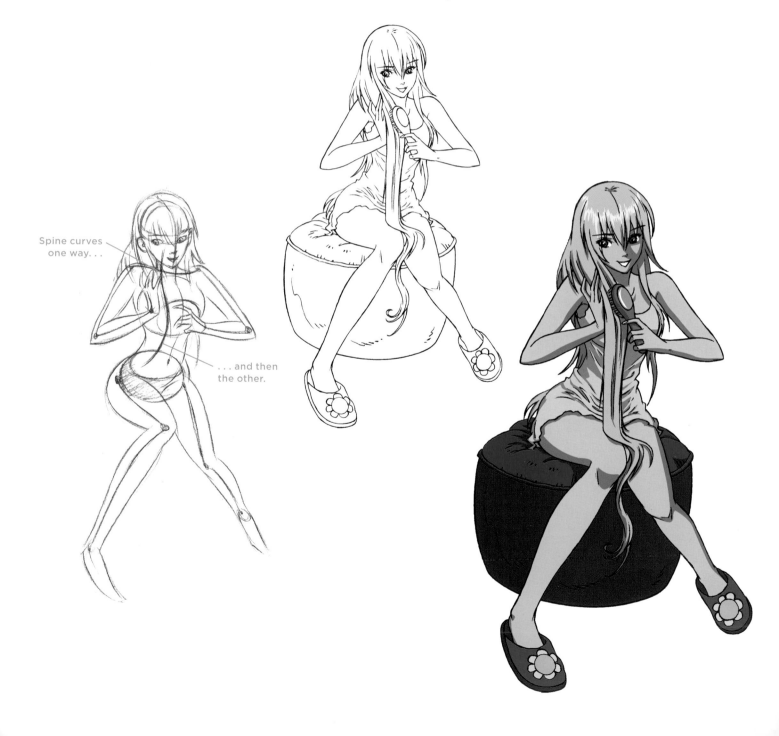

Spine curves one way. . .

. . . and then the other.

Sitting, Slouched Back

The convex curve of the back in this pose propels this crying character into the action so effectively that you can feel her emotions. If she had a straight back, the character would still read as crying, but you wouldn't *feel* anything. Notice that the neck is simply an extension of the spine and that it juts forward as part of the pose.

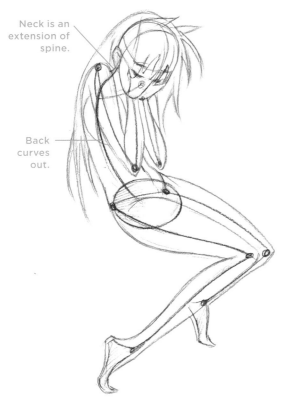

Neck is an extension of spine.

Back curves out.

Leaping Palm-Heel Strike

In heroic poses, the back is usually arched and the chest is held high, giving the character a proud posture. There's also a lot of foreshortening used in this drawing to show the body in perspective, although you may not realize it at first. It affects the legs most noticeably and the thighs. For example, the near thigh appears to be coming at us, so it requires foreshortening—meaning that it gets flattened (compressed) and, therefore, will be drawn shorter than the far leg, which doesn't look as if it is coming at us.

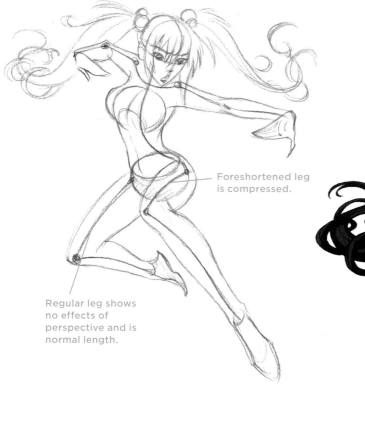

Foreshortened leg is compressed.

Regular leg shows no effects of perspective and is normal length.

Magical Pose

This pose, though flashy, isn't actually complicated or particularly challenging to draw. The arms mirror each other, and one leg is bent at the knee. The main focus is the hourglass figure, which follows the line of the spine. Note the fantasy-style hair, strands of which uncurl as they reach out in all directions. The head needs to tilt forward to avoid the face being hidden by the arm. Be aware that poses often need small adjustments like this to read clearly.

Line of spine starts at neck.

Collarbone dips in middle as both shoulders rise above it.

Line of spine continues down to pelvis.

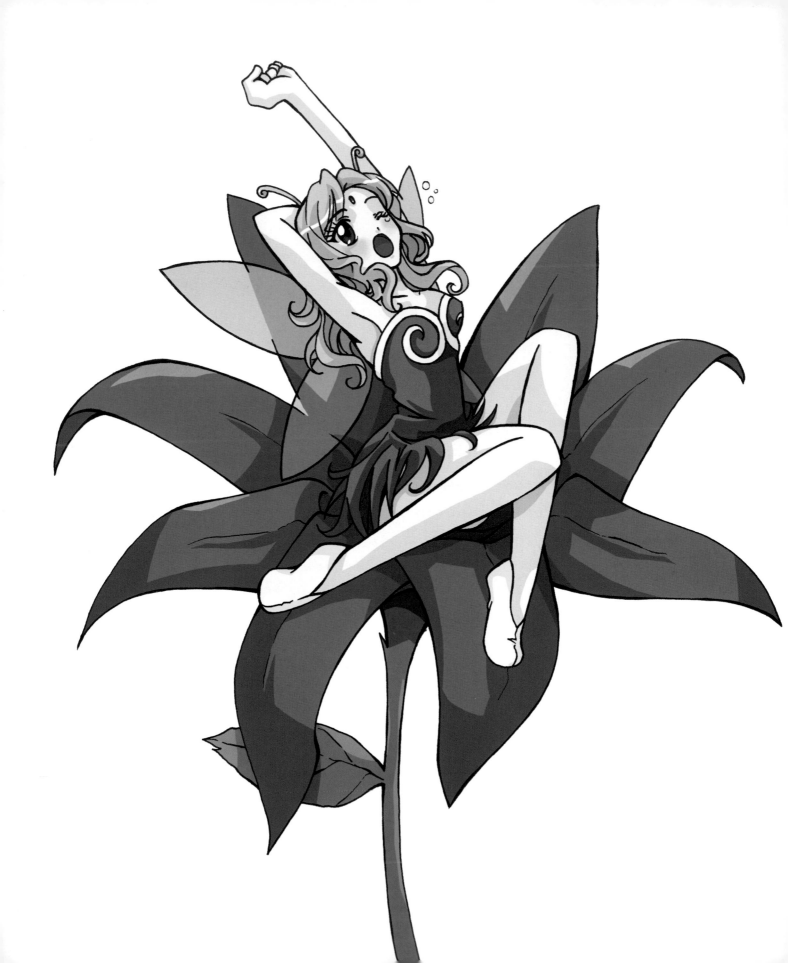

THE Shoujo Girls

I KNOW YOU'VE BEEN gearing up for this part. I can feel it coiling up inside of you. You can't wait to unload all of that creativity onto a host of brand new, original character designs! These never-before-seen, authentic shoujo characters represent all the different subcategories of the style, from the ever-popular cat-girls to bad girls to magical girls and more. Now that you've learned manga drawing principles, allow them seep into your subconscious. They'll stick with you, and you'll be able to recall them when you need them. It's time to free your mind from lesson plans and just have fun drawing fantastic characters. Fun is an absolutely essential part of the learning process. It's when we let our inspiration loose. So you can begin to infuse the images with some of your own ideas, if you so choose. You may decide to change a hairstyle or an eye type. Perhaps you have a new idea for interpreting a pose. Allow yourself the freedom to inject some of yourself into these models. But remember: There's also nothing wrong with continuing to copy the drawings exactly the way you see them. It all raises your skill level.

CAT-GIRLS

Cat-girls are reader favorites. If you want to draw shoujo, these kittenish characters are a really good place to start. Cat-girls are part human and part feline. Although they live among, and interact with, humans, they retain a lot of their cat personality traits, such as curiosity, mischievousness, impulsiveness, and a fondness for milk. They're always attractive, even with their weird cat ears and tails. Some of them have stripes, like tabby cats. Don't try to explain their appeal to your parents. It's hopeless!

Mostly Human Cat-Girl

We'll start the cat-girl section with a character who's mostly human. Only cat ears and a tail show us that she's a furry. She doesn't even sport a cat tooth like some cat-girls. The cat items are used just to spice up the character design and take her out of the ordinary. Why make her a cat-girl at all? Sometimes you do it just to add variety. For example, if you're designing a group of four girlfriends for a story, one might be tall, another short, and a third medium height. So,

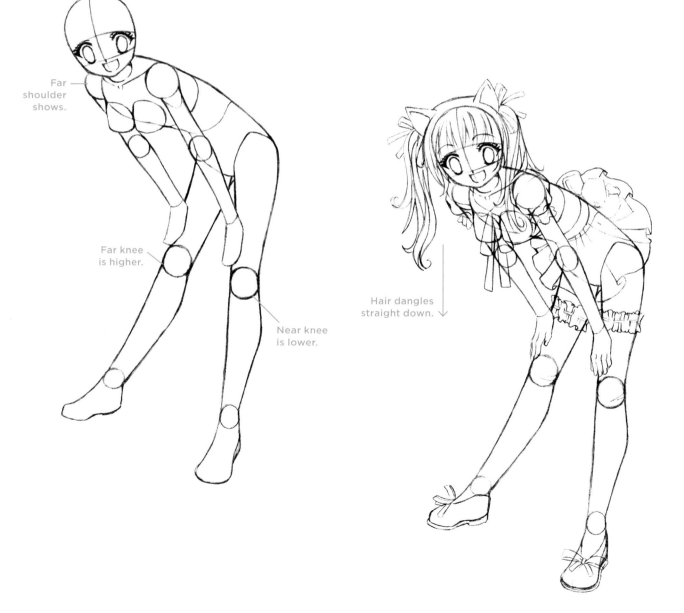

Far shoulder shows.

Far knee is higher.

Near knee is lower.

Hair dangles straight down.

what are you going to do with the fourth friend? How are you going to distinguish her from the group? You could add the minimum adjustments necessary to turn her into a cat-girl. This will keep her looking like part of the group but also carve out her own identity.

Schoolgirl

The schoolgirl cat-girl fits in like any other student and has lots of human friends. But the cat-girls who appear most like humans are the ones who work best in the high school environment. If they are very catlike, they'll be too distracted by quick movements to pay attention in class.

Note that these ears seem to grow right out of the head. Some artists, however, use a headband with the cat ears attached to them instead of this organic look. Either way is a popular convention. The interior of the cat ear is almost always lighter in color than the exterior.

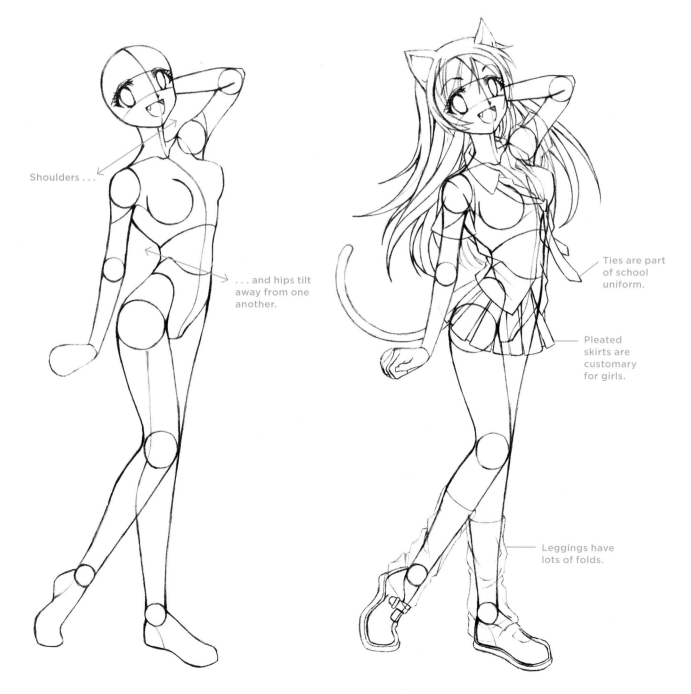

Shoulders . . .

. . . and hips tilt away from one another.

Ties are part of school uniform.

Pleated skirts are customary for girls.

Leggings have lots of folds.

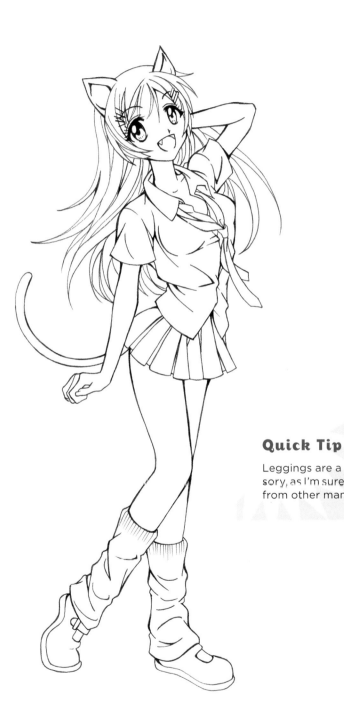

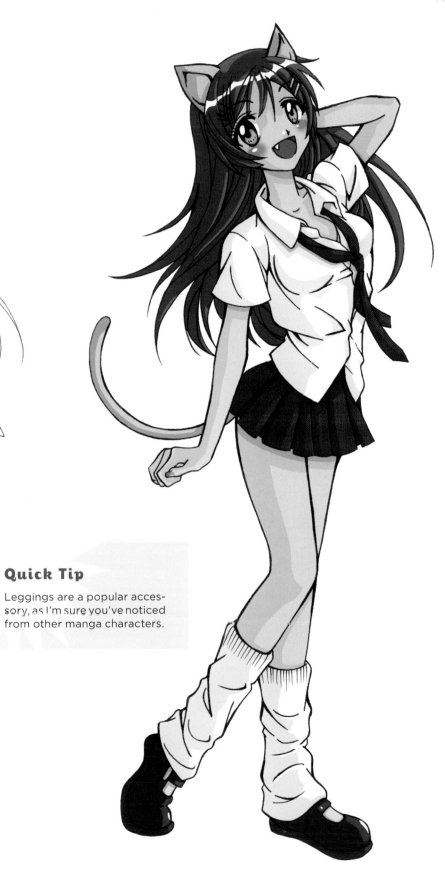

Quick Tip

Leggings are a popular accessory, as I'm sure you've noticed from other manga characters.

Majorette

This high-steppin' cat-girl possesses the right cat "gear" to identify her as such. She's got cat ears, a cat tail, and a cat tooth for an accent. Note that it's only one cat tooth. Two cat teeth begin to look like fangs, and that would give her too much of a feral quality. And what's with the blue hair? Well, we don't really have to quibble about being realistic, do we? After all, we are talking about a *cat-girl*. But note that she's skin-covered and not fur-covered, like some furry creatures in genres such as horror and fantasy. Creating a fur-based cat girl is possible, but it's a less attractive character.

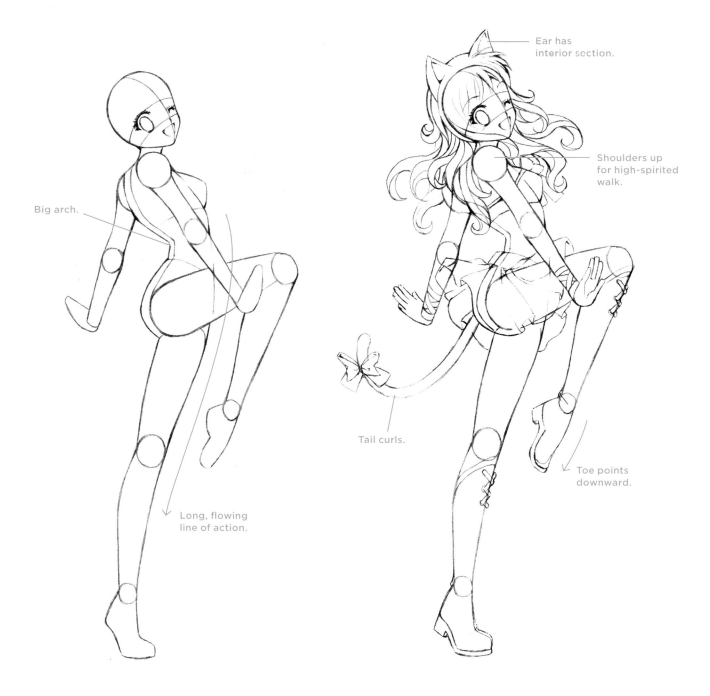

Big arch.

Long, flowing line of action.

Ear has interior section.

Shoulders up for high-spirited walk.

Tail curls.

Toe points downward.

Quick Tip

A curling tail is more expressive than a straight one.

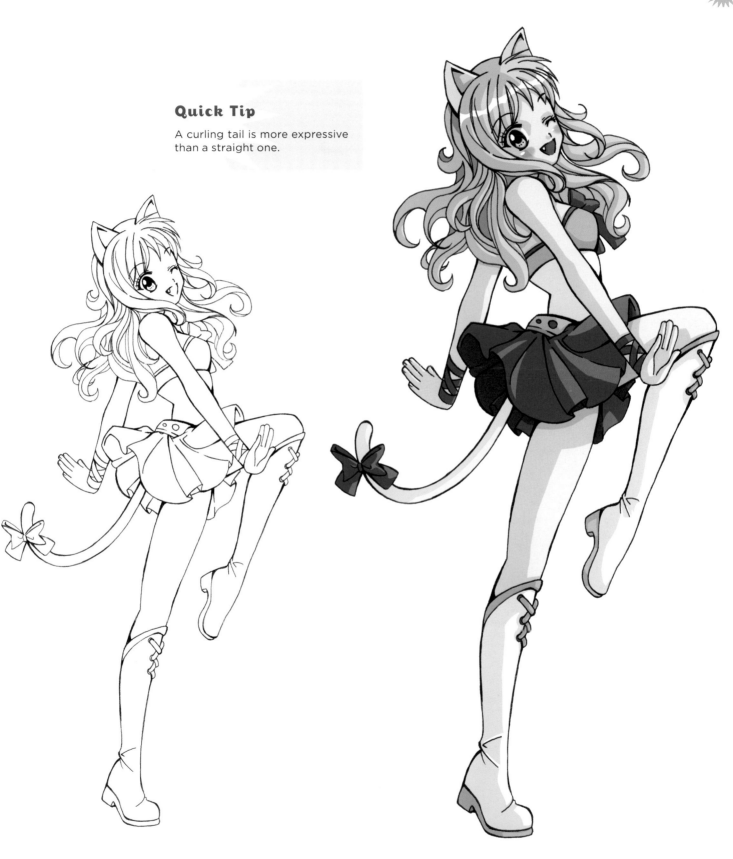

Scaredy-Cat

Let's say you want to push the character's design by giving her more catlike features. Paws would be the next item to add to the list. But you always want to go for cuteness. Drawing anatomically correct animal paws, with the "thumbs" up the sides of the wrists, would look grotesque. Still, there's a way to do it without running into problems: Just turn the cat paws into giant, oversized gloves and boots. They're a great device, and lots of cat-girls wear 'em. They're round and fuzzy.

This cat-girl's paws aren't just giant—they're humongous! The bigger, the funnier! And since giant paws look like boxing gloves, lots of cat-girls who wear them will playfully throw jabs at the reader as they wink. It also makes for a fun image. Adding to the humor here is the fact that she's frightened to death of the little mouse creature at her feet. Tears bubble out the corners of her eyes as she starts to get red in the face. She also comes with the accoutrements of a housecat: collar and bells.

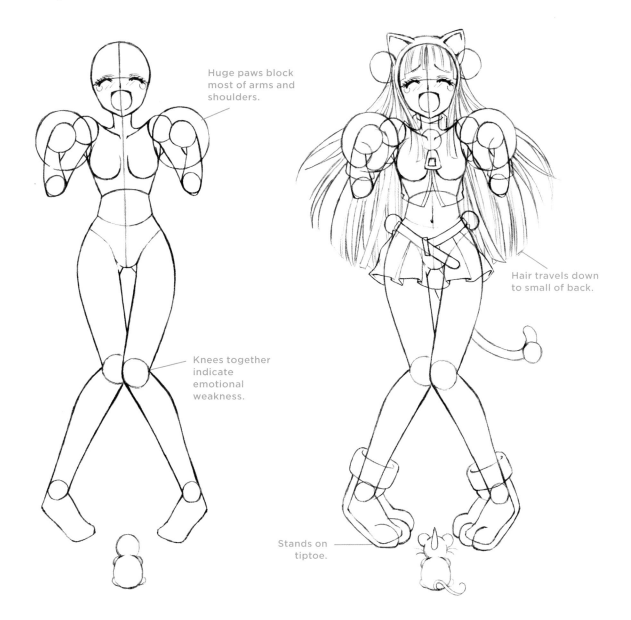

Huge paws block most of arms and shoulders.

Hair travels down to small of back.

Knees together indicate emotional weakness.

Stands on tiptoe.

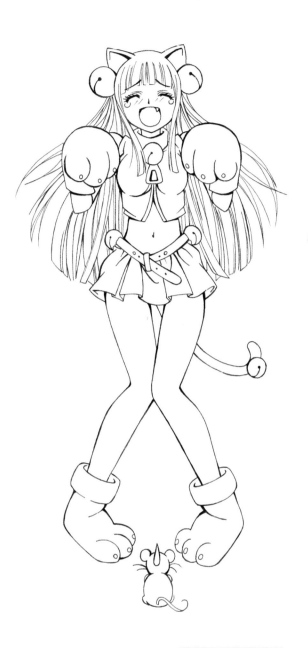

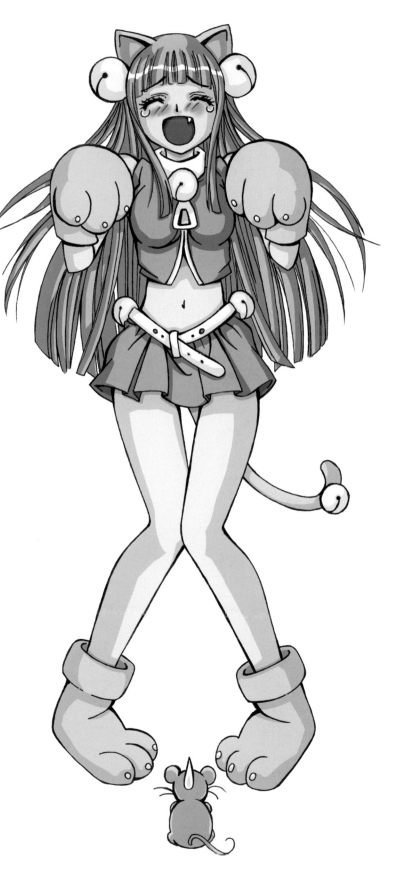

Quick Tip

Give the mouse a horn to turn it into a fantasy creature.

MAGICAL GIRL

The magical girl is usually an ordinary schoolgirl who is magically transformed into a super-idealized fantasy figure with special abilities and talents—things she has only dreamed about. Once transformed, she appears amazingly glamorous in her new, heroic role. She can be a supermodel, a rock star, a famous chef, or, most commonly, a fantasy fighter. Her outfit is often a transformed, totally revamped version of a school uniform. She usually has a wand, a sword, a staff, or jewels and crystals through which she derives her powers.

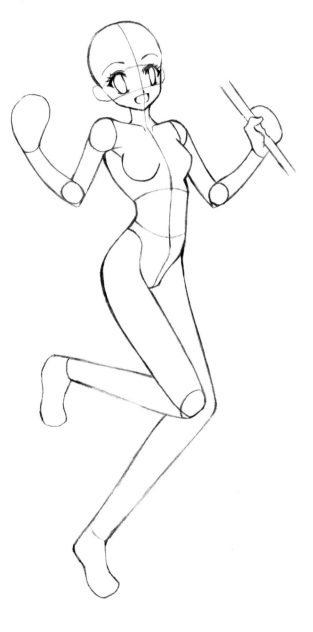

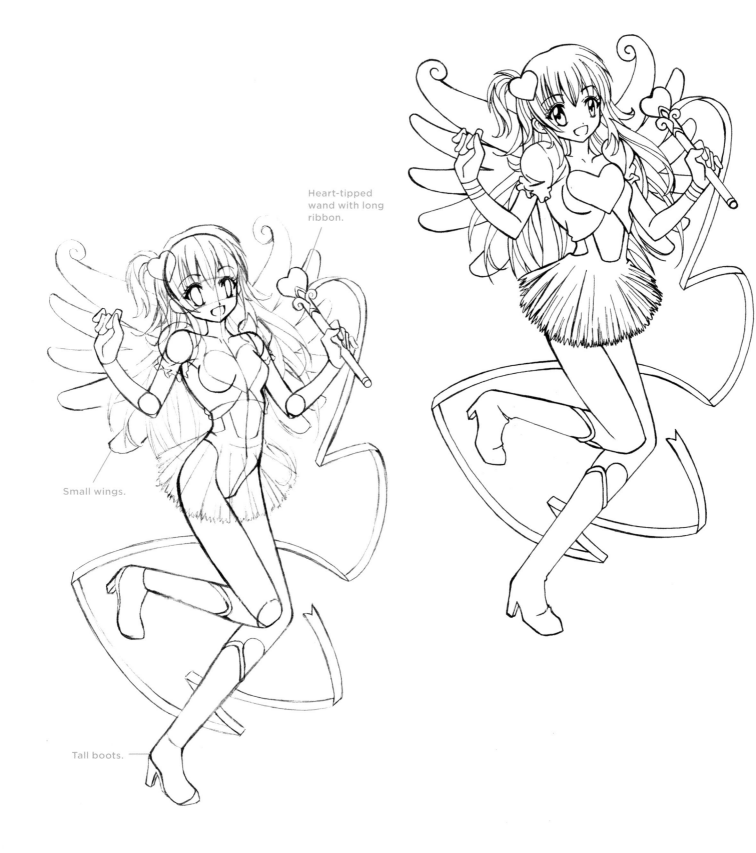

Heart-tipped wand with long ribbon.

Small wings.

Tall boots.

MAGICAL GIRL ACCOUTREMENTS

Hearts are always a popular motif in shoujo and often appear on clothes, accessories, or backgrounds. Magical girls also usually wear either long leggings or high boots. Wings are optional on magical girls. But if you use them, keep them small. If you make them bigger, you could turn her into an angel.

TENNIS PLAYER

With the soaring popularity of the manga graphic novel *The Prince of Tennis*, racket sports have gained tremendous appeal among manga fans. But *The Prince of Tennis* stars a male tennis player, so it's only natural to start introducing female shoujo tennis stars into manga. Maybe you'll be the one to invent the next great manga tennis graphic novel, which will star a *female* champion. Or perhaps it will be a humorous tennis manga. In this humorous scene, which continues on the next two pages, the player's eyes are good at following the ball, but her racket . . . well, that's another story.

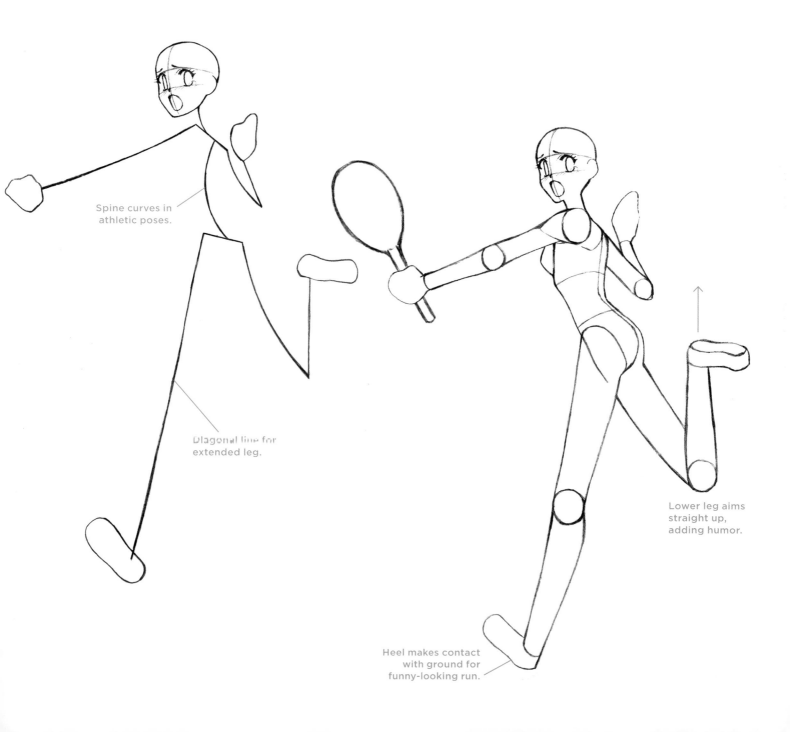

Spine curves in athletic poses.

Diagonal line for extended leg.

Lower leg aims straight up, adding humor.

Heel makes contact with ground for funny-looking run.

Empty hand should be relaxed and open.

Skirt flaps in wind, indicating motion.

Fully extended arm.

Quick Tip

Like the skirt, the hair shows movement. Both ponytails trail behind the head, showing the effects of the character's actions.

J-ROCKER

The term J-Rock refers to Japanese rock music. J-Rock fashions are a huge underground trend in Tokyo. They range all the way from the somewhat mild, like this outfit, to the totally outrageous and loony. Some of these "rock stars" have gotten that way through magical girl–type transformations that are a kind of teen-girl wish fulfillment.

When you draw this type of character, you want the clothes, hair, and body—everything—to be moving to the beat. Nothing in the picture should be static. Many rock singers use a headset, rather than a handheld microphone, in concert. But to quickly communicate her identity to the reader, the more obvious prop (the handheld mic) is the best choice.

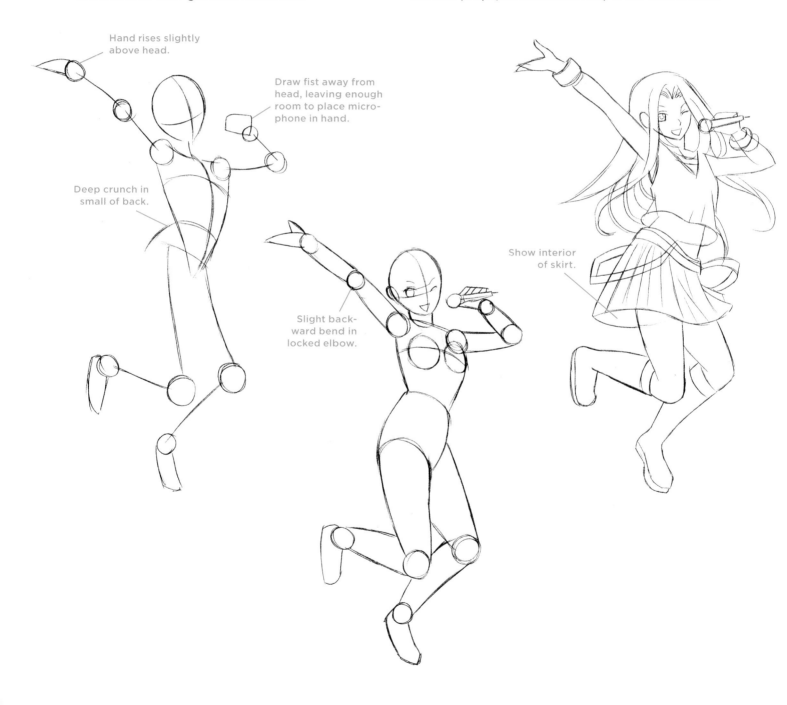

Hand rises slightly above head.

Draw fist away from head, leaving enough room to place microphone in hand.

Deep crunch in small of back.

Slight backward bend in locked elbow.

Show interior of skirt.

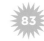

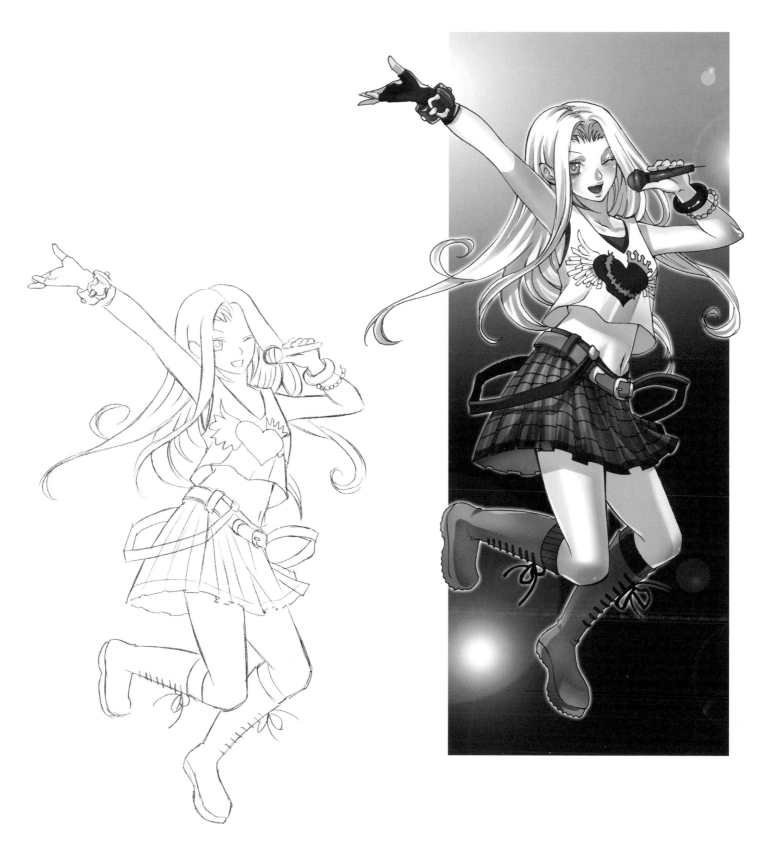

"FANTASY" OCCUPATIONS

Authentic service outfits, like those of the French maid, sushi chef, or airline attendant, are favorites of female readers of shoujo comics. In Japan, these character costumes represent "fantasy" jobs for young girls daydreaming about the romantic life-styles of adults, which is why you see them in so many manga graphic novels. The more official the outfits look, the more appealing they are to young readers. Sometimes, these fantasy occupations are obtained by way of magical girl transformations.

Flight Attendant

Some girls dream of jetting around the globe to exotic places, while at the same time being the object of desire of rich businessmen who travel first class to their international meetings. Even though an airline attendant, technically, wouldn't be a teen-ager, she is drawn with the features of a shoujo girl and therefore belongs in this genre. She is a *shoujo version* of an airline attendant who used her magical girl powers to transform into a flight attendant.

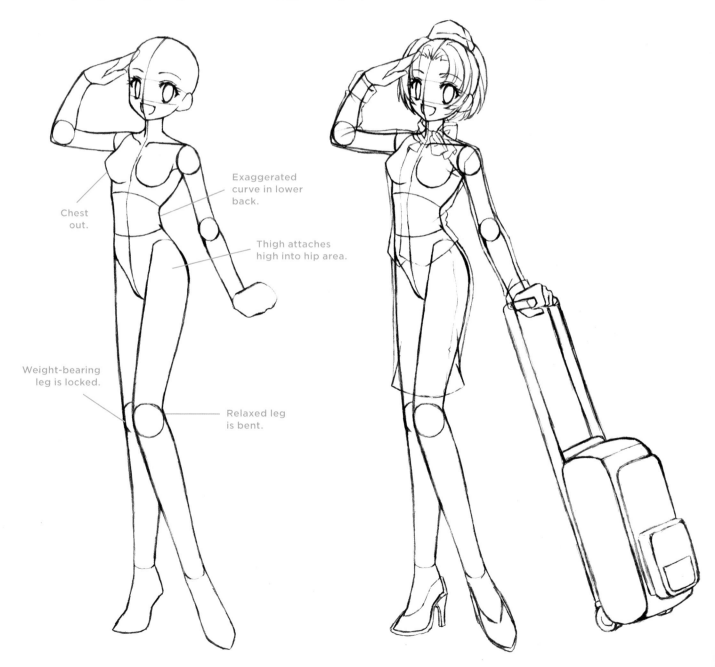

Chest out.

Exaggerated curve in lower back.

Thigh attaches high into hip area.

Weight-bearing leg is locked.

Relaxed leg is bent.

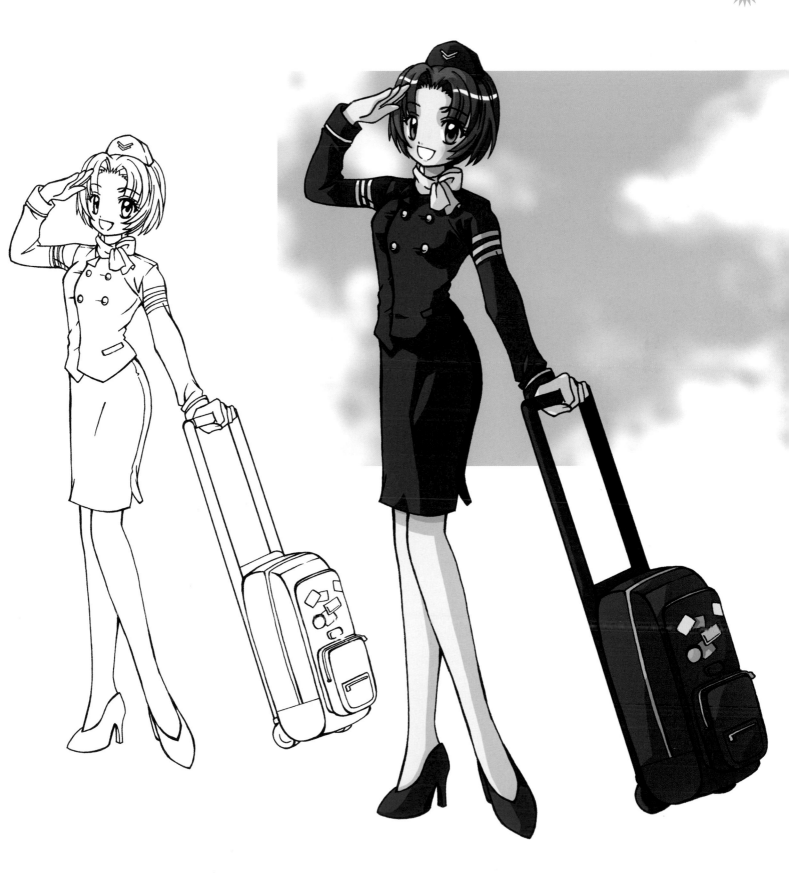

Sushi Girl

This is a typical robe worn by sushi chefs. It's loose and comfortable. She also wears a headband and sash, and if her feet were showing, you'd see that she wears sandals with socks. Her hair is worn up so that it stays out of the food, which is a common practice among food preparers.

Apprentices like our young sushi chef are proud of their work. She can't wait to show this well-prepared meal to the head chef! Of course, the cat will make sure that, the moment she turns her back, the California roll goes bye-bye, leaving her nothing to show for her hard work. Except for a burping cat.

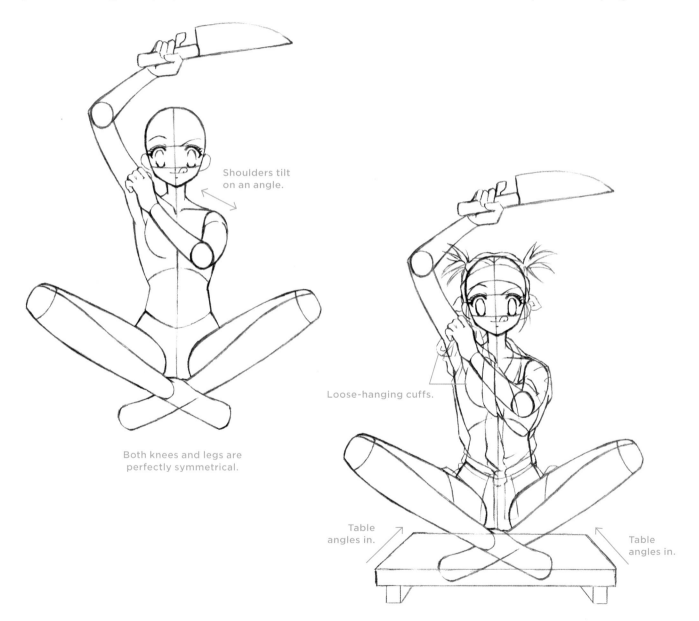

Shoulders tilt on an angle.

Both knees and legs are perfectly symmetrical.

Loose-hanging cuffs.

Table angles in.

Table angles in.

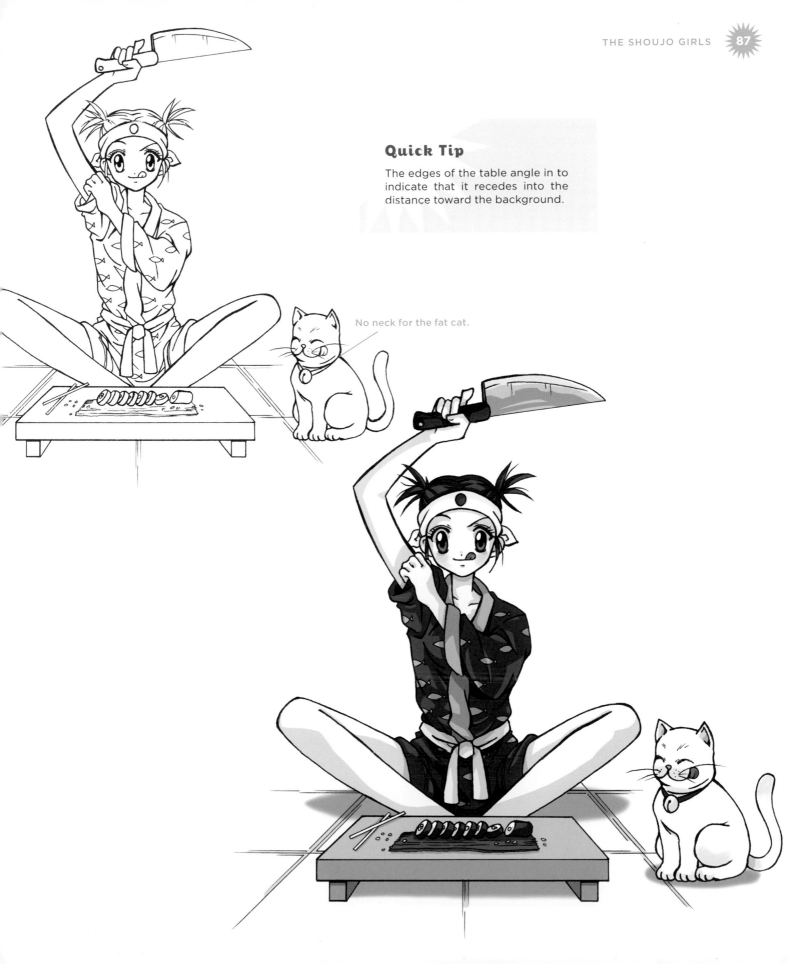

Quick Tip

The edges of the table angle in to indicate that it recedes into the distance toward the background.

No neck for the fat cat.

FAIRY

Fairies work best when shown beside an object—such as a flower, for example—that can reveal their scale. As the flower unfolds, it reveals the fairy inside, and you see just how small this little winged creature really is. Fairy wings are usually of the insect type, like those of the dragonfly or butterfly. They're often translucent. In addition, she can be drawn with tiny antennae, which are another sign of her smallness.

In this scene, the fairy has just awakened from her slumber inside of a flowery bedroom. (I wonder what fairies who have allergies do.) She has a delicious stretch as she rouses herself from sleep.

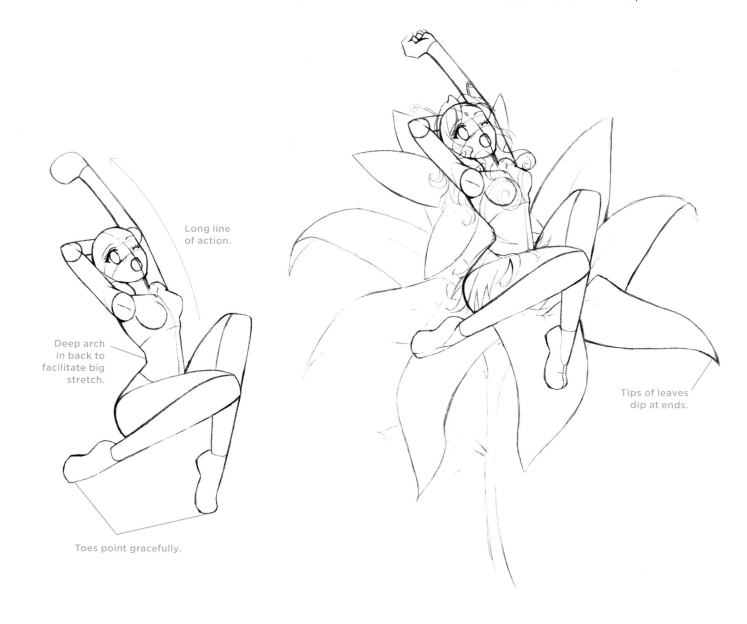

Long line of action.

Deep arch in back to facilitate big stretch.

Toes point gracefully.

Tips of leaves dip at ends.

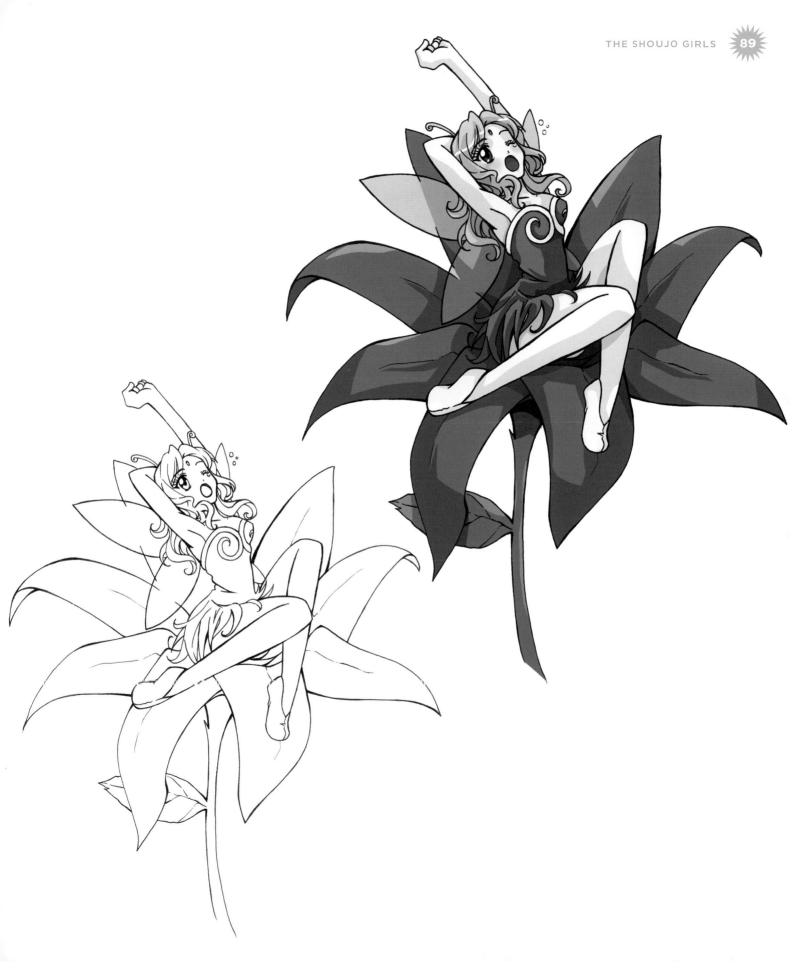

PRINCESS FIGHTER

I guess she's not waiting for any Prince Charming to come to her rescue! When drawing a princess, if you think *poofy* and *layers,* the dress will come out just fine. For example, look how poofy the shoulders are. And the bottom half of the dress looks like it's filled with helium! The torso, on the other hand, is always stitched together tightly, to show off the figure. Rows and rows of flounces, those decorative little ruffles on the hems of the garment, are used extensively all over.

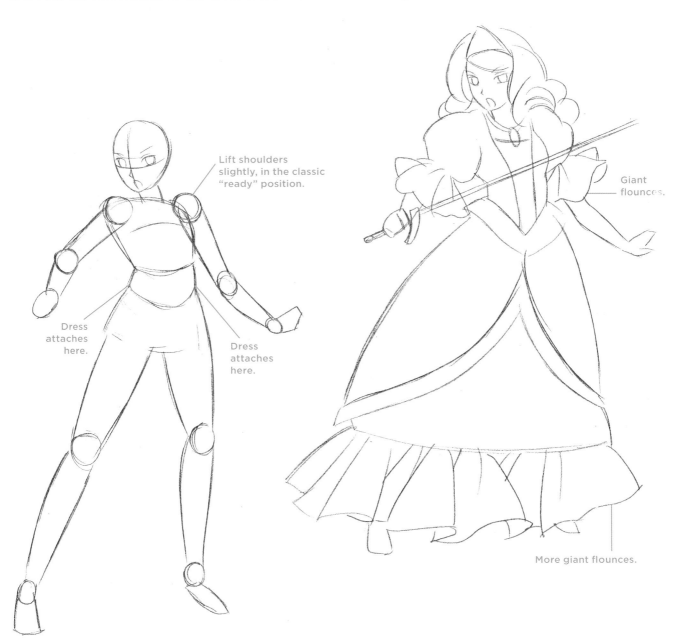

Lift shoulders slightly, in the classic "ready" position.

Dress attaches here.

Dress attaches here.

Giant flounces.

More giant flounces.

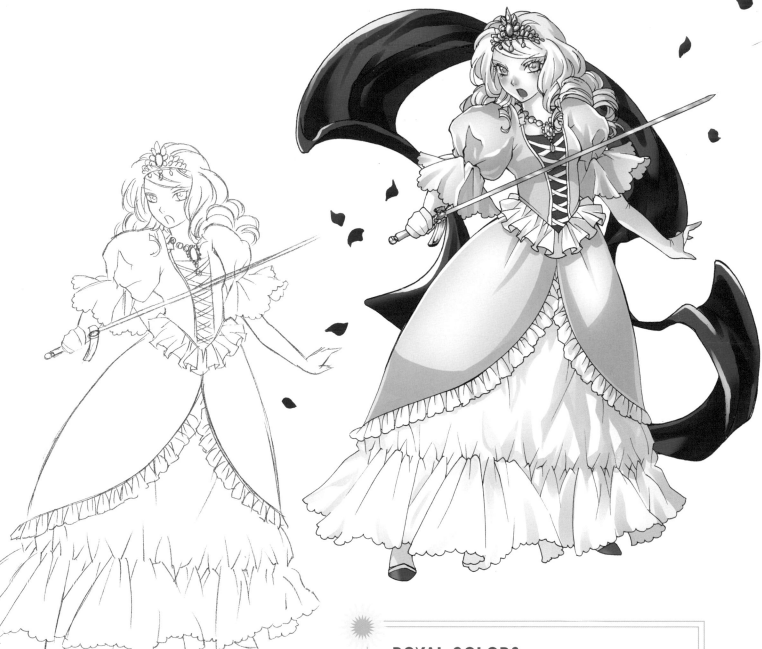

ROYAL COLORS

As to coloring, pinks, white, purples, and yellows in various combinations make good color schemes for royal wardrobes. But you can also go for powder blue or even a very light aqua-green variation. Royal blue is a bit too saturated (muddy), despite having the word "royal" in its name.

SCI-FI FIGHTER

This sci-fi fighter gal has a shoujo-style face, which makes her more attractive than a hard-action sci-fi gal. A sci-fi fighter is a warrior with mecha armor tossed in—namely, in the addition of shoulder guards, hip protectors, and heavy-duty boots. The shoulder guards are usually the largest pieces on any mecha costume; sometimes, they're even weaponized, although they don't have to be. Other additional options include knee guards, elbow guards, chest protectors, and belts. But the more stuff you pile on, the more robotic your character becomes, until you risk losing her behind a mountain of technical clutter. When it all boils down to it, people still want to see the character more than the machinery.

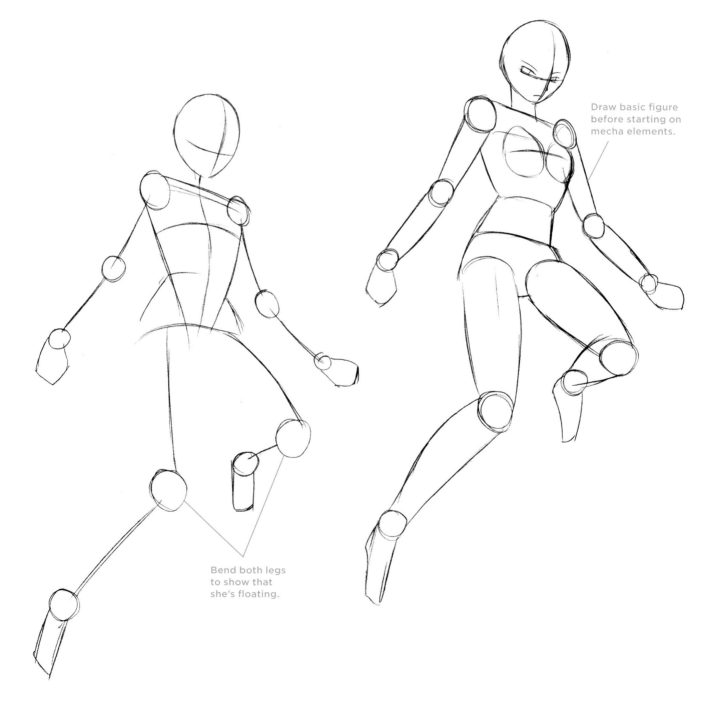

Draw basic figure before starting on mecha elements.

Bend both legs to show that she's floating.

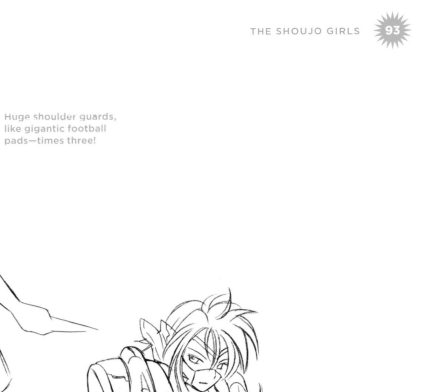

Huge shoulder guards, like gigantic football pads—times three!

Hip guards.

High-heeled boots.

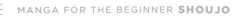

Quick Tip

Mecha boots always have high heels—even when they're on sci-fi guys and "guy" robots!

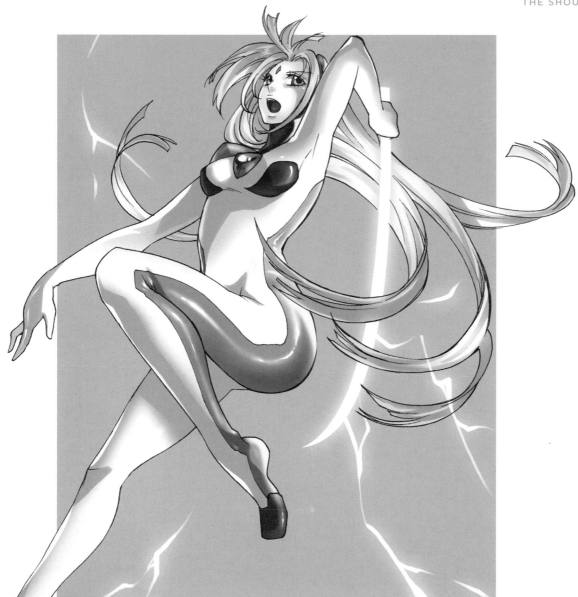

ALTERNATE CHARACTER DESIGN: FANTASY WARRIOR

If you can draw the sci-fi fighter, you'll be able to draw the fantasy warrior. You can see the similarities in the streamlined uniforms and elaborate, swirling hair. Sci-fi and fantasy uniforms are often one-piece and skintight, which points to the future as a place of utilitarian functionality. But it also has the bonus effect of being formfitting on an attractive female character. Note that much of fantasy ends up in the shoujo category because of its aesthetically appealing quality and because the faces of the characters share the shoujoesque features and large eyes.

The poses are also similar, with one leg bent more than the other and a distinct arch in the back. And like the sci-fi fighter, the fantasy warrior strikes her best pose in zero gravity. This allows you the freedom to get really dramatic. Floating poses like this are often more poetic than they are practical. The only purpose of such poses is to capture the imagination of the reader. Use them when you want to introduce a new and important character into a scene or create a dramatic moment.

ON THE EDGE: "EVIL" GIRLS

Evil is fun. Fun to read, fun to draw. Some say villains make the best characters, because they're flamboyant and personality driven. Female villains are typically excitable, seductive, and scheming. This makes them dangerous and formidable foes. And to top it off, they're drop-dead gorgeous. Many a male character has been lured to his demise by their beauty.

Shoujo villainesses are typically drawn with idealized proportions: extra-long legs with a curvaceous torso and long, elegant arms. Costuming is an essential part of character design for the wicked, because they're generally vain. They tend to wear outlandish outfits—the more outlandish, the more your audience will enjoy them.

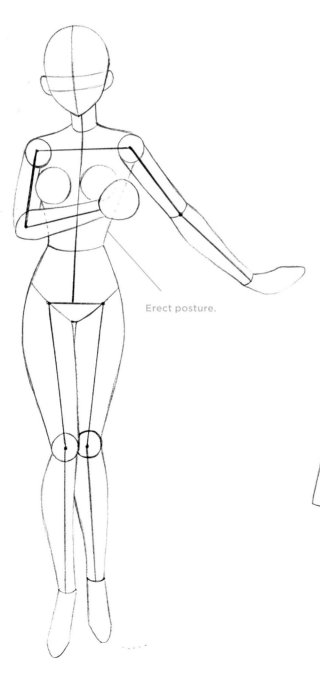

Erect posture.

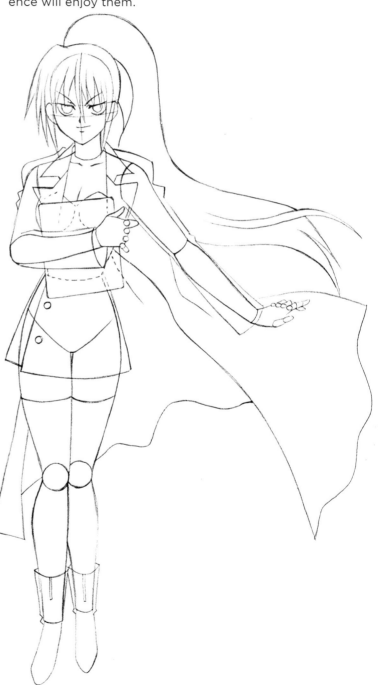

Doctor Deadly

The beautiful doctor will see you now. And she has a special, experimental treatment plan designed just for you . . . that includes brain-chip implantation. Don't be afraid. So what if no one has survived the procedure yet? There's always a first time.

Highly intelligent characters usually wear glasses. These include geniuses, professors, scientists, and doctors. They're also known for wearing lab coats. But gorgeous, evil doctors wear racy outfits under those lab coats to show that their minds are also on other things besides healing the sick. The red dress and purple leggings are a particularly charged combination. The hair is equally tempestuous. The clipboard is a must-have doctor prop. Forget stethoscopes and mirrored headbands, as those are old-fashioned cartoon stereotypes.

Hair lifts in breeze in an appealing wave.

Interior of coat.

Legs go in at knees.

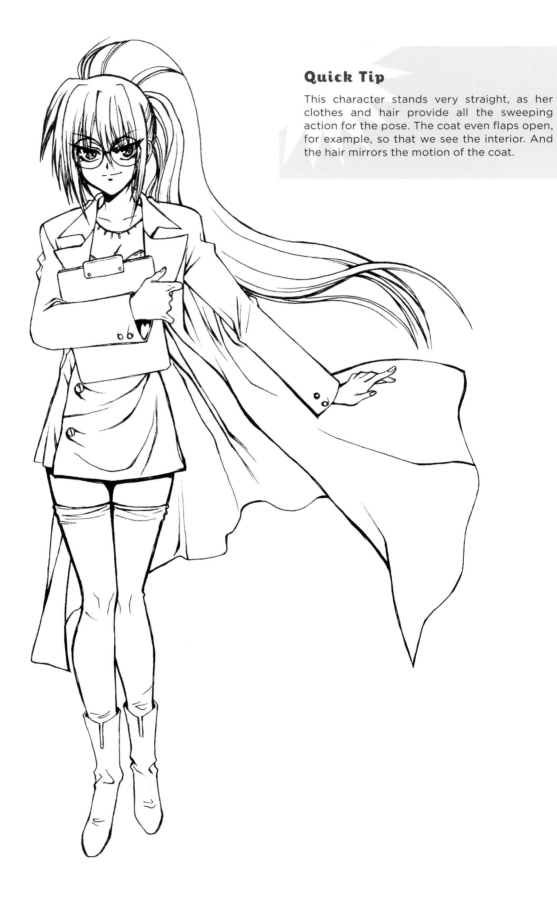

Quick Tip

This character stands very straight, as her clothes and hair provide all the sweeping action for the pose. The coat even flaps open, for example, so that we see the interior. And the hair mirrors the motion of the coat.

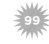

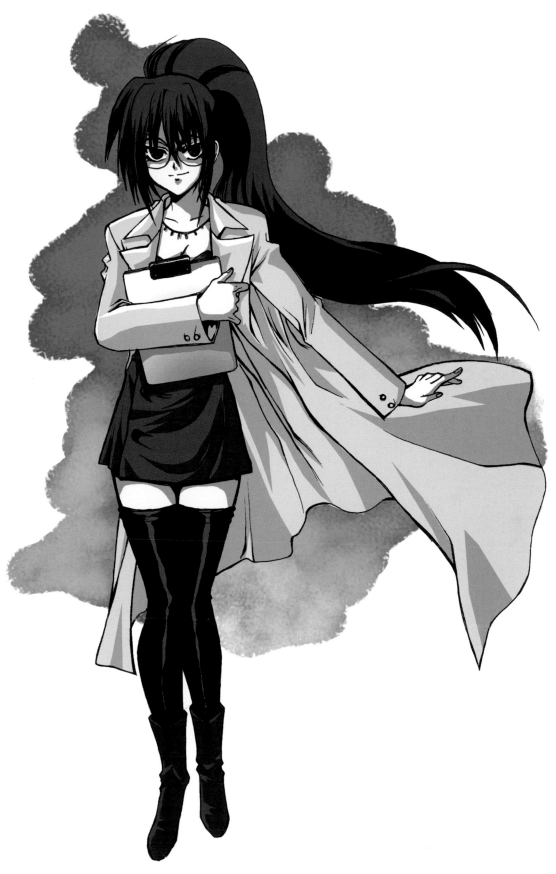

Ice Queen

The ice queen is a popular character type who is nonetheless drawn in many different ways by various artists. Not surprisingly, she is usually portrayed as cold and evil yet at the same time alluring and beautiful. Sometimes she's thought of as the queen of winter or an ice fairy. Her color scheme is usually white and blue—white to signify snow, and blue to signify cold and ice.

Her clothes appear torn to show a lack of purity. If her costume were all white and intact, she would look virtuous. But the torn and ragged blue-gray outfit conveys bad intentions. And that tiara is made of ice crystals, not jewels.

Tiara goes down to middle of forehead.

Short, feathered skirt.

Shoulders square across.

Far knee is higher.

Near knee is lower.

Ragged dress.

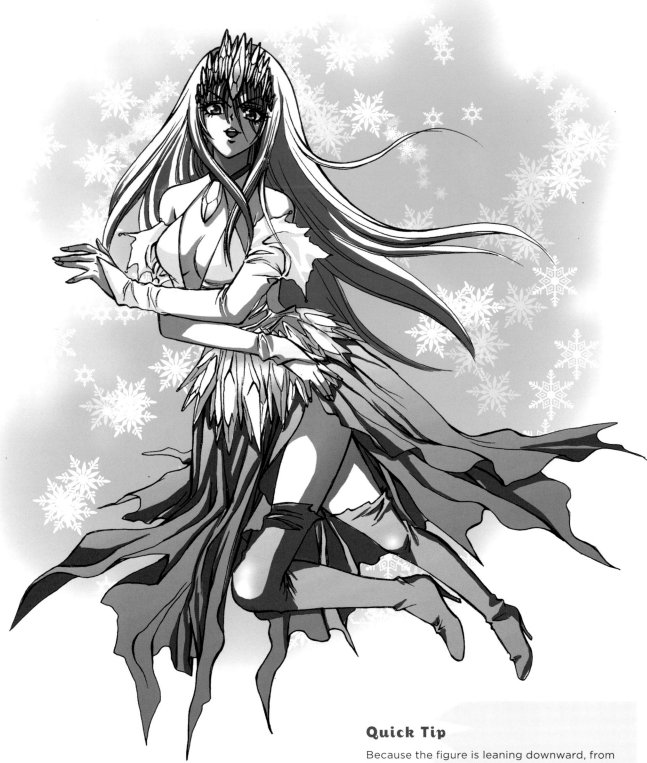

Quick Tip

Because the figure is leaning downward, from this angle, the bent near knee appears lower than the straight far knee.

ALTERNATE CHARACTER DESIGN: GOTH OCCULT GIRL

As with the sci-fi fighter and fantasy warrior on pages 94 and 95, you can use one character pose and design as a jumping-off point for another. Here, the ice queen serves as inspiration for another appealingly evil female character: the Goth occult gal. You can see the similarities in the pose, with most of the difference appearing only in the arm positions. There are slight adjustments in the leg and overall thrust of the torso, but it's really the costume that differentiates the characters. As with the ice queen, the waist is narrow, while the shoulders and hips are wider, and the hair flows back in one main direction, as if blown by the breeze. Long, curling hair is the standard approach for this Gothic gal. So are dark eyes and lashes, especially the lower ones. Black lipstick is also sometimes a convention used to connote a sensual villainy. The dress has a long train that flows in the same direction as the hair. The train attaches to a formfitting waist area, and the neckline is low cut to flaunt her seductive ways. Elbow-length gloves, or long sleeves that go halfway down the hand, are also common, as are high heels.

ALTERNATE CHARACTER DESIGN: DEMON GIRL

Demons don't have to be grotesque, underworld things with huge fangs and dripping blood. They can be playful, attractive, and friendly . . . that is, until you let down your guard. Then all bets are off. Demons always retain great powers, should they choose to use them. Some of these evil beauties, however, are also capable of empathy. But you can never be completely sure that their desire for your soul won't take over when you're at your most vulnerable.

Those tiny wings are purely decorative. They're not going to get her two inches off the ground. They're simply there to give her a little extra in the "evil" department. And they work quite well for that purpose. Think of them more as part of her costume than her anatomy. Other things to note? The shoulders are drawn at an angle, the costume leg openings are high on the hips, and instead of a flowing costume, the tail curves out behind the figure. But again, the same basic pose that you see in the ice queen and the occult gal is at work here, with minor adjustments. So if you can draw the ice queen, you can draw the other two.

Angry Cyborg

Cyborgs are half human and half robot. And they're very powerful. This one has got a bad temper. But with that expression, she also has a cute, shoujo face. Still, I wouldn't want to get in the way of those hydraulic arms.

It's important to draw the first step based totally on the human figure. Only then should you turn it into a robot with doodads and techno stuff. If you try to add the mechanical wizardry from the outset, chances are you won't get the form right.

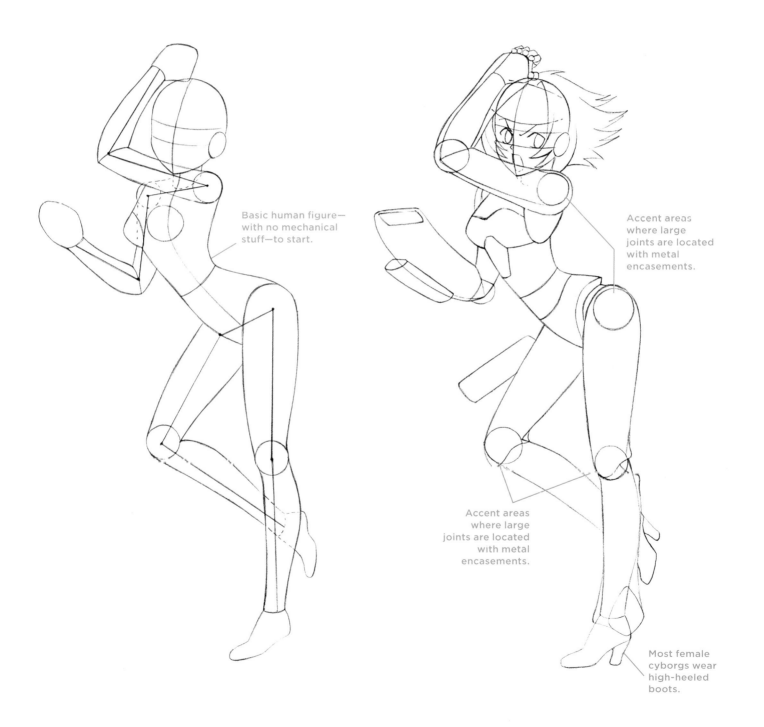

Basic human figure—with no mechanical stuff—to start.

Accent areas where large joints are located with metal encasements.

Accent areas where large joints are located with metal encasements.

Most female cyborgs wear high-heeled boots.

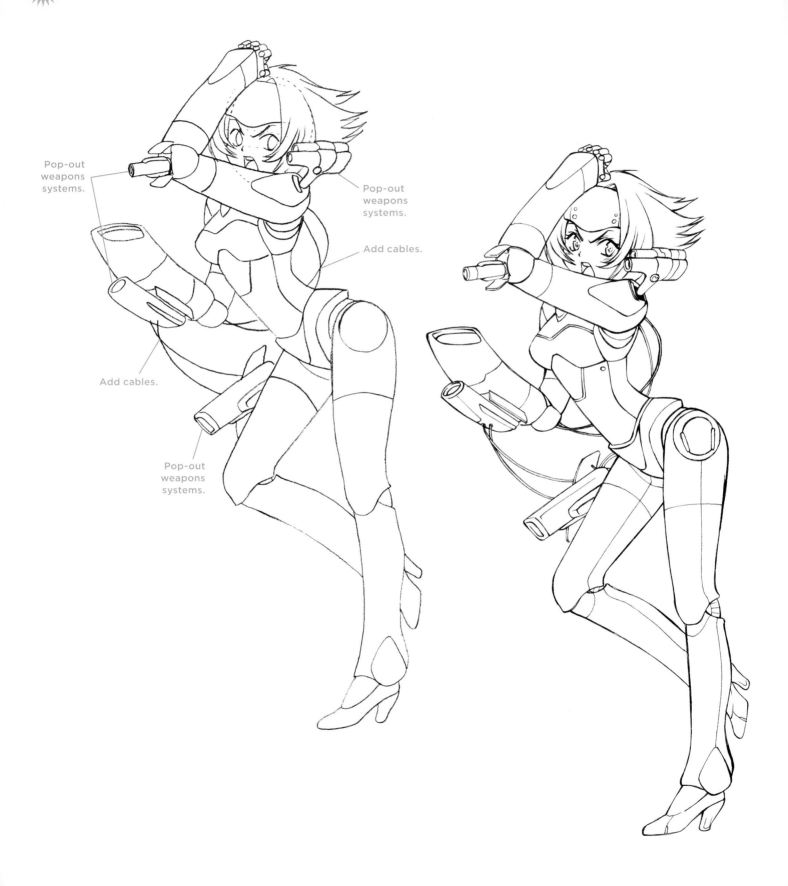

Pop-out weapons systems.

Pop-out weapons systems.

Add cables.

Add cables.

Pop-out weapons systems.

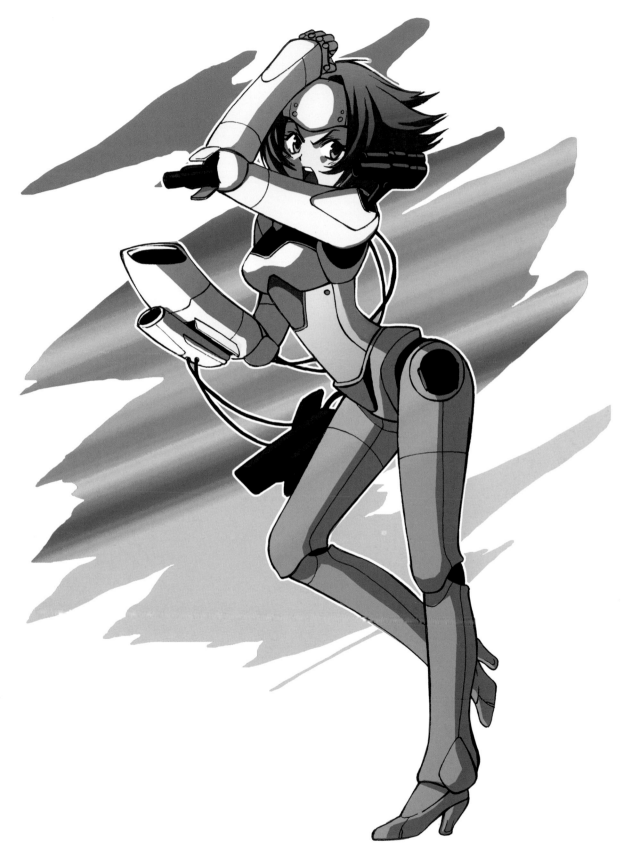

THE Shoujo Boys

SHOUJO BOYS ARE DRAWN with more subtlety than girls. That's because instead of being chipper, cute, ebullient characters, they're moody, angst-ridden, and somewhat socially withdrawn. Generally, they are handsome teens about whom girls get all in a panic. They have those boyish rock-star good looks: too mature to be considered adorable but too young to be an adult. It's an age of transition, and girls fall like feathers for guys with these matinee-idol good looks. We'll explore all the popular variations, from younger teens (cuter) to older teens (more dangerous looking).

YOUNG TEEN BOYS

A popular category of teen boy characters in shoujo starts at around ages twelve to fifteen. Young girls often have their first crushes on these boys in school. Unfortunately, the boys are frequently preoccupied with sports and cars and are kind of clueless that the girl they've thought of as a friend is actually thinking of them as *more* than a friend. The young teen boy has all the youthful features of shoujo: huge eyes, small nose and mouth, and carefree hair. He has a medium-sized build—not too slight but not a jock, either. He's a casual dresser, sometimes shown in sports uniforms. Later, when he turns into an older teen type, he'll graduate to more stylish clothes and a more impressive build.

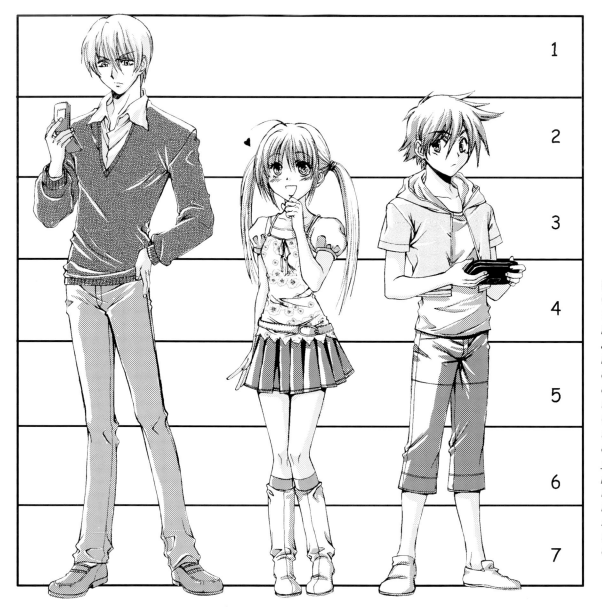

1

2

3

4

5

6

7

HEIGHT COMPARISON

The younger teen boy and girl are almost the same height. But the older teen boy is considerably taller than both of them. Girls always go for the taller, older character over the younger guy. They prefer the mature look to the cute, boyish look. Sorry, shorty. (We'll get to those older teen boys on page 120.)

Ballplayer

Young teens are often portrayed as sports enthusiasts. Sports competition on the field or on the court is a natural setting for dramatics. Readers get to root for their favorite player. Girl characters cheer from the sidelines and bleachers. Injuries must be ministered to—by wannabe girlfriends. And a connection is often made that way.

A boy who cannot seem to muster what it takes to win can often dig down deep if he's doing it "for his girl." Grudges play out, and one-upmanship also occurs during the heat of battle. Two guys vie for the attention of a single girl when dueling for a run, a goal, or a point. So a lot of good story elements come into play around the theme of sports.

Here, we have a character who's practicing with his team. How can we tell it's practice? By his clothing. He wears a hooded shirt under his jersey and regular pants, not a complete uniform. It's a good look that shows he's on a school league, even if it's not game day.

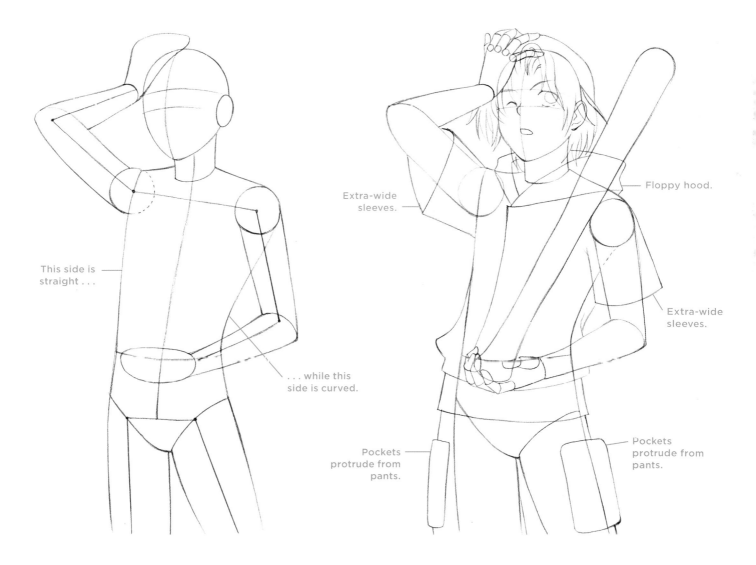

This side is straight . . .

. . . while this side is curved.

Extra-wide sleeves.

Floppy hood.

Extra-wide sleeves.

Pockets protrude from pants.

Pockets protrude from pants.

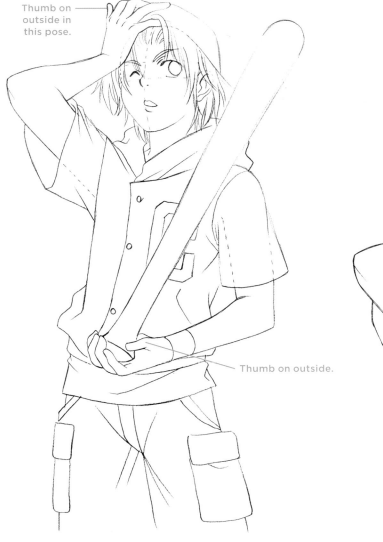

Thumb on outside in this pose.

Thumb on outside.

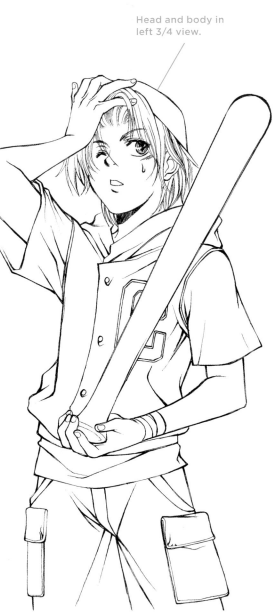

Head and body in left 3/4 view.

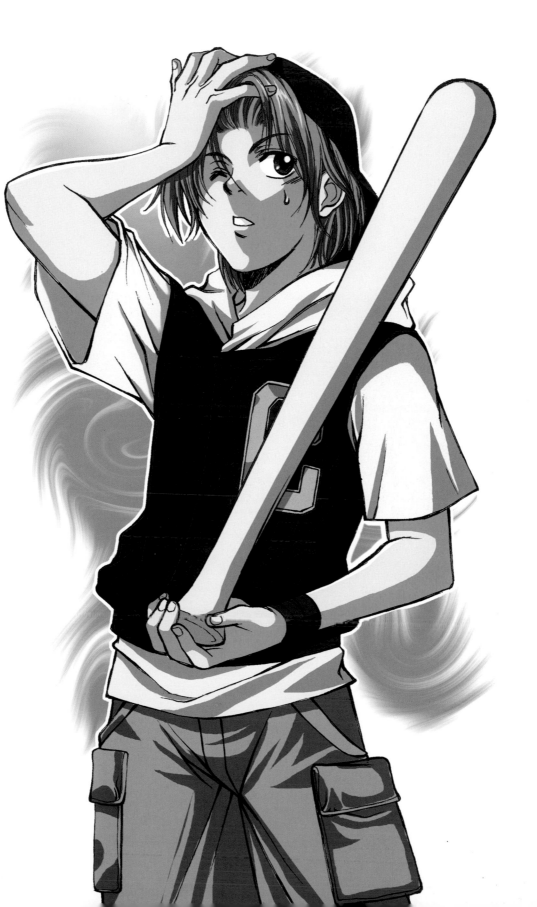

ALTERNATE CHARACTER DESIGN: BAD-BOY ROCKER

Using a similar construction to the ballplayer (also a left 3/4 view), you can build a variety of different character types that will allow you to find your own style. For example, the costume provides most of the changes for this lead guitarist. The garage is his domain, where he practices with his band members and tries to fend off the high school groupies who keep dropping by. He's the bad boy, and every school has one. Note how large the eyes are in contrast to the rest of the facial features. This is the classic shoujo look. Place the eyes low on the head to create a large forehead with lots of wild hair. Tilt the shoulders to give the pose a feeling of action, and angle the head to one side—you want him to look like he's moving as he plays.

Kid Confident

Artists are always looking for fresh ways to draw things they've seen before, and new angles from which to draw them. For example, we all have to draw characters in standing poses. It can't be avoided. But it can be boring to see a figure simply standing in place. Here is an inventive way to show it; it's unusual because the foot placement is uneven. And the body language, combined with that appealing smile, gives the character an air of confidence. Although the torso leans back, the hips and the head remain straight and in place.

Props also add interest. Here, it's a ball, but you can use other props for this pose: a crate, tree stump, rock, backpack, or some stairs would all work.

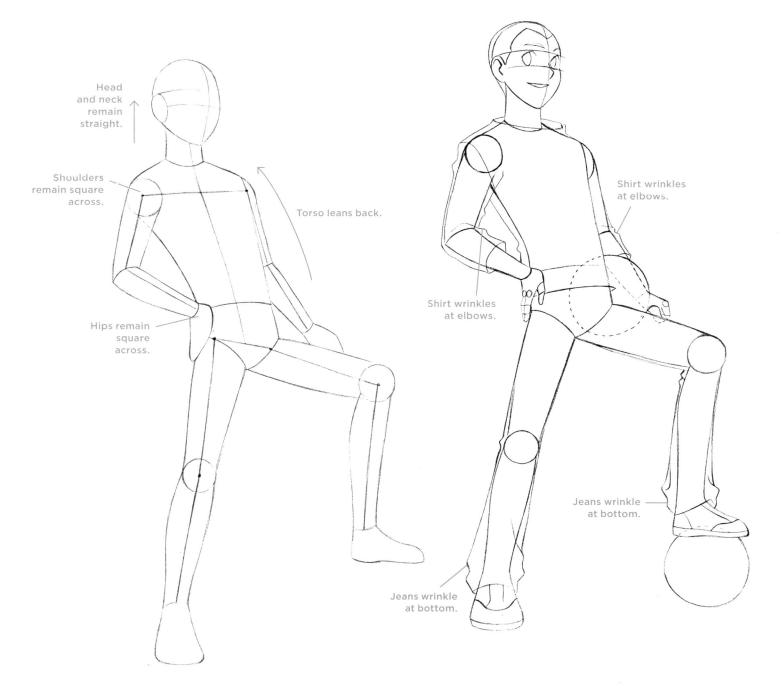

Head and neck remain straight.

Shoulders remain square across.

Torso leans back.

Hips remain square across.

Shirt wrinkles at elbows.

Shirt wrinkles at elbows.

Jeans wrinkle at bottom.

Jeans wrinkle at bottom.

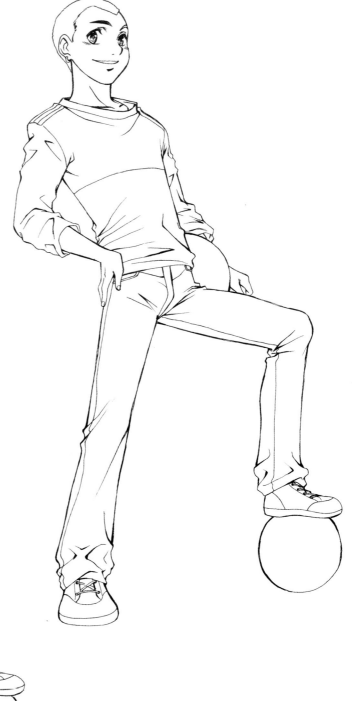

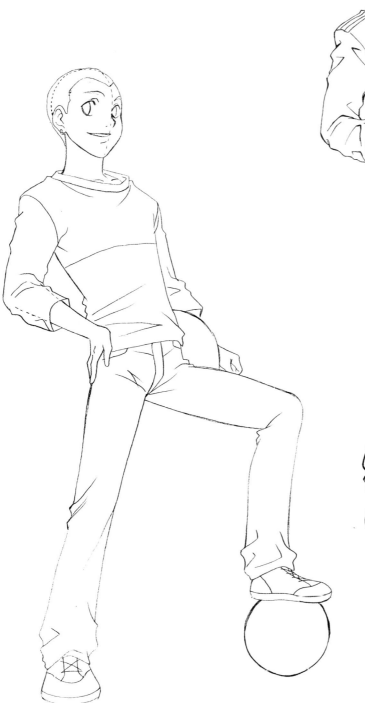

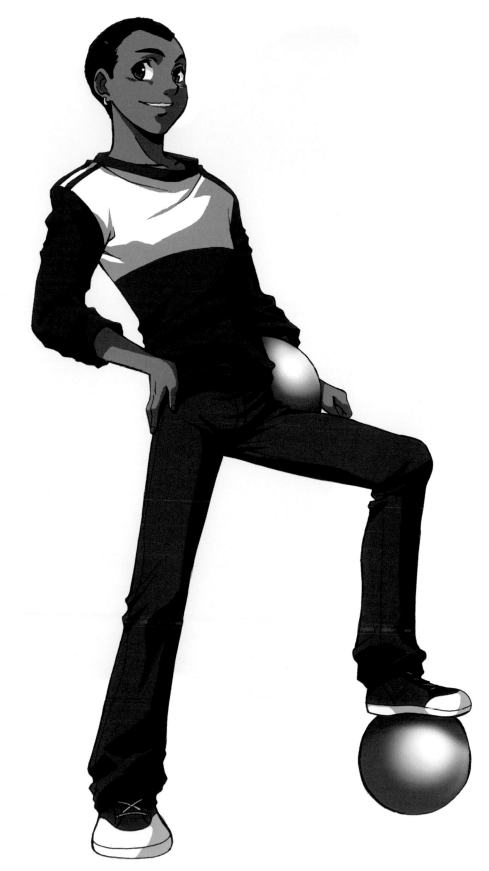

Honors Student

With his glasses and books, he's a scholar who also happens to be a good-looking young kid. All the girls go to him for help with their homework—even if they already know the answers!

This character has been drawn at a slight "down angle." It's subtle, but we, the readers, are looking down on the character from above, from a high vantage point. And we know that because we're also looking at the top of his head, the top of his shoulders, the top of his books, and the top of his shoes. This approach spices up what otherwise would be an ordinary, flat drawing of a standing character.

Take special notice that the shoulders are slightly wider than the feet. Due to the effects of perspective, things that are closer to us (the shoulders) look bigger than things farther away (the feet).

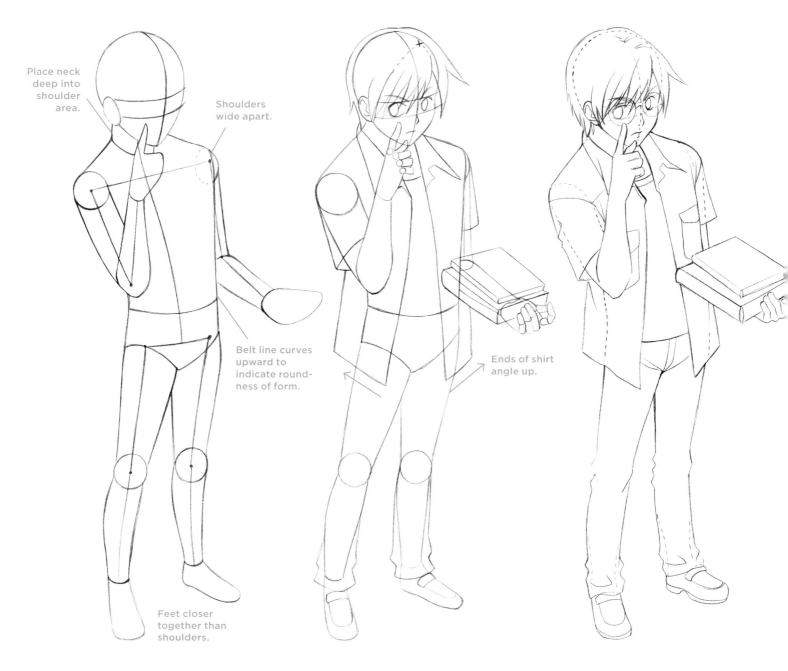

Place neck deep into shoulder area.

Shoulders wide apart.

Belt line curves upward to indicate roundness of form.

Feet closer together than shoulders.

Ends of shirt angle up.

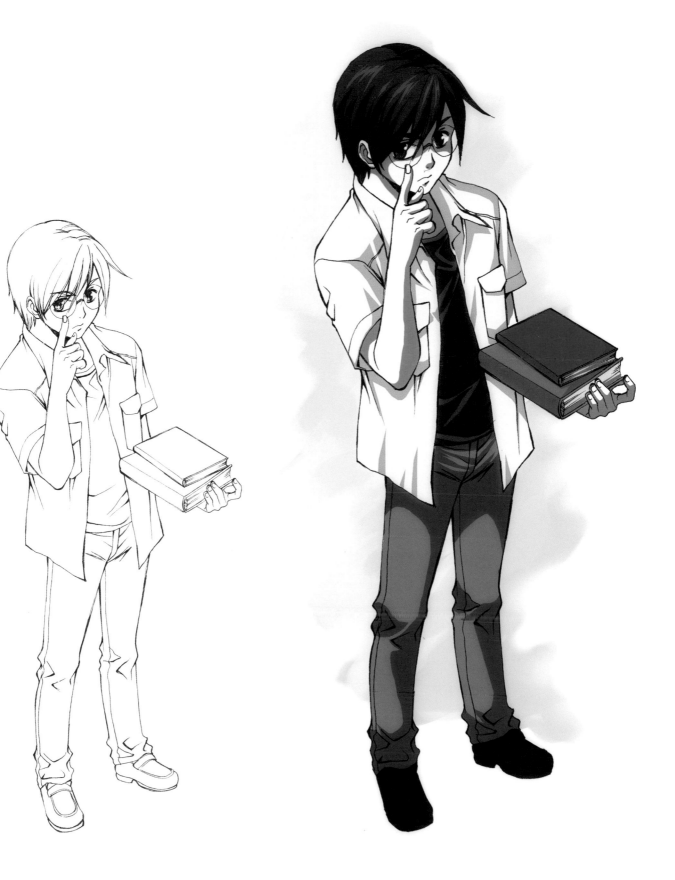

OLDER TEEN BOYS

The younger boys of shoujo whom we've just seen have youthful, cute, round faces and giant eyes. They're somewhat small in stature but, nonetheless, pack a lot of heart into everything they do. Then there's another type of teenage boy who graces the pages of the majority of shoujo manga: the older teen.

This teenage group runs from ages sixteen to nineteen and is one of the most popular character types in all of manga. Girls just swoon over these shoujo boys. They're more dashing and feature mature good looks. The face is more angular, with narrow, piercing eyes. The head is slightly small for the overall body length. The hair is often worn longer in the back. And the upper body is more powerful, but with long, lanky legs. Compare the two types, shown here.

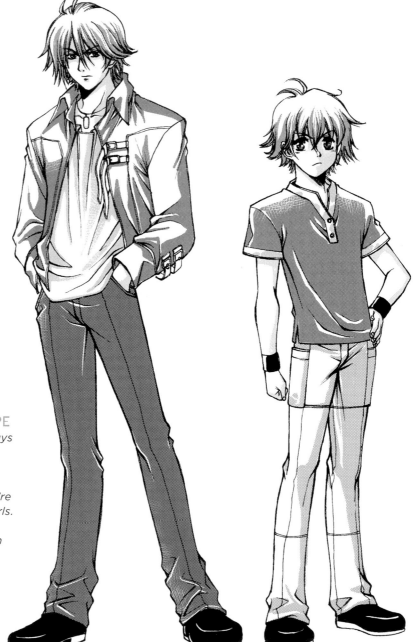

OLDER TYPE VS. YOUNGER TYPE
Some of these older good-looking guys are decent types, but often, they're emotionally unavailable or allergic to commitment. Younger boys look up to them as role models because they're so cool—and because they get the girls. But it's never a good idea to ask one of these guys to show you how to win a certain girl's heart, because in the process, the girl is likely to fall for him instead!

Body Front View

The older teen can be a challenging personality type to master. It takes some skill in drawing the human figure, because the characters are slightly more realistic, stylistically. But you don't have to become an expert all at once. You can ease into it here with these basic views of the body. The steps start off with basic stick figures and work their way up to fully realized drawings. The stick figures serve you well if you focus on the correct placement of the three horizontal lines that intersect the torso: the collarbone, the line of the chest, and the hips. The remaining steps create volume, muscle contours, and finishing details.

The shoujo older teen boy is known for having the body type of a gymnast: slender yet athletic. Give him broad shoulders, a thin waist, and thin legs. Don't worry about defining every muscle group the way you would if you were drawing a Western-style American comic book hero.

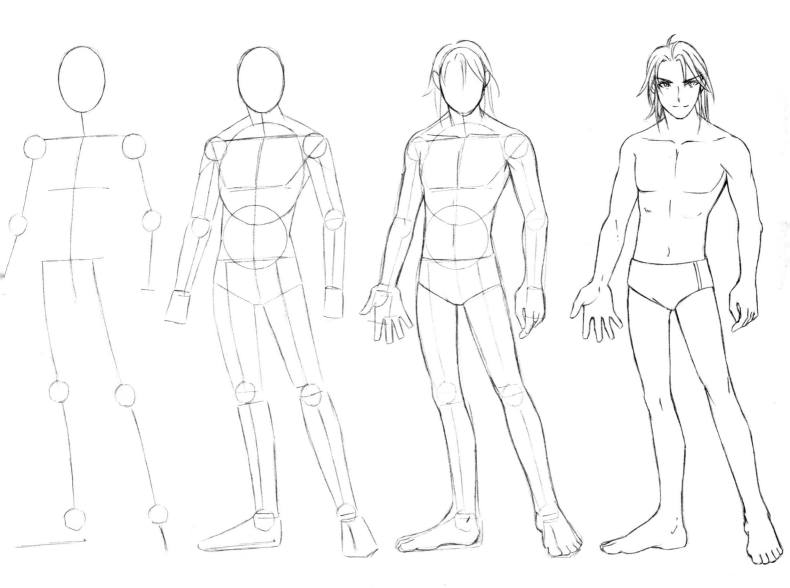

Body Side View

There are a few common mistakes to avoid in the side view. First, don't make the figure too narrow. The character shouldn't suddenly lose all of his width because he's in profile. Also, don't draw the legs straight; you want a subtle curve to them. The neck should also not be straight up and down but instead should tilt forward slightly. As you add mass to the body, don't draw the front of the torso flat; give it some contours to indicate the chest muscles, sternum, and abdominals. The small of the back should also display enough of a concave curve. And the knees shouldn't look too pronounced or bony.

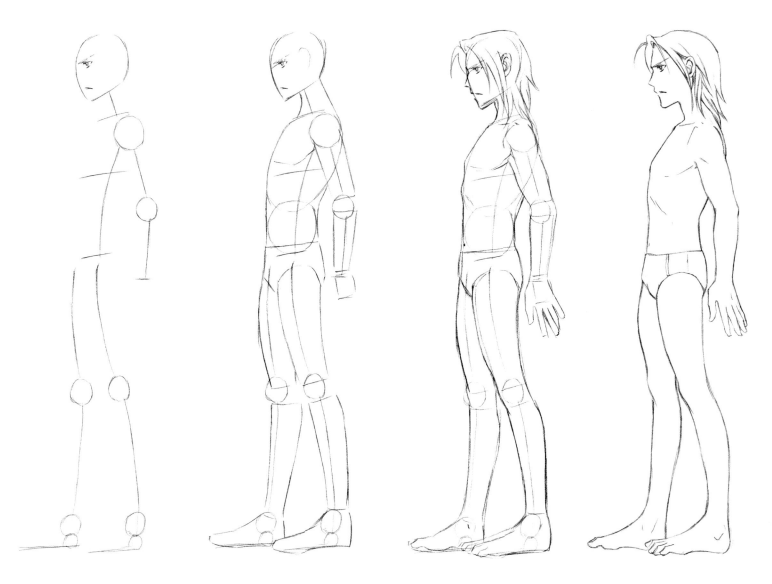

Body Back View

For the back view, there are also a few mistakes beginners tend to make that you now have the opportunity to correct. Beginners typically add too many definition muscles to the back. They draw the shoulder blades too close together and don't widen the upper back enough toward the upper shoulders.

And they forget to widen out the torso at the hips, simply because it's a male character. Angling the feet sideways—completely in profile, instead of positioning them slightly frontward at a 45-degree angle—is a frequent problem, as is drawing the legs as straight tubes, without a visible break for the knees.

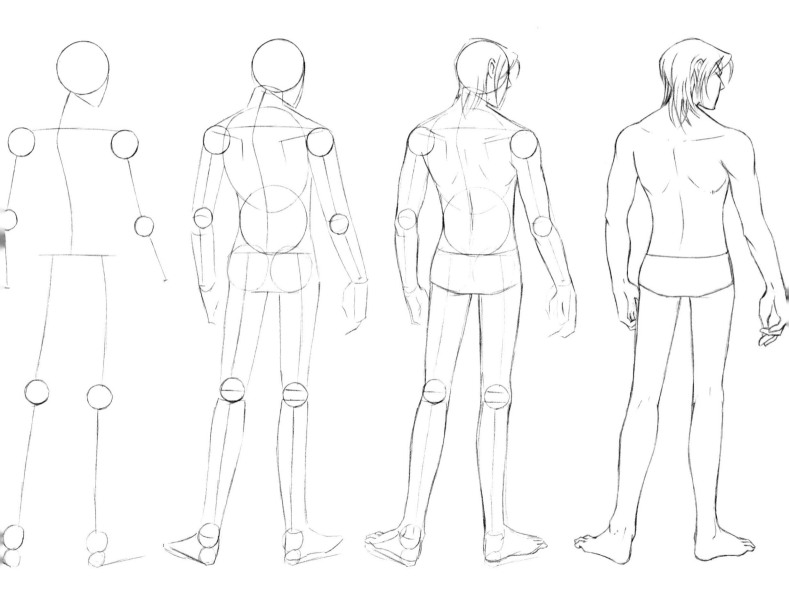

Stylish Guy

One of the main differences between the younger teen boy and the older teen boy is that the younger ones never wear suits or trendy clothes. They're just not as dapper as their more mature counterparts. Pose the older teen characters so that they look casual and comfortable in their stylish clothing.

This seated pose looks simple at first glance, but it's actually fairly complex. The upper body twists toward the reader, while the lower half of the body twists away. This adds tension to the body, which brings energy to the pose. Always look for a way to use posture to invigorate your seated poses.

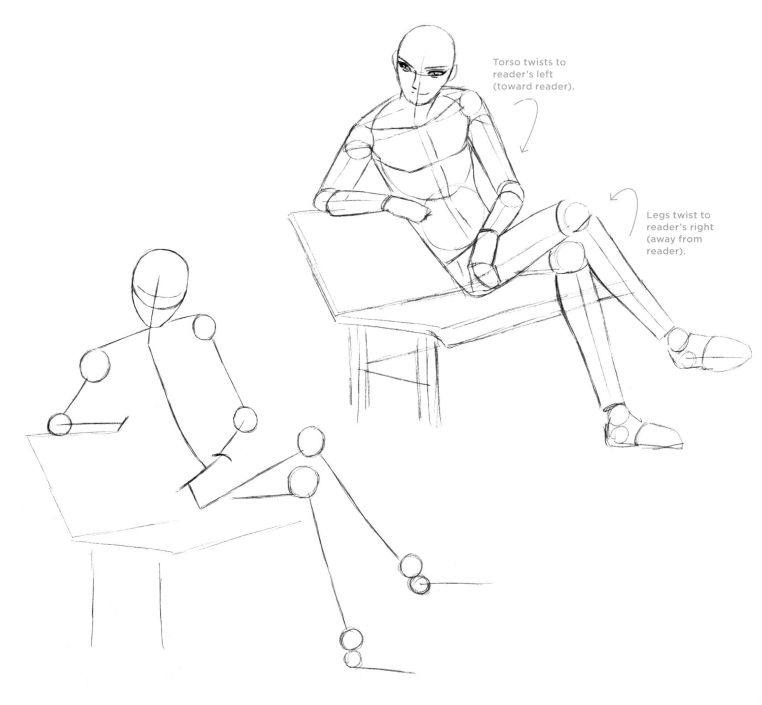

Torso twists to reader's left (toward reader).

Legs twist to reader's right (away from reader).

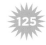

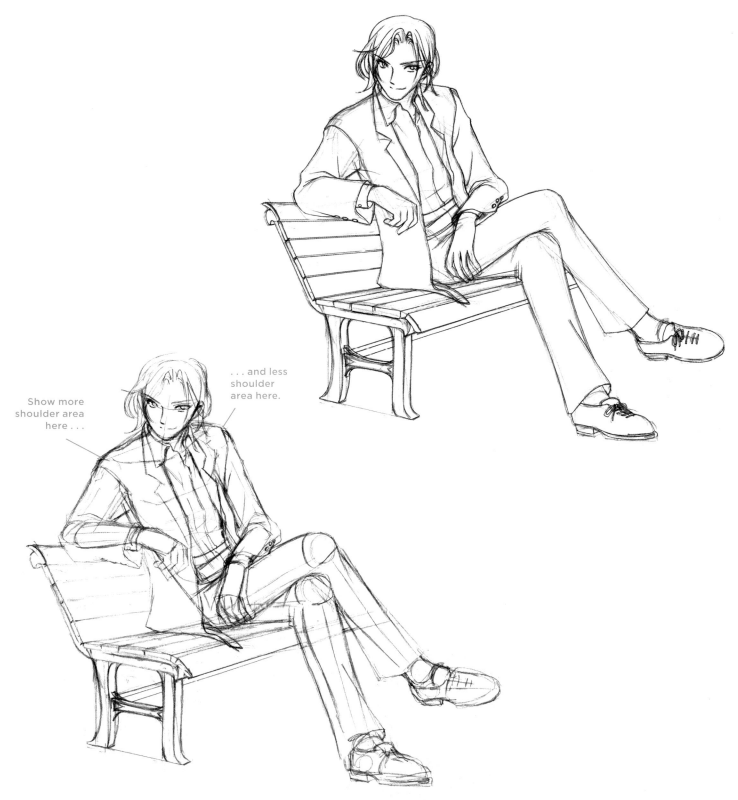

Show more
shoulder area
here . . .

. . . and less
shoulder
area here.

A NOTE ABOUT SHADOWS

Shadows don't have to be precise to be effective. Just mirror the general shape. Also, they don't have to be black. You can choose a color. But if you do make them a color, be sure that the tone you choose remains muted enough to fade into the background. Don't allow the shadow color to compete with the character.

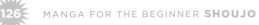

Teen Scientist

Remember what we said earlier? The rule is that intellectual characters wear glasses and lab coats. This quickly identifies them as brainy rather than athletic. But here, the long, braided hair is a way of winking at readers to let them know that this character, though a science guy, is far from a nerd. He'll have no problem getting a date for the prom.

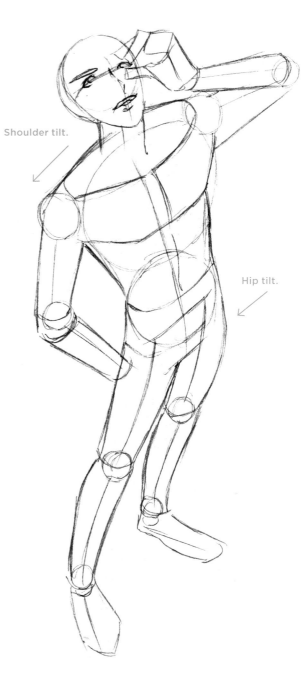

Shoulder tilt.

Hip tilt.

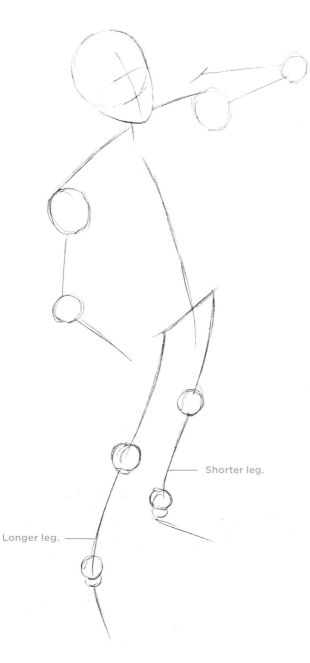

Shorter leg.

Longer leg.

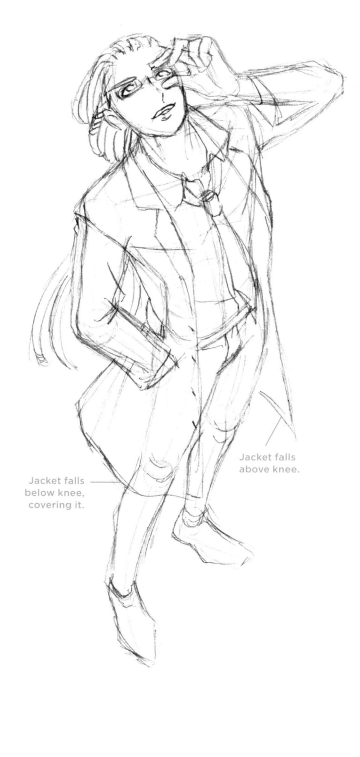

Jacket falls below knee, covering it.

Jacket falls above knee.

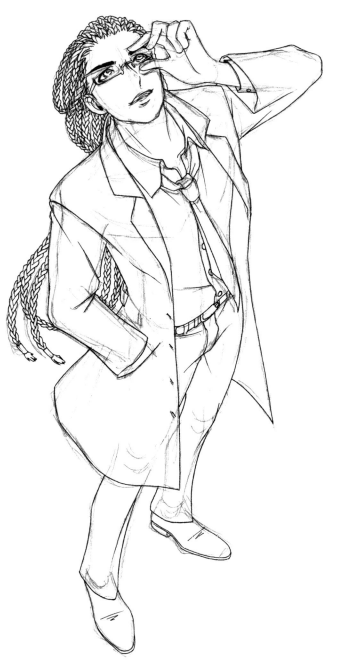

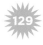

PERSPECTIVE IN THE "DOWN ANGLE"

See how short the leg to the right side of the page looks? That's due to the reducing effects of perspective on the side of the body that's farther away from the reader. And yet, because of the "down angle," it looks natural.

Racer

Give a teenager a red sports car and you've got trouble. Not in the way of drawing, but in high insurance premiums. As far as drawing is concerned, you can simplify the car if you think of it first as a box. Try to visualize the box as having two sides to it. That'll make it look as if it has dimensions and depth. To keep the proportions correct, take a look at the drawing steps here, which remind you where the boy's figure is in relation to the car. Keep in mind that you should draw him leaning back, with all of his weight against the vehicle. This will give him the cool and casual attitude you want.

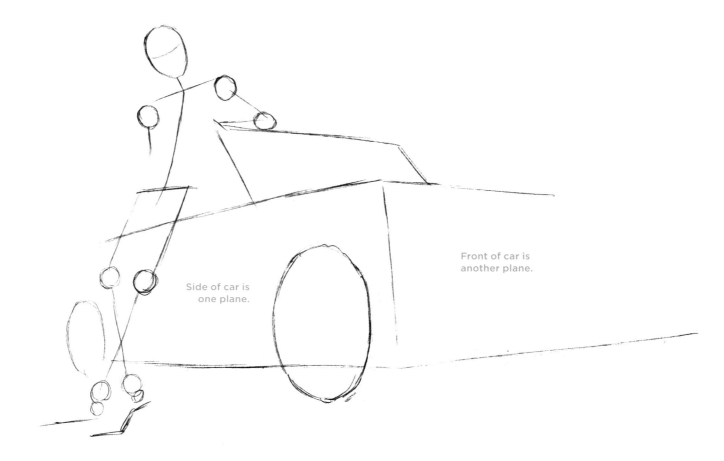

Front of car is
another plane.

Side of car is
one plane.

Quick Tip

Draw the car with two distinctly visible planes: side and front. This both simplifies it and gives it believable form.

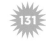

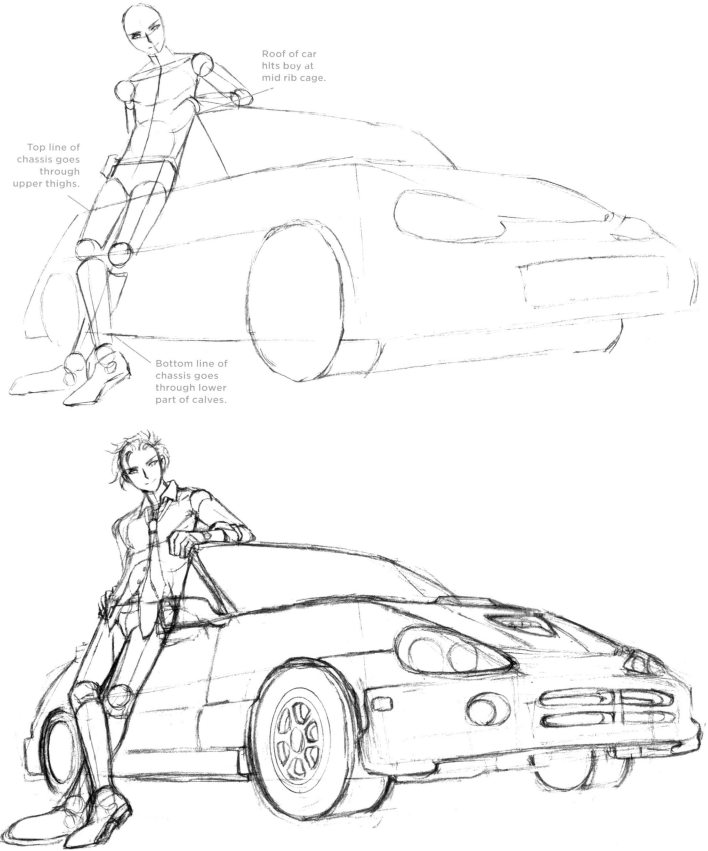

Roof of car hits boy at mid rib cage.

Top line of chassis goes through upper thighs.

Bottom line of chassis goes through lower part of calves.

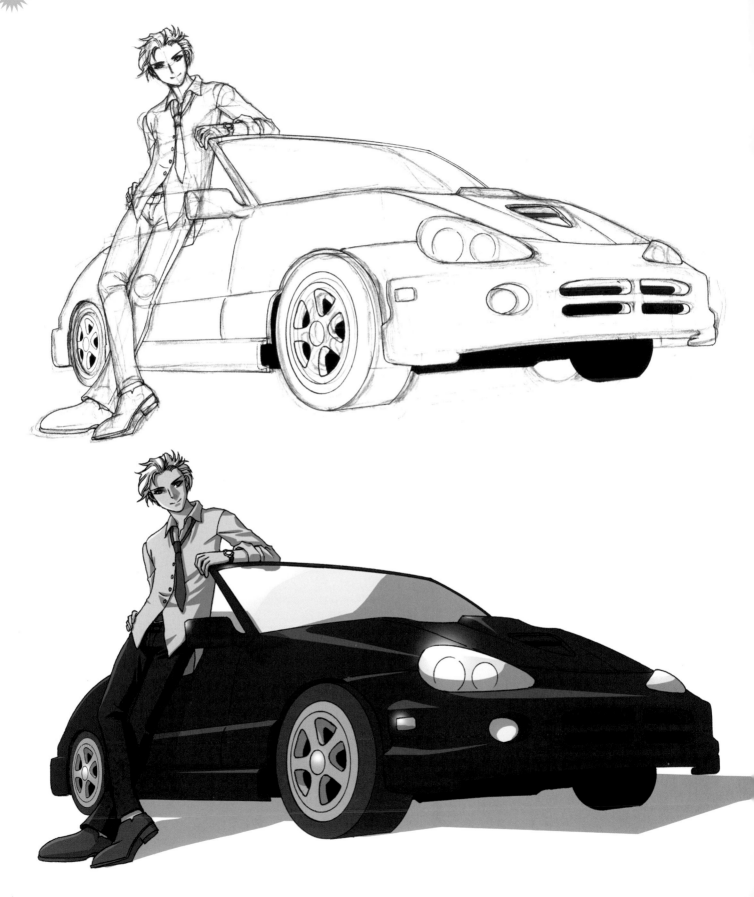

Fallen Angel

Good-looking evil boys are very popular in shoujo. High school girls tend to look past the fact that they're wicked and instead think of them as "misunderstood." So what if they want to steal your soul and take you down to Hades with them to spend all eternity in darkness? They're so sensitive! And that's the part you have to play up with these guys: They're loners and troubled. They need someone to care for them as they go along with their evil ways. But be clear about this: They are evil, totally evil. They have no soul. And they love to seduce good girls. In other words, they're girl magnets for teenagers.

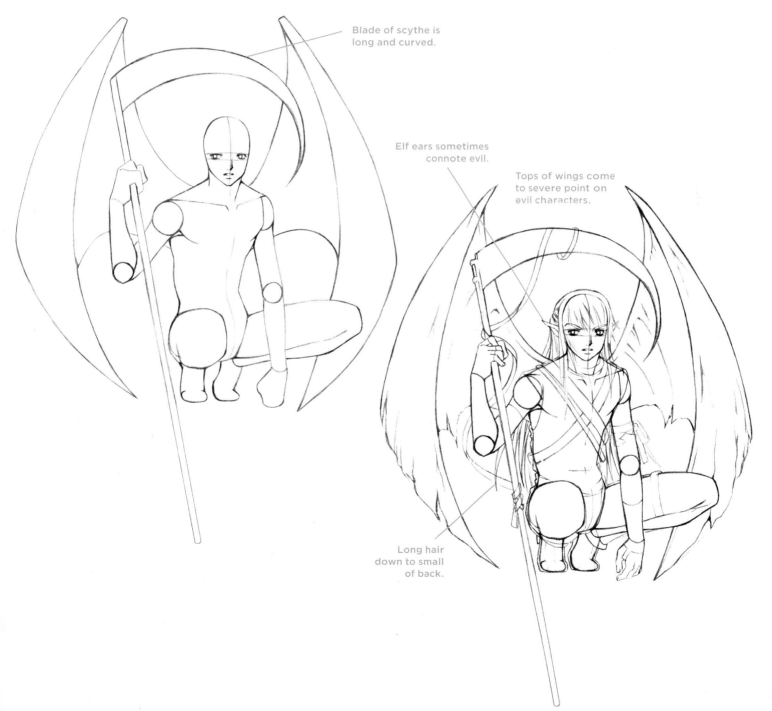

Blade of scythe is long and curved.

Elf ears sometimes connote evil.

Tops of wings come to severe point on evil characters.

Long hair down to small of back.

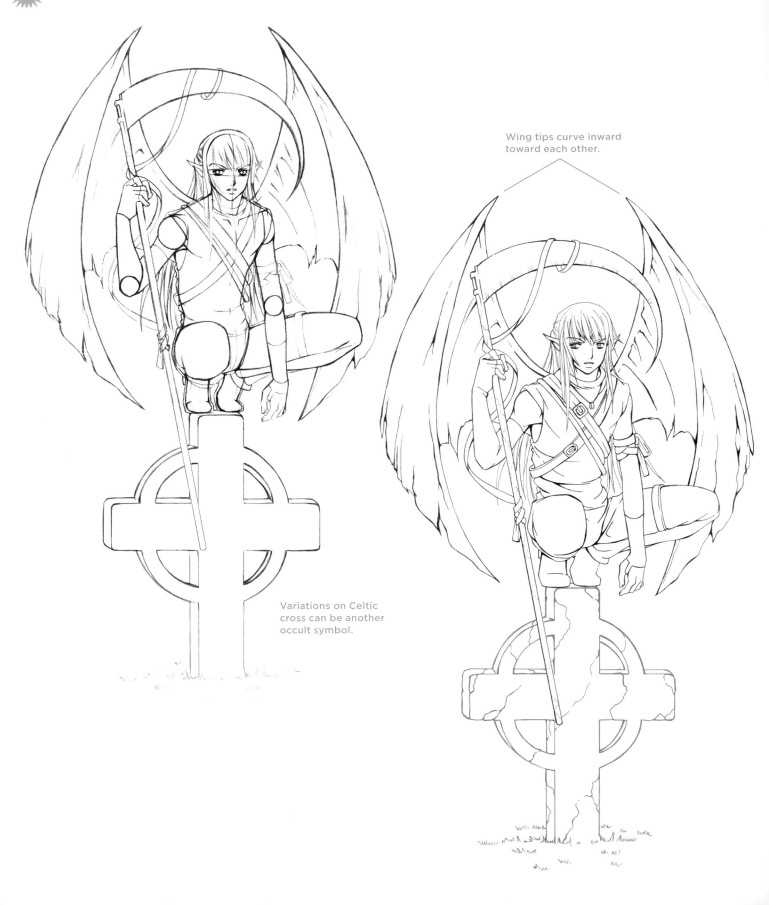

Wing tips curve inward
toward each other.

Variations on Celtic
cross can be another
occult symbol.

Quick Tip

The scythe is a weapon
that's often used as an
occult symbol.

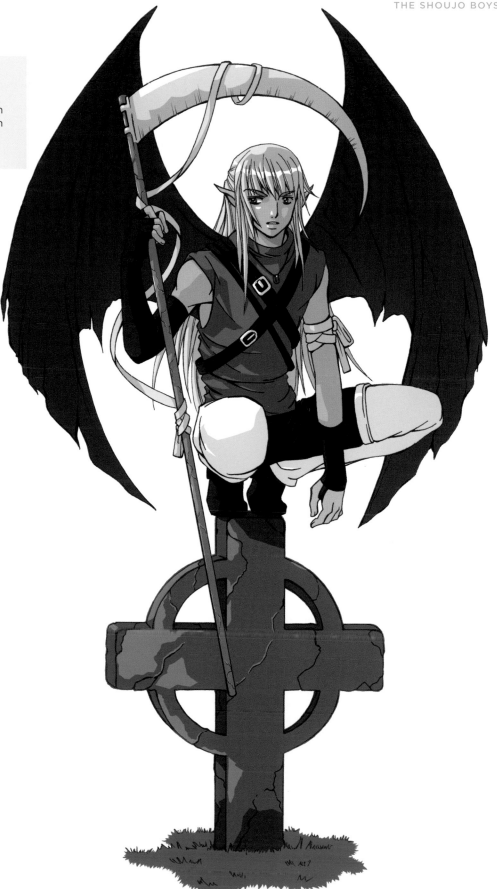

Teen Corporate Villain

Manga is youth-obsessed, and because of that, teens are often cast in roles normally reserved for adults. A teen with slicked-back hair, an evil glint in his eye, and a suit worth a couple grand can easily portray a corporate villain. It's also no coincidence that the chair mimics a throne in proportion. In addition, the asymmetry of the pose is what makes it dynamic:

One arm is straight, while the other is bent. One leg is up, while the other is down. Also notice the body gesture: The straight arm pulls the body forward slightly rather than allowing it to recline. This gives the character an assertive posture, even though he's sitting. Once again, posture is brought to bear in making a sitting pose interesting.

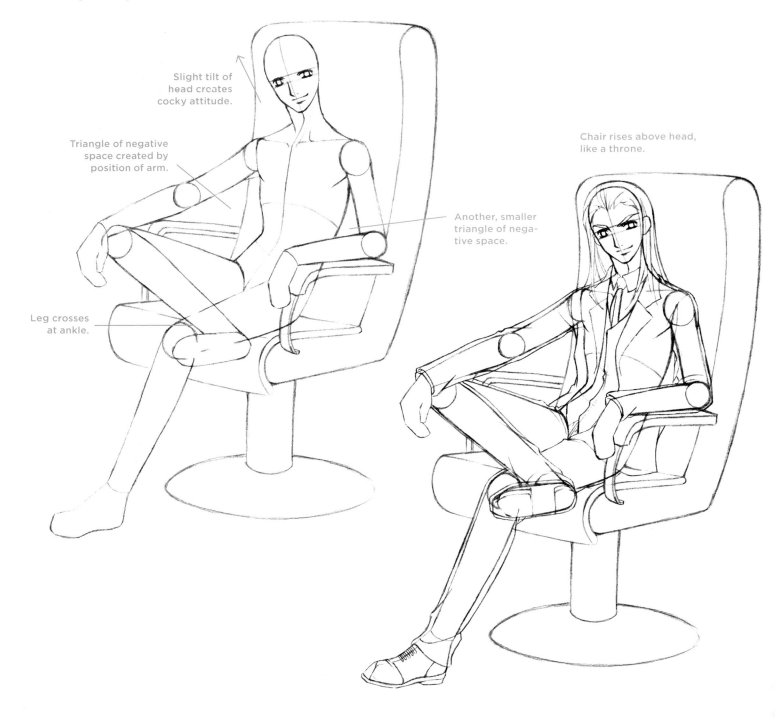

Slight tilt of head creates cocky attitude.

Triangle of negative space created by position of arm.

Leg crosses at ankle.

Chair rises above head, like a throne.

Another, smaller triangle of negative space.

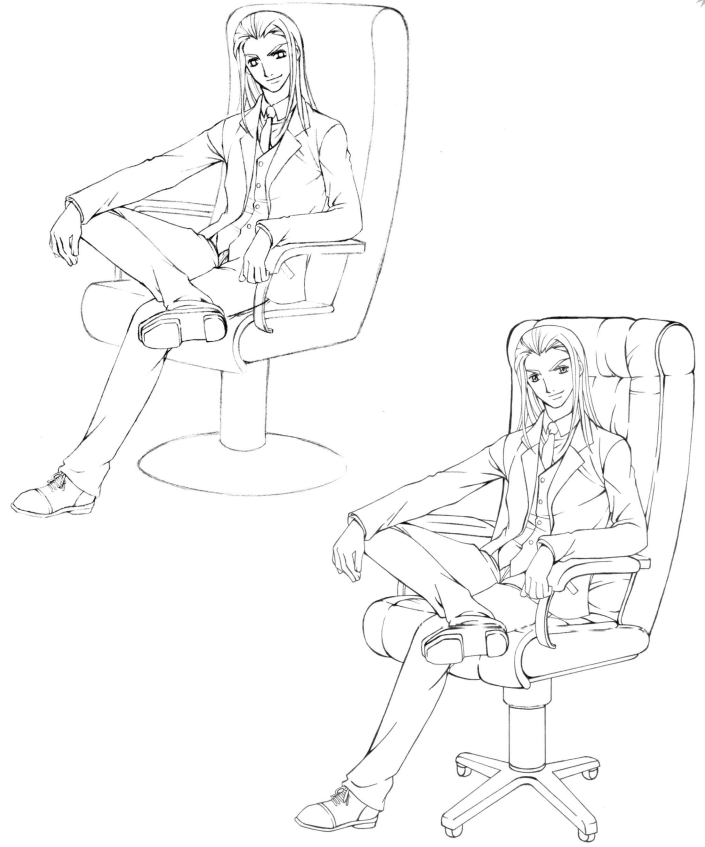

Quick Tip

Whenever a character is sitting, the jacket should be unbuttoned.

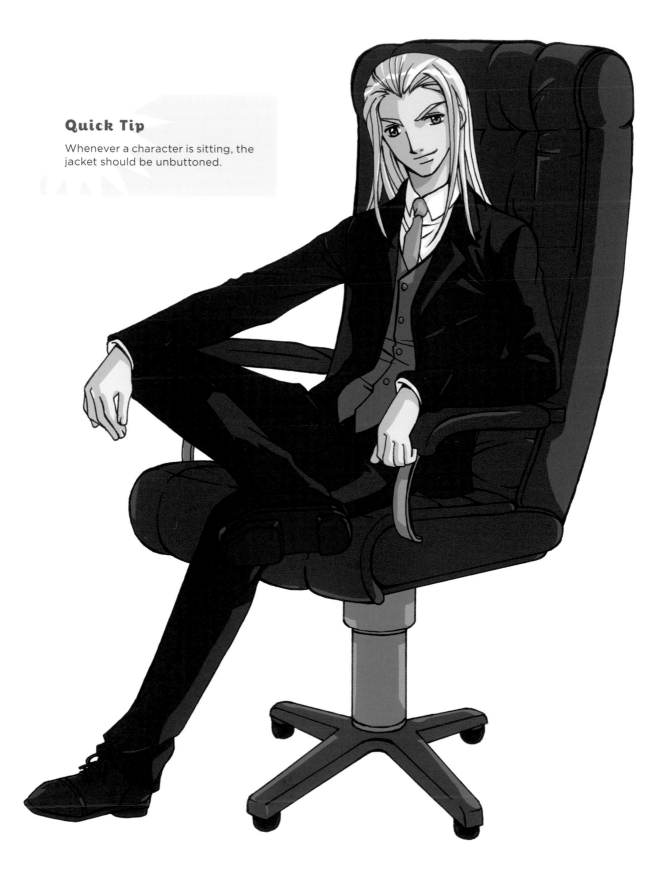

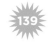

Everyone's Favorite Teacher

Although not a teen, the good-looking teacher shows up as a favorite character in lots of shoujo stories about girls in high school, so we don't want to leave him out. All the girls sign up for his class, no matter what he's teaching. His breezy style and unassuming pose make him an attractive character. The sports jacket is necessary to give him some sort of grown-up attire, even though it's about as casual as they come. The crew-neck shirt replaces the collar and tie to give him a more youthful look. Again, glasses are used to indicate an intellectual type. The middle part in the hair is likewise used in such characters.

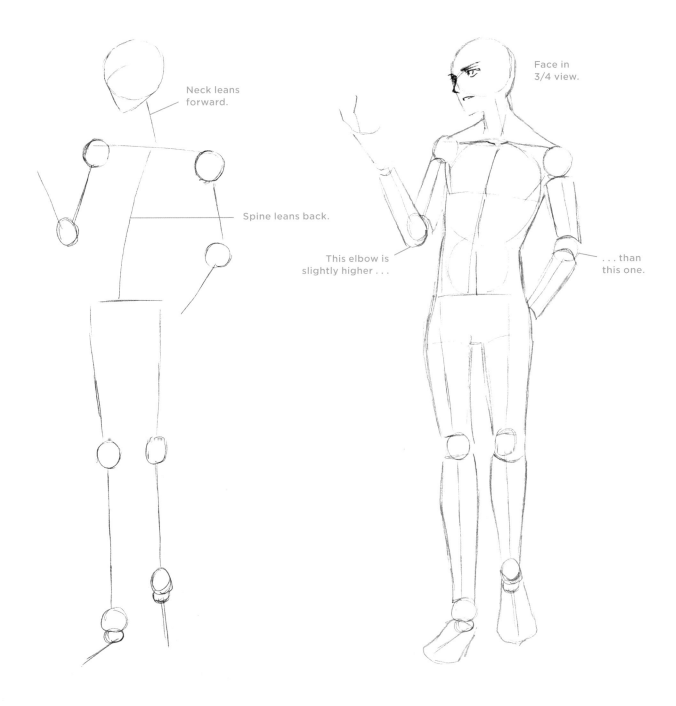

Neck leans forward.

Spine leans back.

Face in 3/4 view.

This elbow is slightly higher . . .

. . . than this one.

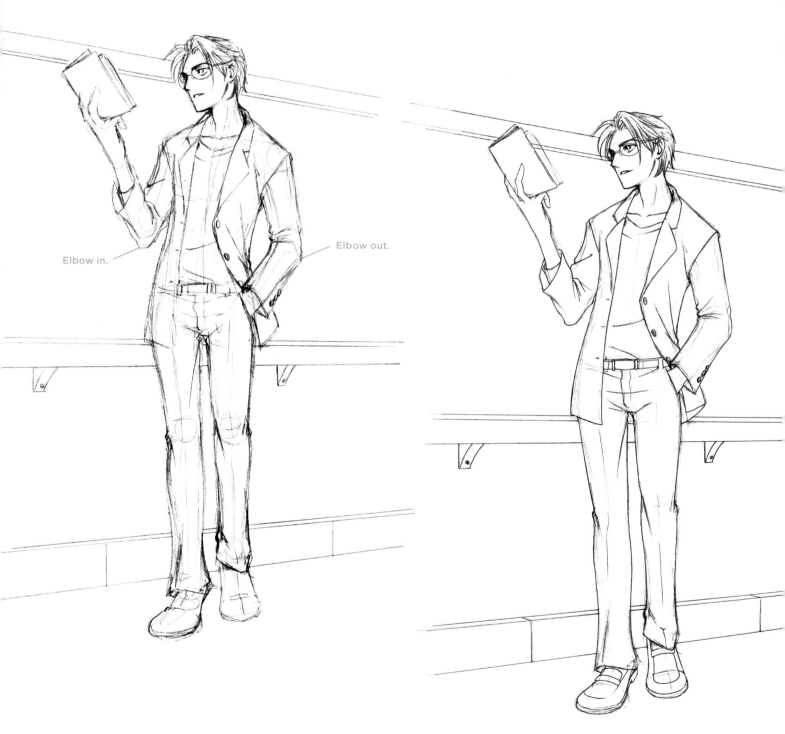

Elbow in.

Elbow out.

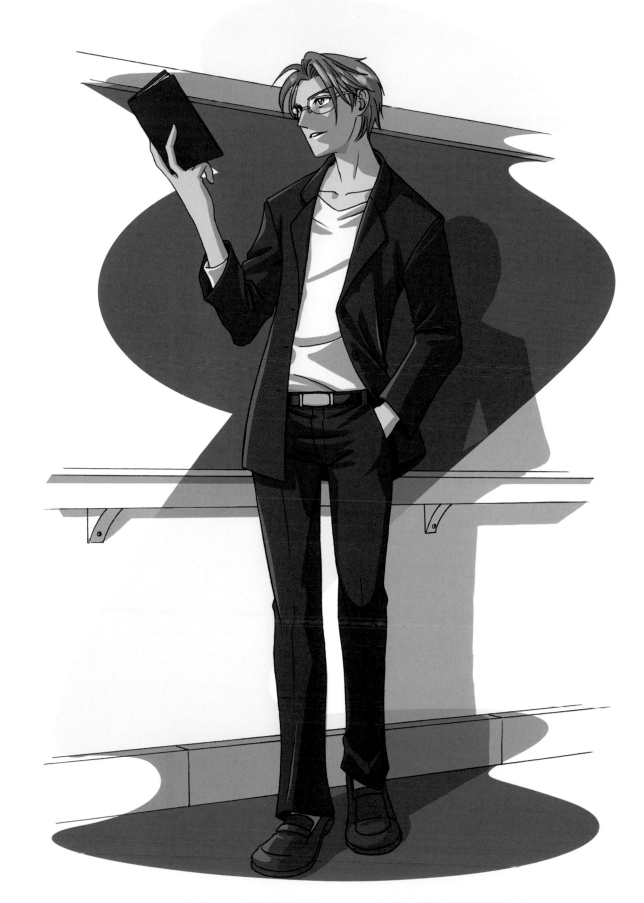

Knight

Unlike the earnest but inexperienced squires of King Arthur fame, teen knights in manga are pretty good at being knights. Maybe they took a crash course in swordsmanship; they sure don't look like apprentices. (Note: They don't appear in the same stories as samurai swordsmen, because that's a different genre.)

The knight can be fitted with armor from head to foot, but where's the fun in that? Your reader would never get to see your character, and the poses would be as dynamic as a guy wearing a soda can. So dress him mainly in flashy garments, with as little padding and protective gear as you can get away with.

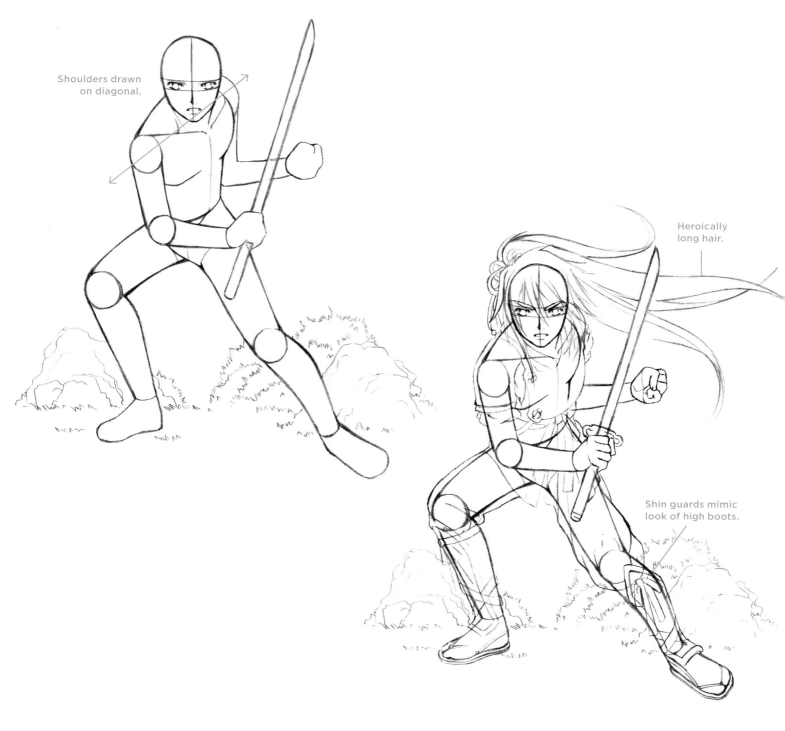

Shoulders drawn on diagonal.

Heroically long hair.

Shin guards mimic look of high boots.

Quick Tip

When you position the shoulders on a diagonal line, it makes for a dynamic "ready" pose.

Samurai

Samurais are always portrayed with long, dramatic hair. They must all go to the same barber. As an alternative, you can draw the hair in a bun rather than a ponytail, but the front of the hair should still be long. This is the classic samurai costume, complete with his essential long blade. Yep, they all shop at the same department store, too. The forearm and shin guards, however, are optional.

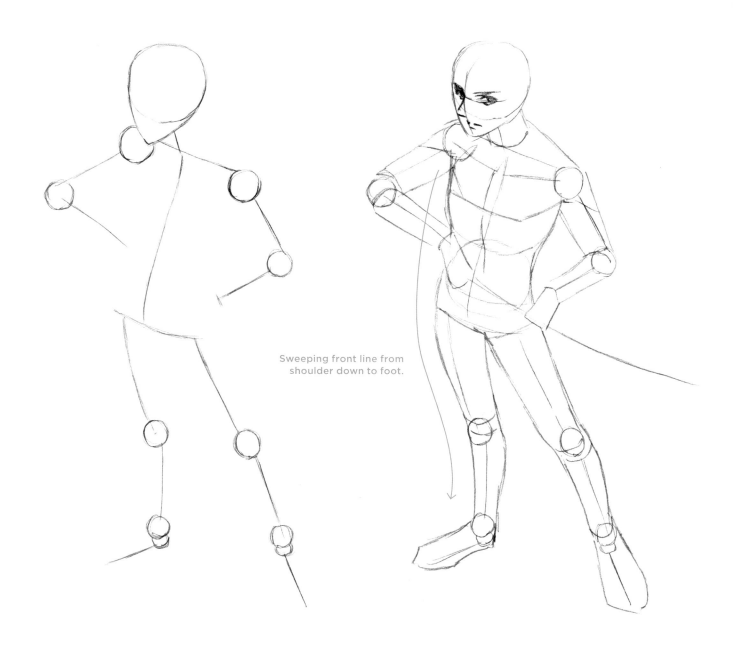

Sweeping front line from shoulder down to foot.

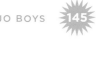

Head overlaps
shoulder.

Leg is shortened
to indicate
perspective.

MORE PERSPECTIVE IN THE "DOWN ANGLE"

This is another good example of a classic "down angle" shot (when the reader looks down at the character from a high vantage point). Since we're seeing the effects of perspective on him, his legs appear to be a little truncated. That's also why his head appears to overlap his shoulder. If we were looking at him head-on, his chin would clear his shoulder.

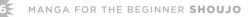

THE SAMURAI COLOR SCHEME

Samurais are serious fighters, which is why the color scheme here has all that red and black in it. No happy colors, like powder blue, orange, or, God forbid, pink. These outfits also look serious when drawn starkly in black and white.

Wizard

Teen wizards can be far more appealing than craggy, old, bearded sorcerers. First of all, their costumes aren't confined to the long robe and conical hat. Instead, their outfit borrows from the pagan fairy theme. In fact, if you were to elongate his ears and put a bow in his hands, he would look just like a fairy archer. But it's the flowing quality of his layered costume that gives him the sweep of a master magician. A long staff, bejeweled cane, or wand makes a good accessory. A sword is good, too, although that would put him in the realm of a fantasy fighter, rather than a wizard.

Eye line goes straight to special effect.

High shoulder.

Low shoulder.

Lower leg is perfectly horizontal.

Note natural curve of lower leg.

Clothes should blow about dramatically.

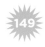

SPECIAL POWERS

The special powers the wizard calls forth should not be just an afterthought. They're an important element in the character design. They clue the reader in to recognize him as other than merely mortal. You can choose any special power you like: shape-shifting, invisibility, mind-melding, and so on. This sorcerer has developed the skill of creating something out of nothing.

THE SUPER-ELEGANT GUYS

Now you're going to get the inside info on the character type that is riding the crest of popularity in today's most well-read manga graphic novels. It's the male-model type of older teenage boy character: the super-elegant guys. These guys are the rock stars of shoujo. Ultra-popular with the girls, everyone wants to know how to draw them—and now you can.

Fashions are just as important as character designs to the elegant type. Expensive and stylish clothing make these guys look swanky. Pay attention not just to the type of clothing but also to the cut of the material (where the seams fall), which will help the clothes look good on the character.

The shoulders of these figures are wide and square, giving the impression of power. In many cases, these characters are portrayed as unlikely but highly skilled fighters. They're long and lean and built like swimmers.

Medium Build

There are three basic male physiques for the super-elegant character: large build, medium build, and small build. The medium build is the most commonly seen in shoujo, followed by the large build, with the small build being the least common. Each one creates a slightly different impression. For the artist, it takes a careful balance of masculinity with fine and elegant features to produce the correct look. And they're all drawn with a thin ink line. We'll start with the medium build, since it's the most common.

The medium-build elegant teen has long legs with a thin waist and a robust rib cage; however, the arms are thin—especially the forearms and hands—which gives him a sensitive look. He's an appealing, lanky character. The lankier the character, the greater the distance between the rib cage and the hips, giving him a long abdominal wall or waistline. The legs and arms are longer on the older teen than on any other male manga character. The shoulders are muscular and have good definition, but the trapezius muscles (which run from the shoulders to the neck) should remain undeveloped, avoiding the bodybuilder look. The head is on the small side, which emphasizes the willowy appearance of the character. In fashion designers' sketches of models, the figures always have small heads, and this Japanese teen shares those same proportions.

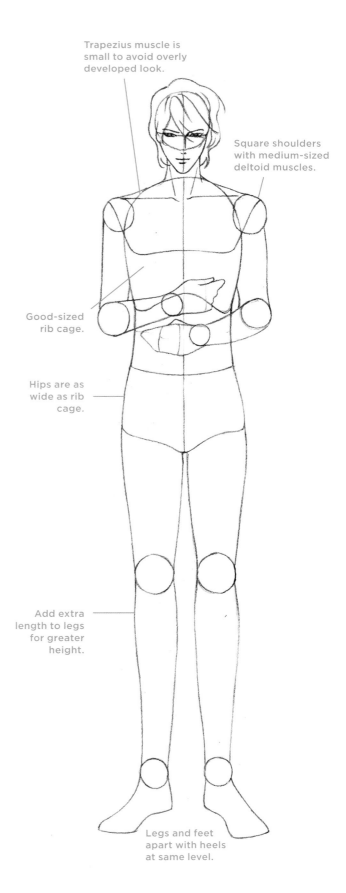

Trapezius muscle is small to avoid overly developed look.

Square shoulders with medium-sized deltoid muscles.

Good-sized rib cage.

Hips are as wide as rib cage.

Add extra length to legs for greater height.

Legs and feet apart with heels at same level.

Shoulders form straight line.

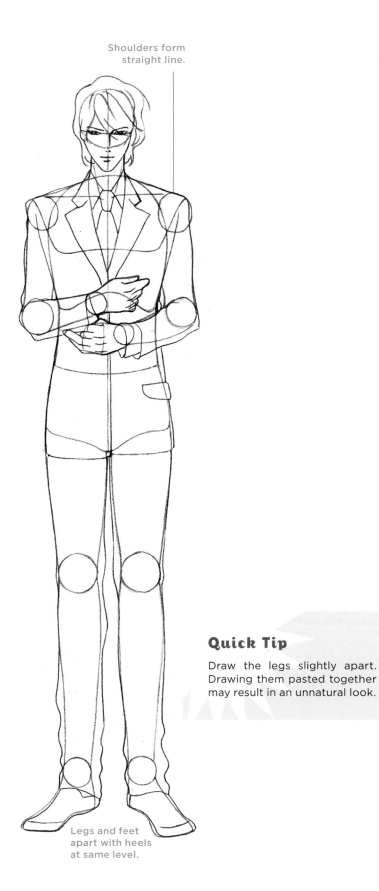

Legs and feet apart with heels at same level.

Quick Tip

Draw the legs slightly apart. Drawing them pasted together may result in an unnatural look.

Make bottom of pants baggy, not straight.

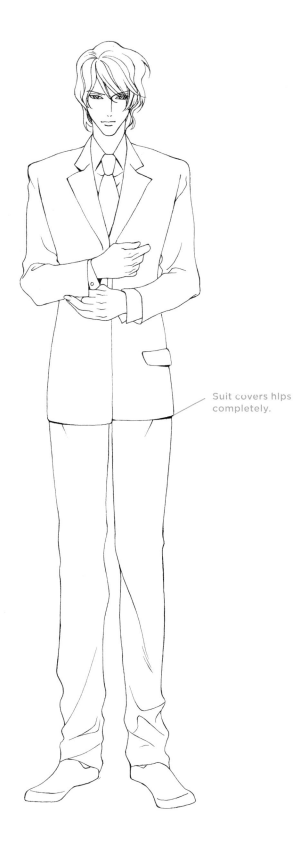

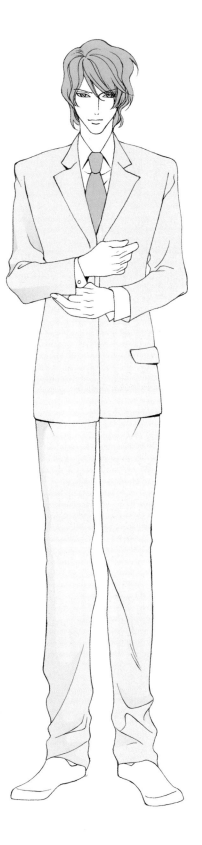

Suit covers hips completely.

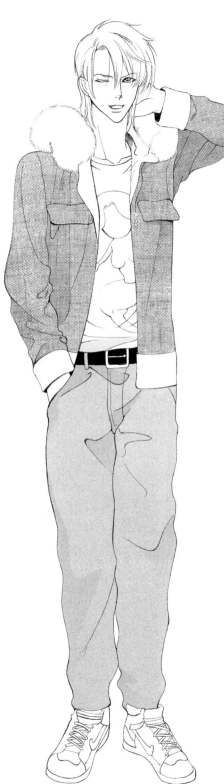

CLOTHING DESIGNS: CASUAL URBAN LOOKS

Loose, baggy outfits work well on these characters. They give them an edgy, urban appearance. The long-sleeve, crew-neck shirt is a more polished-looking alternative to the T-shirt and makes the outfit seem complete. Folding the arms across the body creates an introspective pose for an introspective character.

Note that the first sign of a more mature build is the straight line across that forms the shoulders, rather than the younger, teenage "sag" that forms the droopy posture your mother has always reprimanded you about. The neck isn't so skinny. The trunk of the body is long. But wearing the belt low is a sign of youth. The older you get, the higher the belt is worn, until you're seventy, when it's almost at chest level! (Kind of creeps up on you when you're not looking.)

Large Build

This is the second most popular super-elegant body type. These guys are all *tall* but with the same proportions as the medium-sized guys: wide shoulders, thin waist, long legs. The limbs are, again, long and athletic but without bunchy muscles. Often, vampire characters are drawn with these large, super-elegant builds to connote personal power and magnetism. So are skilled martial artists and samurai. And anyone who has a little "bad boy" in his blood is a good candidate for this type of character design.

When you increase the medium-sized build to proportions for a larger character, the head remains the same size, but the body stretches. It's this change in the ratio of the body size to the head size that makes the character more impressive looking. If you were to increase the size of the head along with the size of the body, the character would look the same, only enlarged. But this way, the proportions themselves are different, which results in a taller-looking figure. You can see here that the head looks just slightly small for the body.

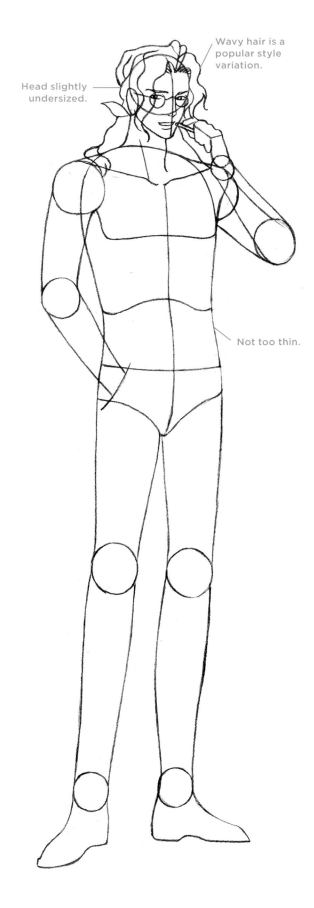

Wavy hair is a popular style variation.

Head slightly undersized.

Not too thin.

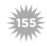

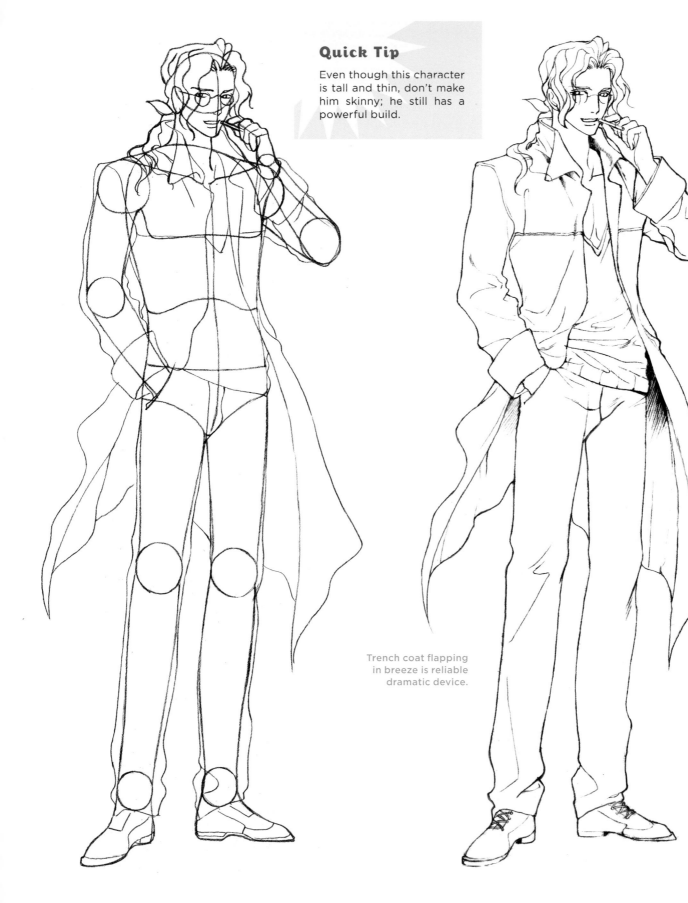

Quick Tip

Even though this character is tall and thin, don't make him skinny; he still has a powerful build.

Trench coat flapping in breeze is reliable dramatic device.

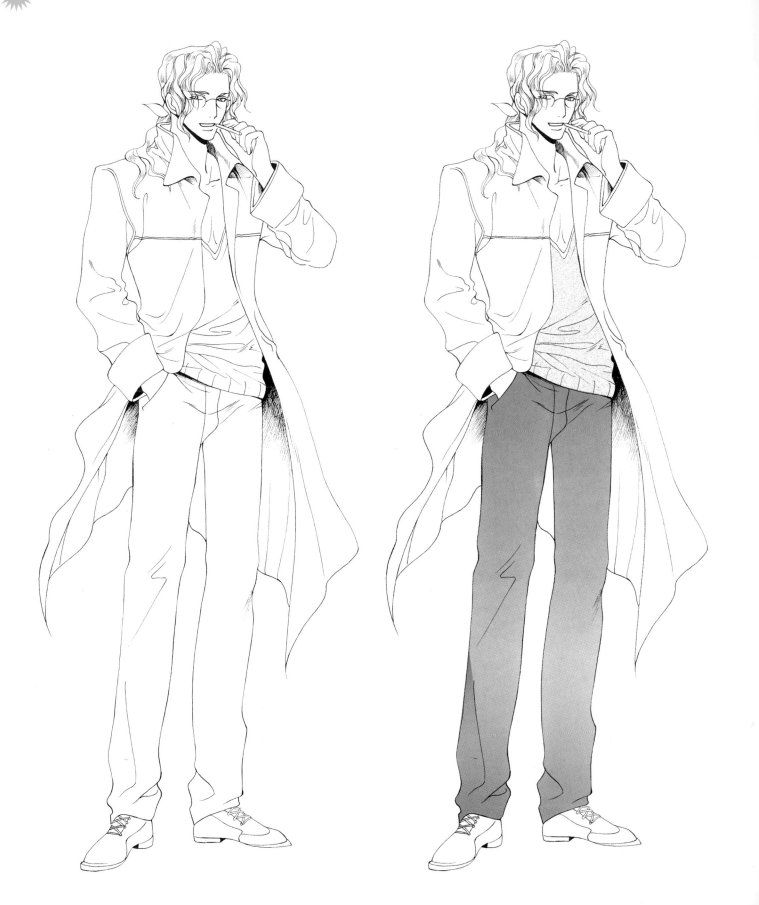

ALTERNATE CLOTHING DESIGNS

Short hair, chopped off at the bottom but falling in front of the face, gives this trendsetter to the left a moody look. His whole design is angular: His eyes are narrow, with thin, sharply angled eyebrows. The jaw is well chiseled and tapers toward the chin. The shoulders are square. In fact, the entire silhouette is quite rectangular, overall. His clothes are sporty, indicating that he's on an athletic team. His gym bag gives him a prop and something to do with one of his hands. Other props could be a tennis racket, a golf club, a hockey stick, or ice skates. Notice how the zippers on the shirt and jacket, along with the added pockets on the pants, add to the sporty look.

In contrast, the figure next to him flashes a confident grin. His hair is slightly a mess, but it's intentional. In fact, everything about him is extremely casual—but in a planned way. Your mom warned you to stay away from guys like this. They're broken hearts looking for their next victims. But shoujo girl characters find these hard-to-get guys hard to resist, so the bad boy remains a staple of manga graphic novels. And although this guy wears a low-cut, V-neck shirt, some bad boys are also shown with a bare torso, wearing only an opened shirt. The pendant, like all male jewelry, is a sign of a rebellious nature. And the sandals show that he's more informal than might be deemed appropriate—especially when meeting your mother.

Small Build

The third most popular super-elegant male characters, pretty boys with small builds are generally portrayed as sensitive and are drawn with more androgynous characteristics than the previous two types. They tend to be moody and can isolate themselves from people—even in a crowd. Young girls find them fascinating because of their quiet, withdrawn nature, good looks, and neediness.

The shoulders, while still square, are not very wide. Narrow shoulders give the impression of a slight build. The smaller rib cage also contributes to the less powerful appearance. Smaller builds are not quite so long-legged as the medium and large builds. These characters also look younger than the two previous types.

This particular Japanese pop-culture fan is dressed up to go to a concert or an anime convention—where outrageous dress is the norm. The clothes are a creative mix, both in tone and form. Looks like he raided a thrift store. J-Pop guys, or J-Rockers, are flamboyant dressers. Some, like this guy, have a hint of the 1960s in their outfits (suggested by the tie-dye and animal-print patterns). The '60s were a very influential period in fashion, and the decade is mined continuously for fresh angles in developing themes for today's trends.

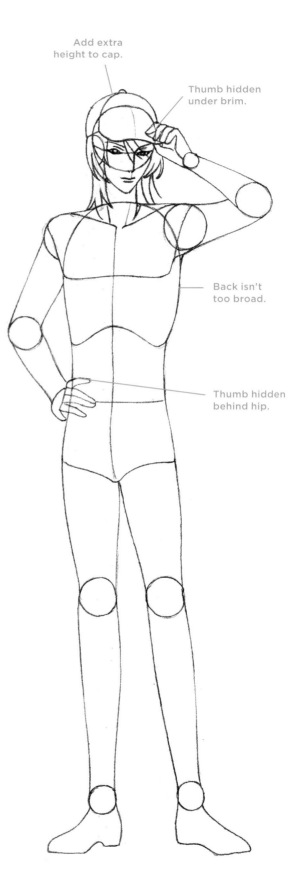

Add extra height to cap.

Thumb hidden under brim.

Back isn't too broad.

Thumb hidden behind hip.

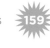

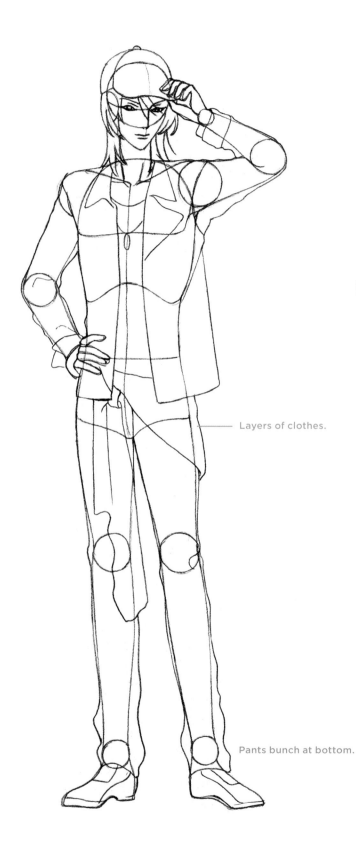

Layers of clothes.

Pants bunch at bottom.

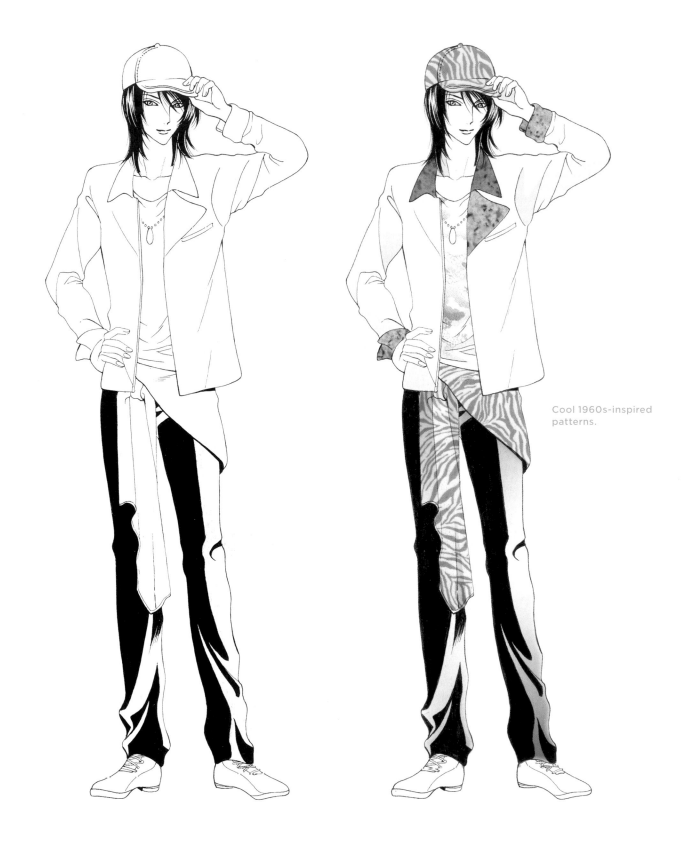

Cool 1960s-inspired patterns.

ALTERNATE HAIR & CLOTHING DESIGNS

Many super-elegant characters have such long hair that people unfamiliar with manga confuse them with girls. But to the experienced mangaka (manga artist), it's obvious that a character without an abundance of eyeliner and eyelashes—or a female figure—couldn't possibly be a woman.

The long hair on a male manga character conveys a dramatic presence that's ubiquitous among the genre's leading men. The hair usually either cascades off the shoulders, as it does on the left figure, or blows poetically in the breeze. And note that even black hair needs white highlights, or "shines." Without the shines, the hair will appear dull and lifeless.

Since small super-elegant guys are often loners, use costume design to communicate this: On the right-hand figure, the hat pulled down just above the eyes conveys the idea of being a loner. Then, rather than dress the rest of him in a preppy school uniform, opt for a casual vest and jeans—something you'd see on more of a street kid. It's a simple design, but it works.

Don't try to do too much, overdesigning your characters and costumes. For an outsider character, you don't need torn pants, an earring, short sleeves, spiked hair, and an eye patch! That might be okay in the shounen style of manga (the heavy-action genre), but in shoujo, you don't want your character to get lost under a surfeit of accoutrements. With just a few suggestions to define the character, like the cap and vest, the reader will be keyed in to his personality right away.

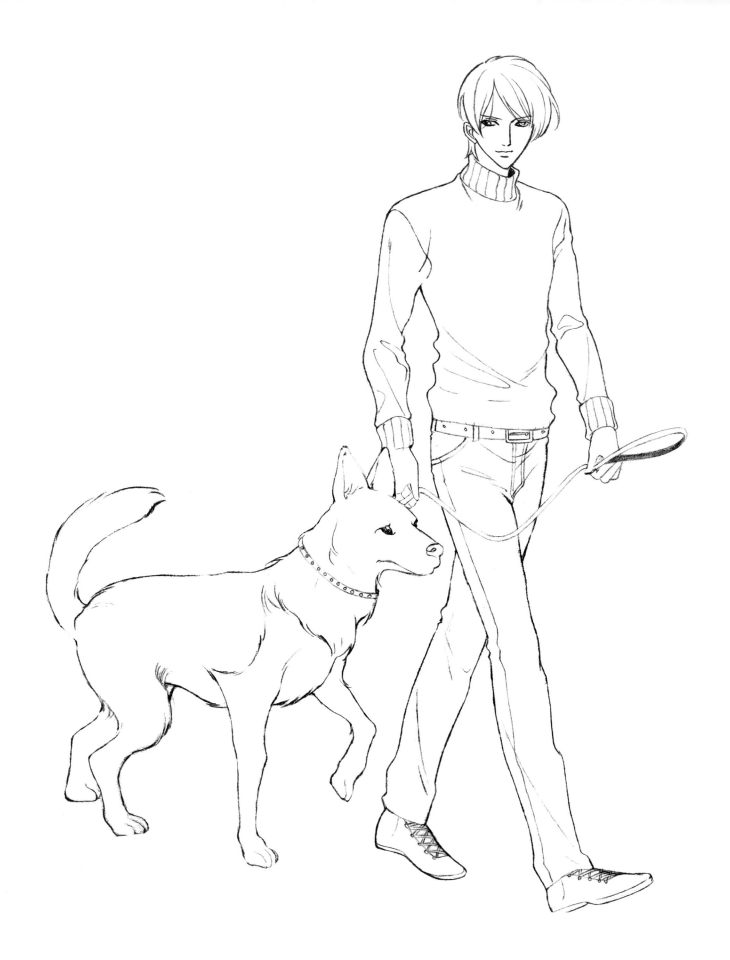

THE Key to Successful Drawing

OFFEN, BEGINNERS TRY VERY HARD to get the faces and bodies right, yet their poses still end up being uninteresting. What went wrong? The invaluable drawing secret that most beginners have never even heard about—that will transform beginner work into advanced drawing without much effort—is *secondary action*.

When a character performs a primary action (such as standing, talking, or walking), which frequently isn't interesting in its own right, the solution lies in giving the character a secondary action— something minor to do—simultaneously. When you do this, characters are more interesting to watch. Maybe she's walking but also talking on a cell phone. Maybe he's sitting but at the same time writing a note to himself—in other words, doing something active. Believe me, these minor tweaks make a *tremendous* difference in the energy and vitality of a pose. And they're easy fixes, techniques you can start using right away. Examine the examples in this chapter, and see for yourself. I want *you* to decide which is more interesting to look at. Ready?

STANDING

Characters standing around doing a lot of nothing are every artist's great nemesis. You've got to fight these soporific scene destroyers by sprucing up your staging with a little bit of secondary action, as shown.

PRIMARY ACTION:
STANDING (WHILE TALKING)

Standing and talking (which doesn't count as a secondary action) is the most common pose in manga graphic novels. But it becomes boring having characters just stand there next to speech balloons with their mouths open. A hand gesture, like this one, helps a little, but the energy level is still low. Low energy is okay if a character's doing the listening. But this character is a teenager who's doing the talking. How many teenage girls do you know who are low energy?

SECONDARY ACTION:
RUMMAGING THROUGH PURSE

Adding a secondary action provides a quick and simple solution. All she has to do while speaking is to dig into her purse, and suddenly, she's actively engaged in doing something, rather than standing still. Her posture loses its stiffness, and the prop, her purse, is also brought into the act.

PRIMARY ACTION:
STANDING (WHILE TALKING)

Whoa! Talk about stiff! This drawing is crying out for a secondary action. Looks like he's standing at attention or rigor mortis has set in—I'm not sure which. Yet this is a very common pose among beginners.

SECONDARY ACTION: ADJUSTING HIS CLOTHES

A quick, little adjustment of his cuff (whether or not it really needs it) is all it takes. See how much more relaxed he looks as he bends both of his arms? He looks at his sleeve, so he's not continuously looking straight ahead at the person he's talking to panel after panel. This breaks up the rhythm and therefore is a pleasing technique to use in storytelling for graphic novels.

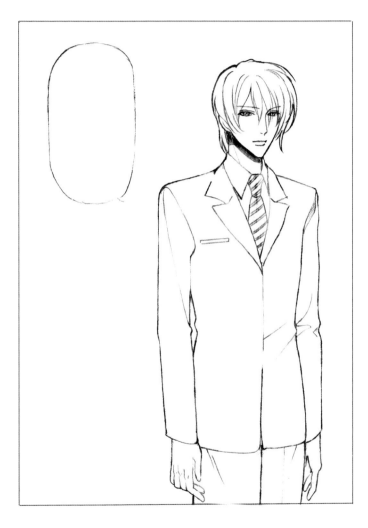

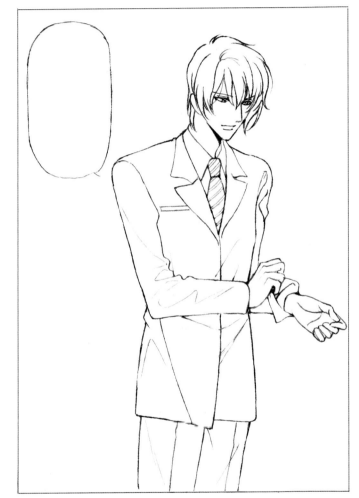

WALKING

Walking is a more difficult pose to draw than people realize. The arms move in front and behind the torso, with fingers spread, holding nothing. It's hard to make that look natural. And once you've got it, it's not all that interesting, either!

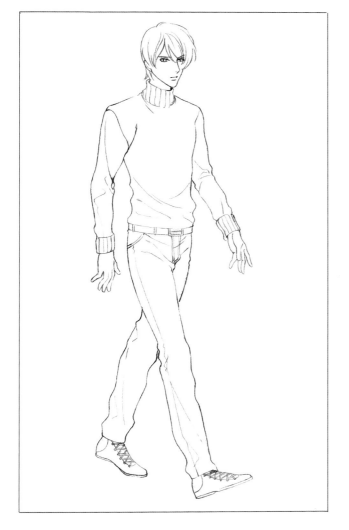

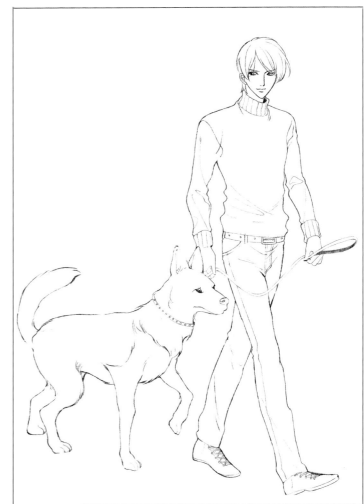

PRIMARY ACTION: WALKING

This guy is walking without purpose, it seems. What can you do to make it look more engaging? What about giving him a secondary action, something that gives him another thing to do with his hands while he's walking?

SECONDARY ACTION: WALKING THE DOG

By giving the teen a dog, you not only give him something to do, but you suggest a story. There's suddenly the possibility that he'll meet someone with his dog, maybe a girl and her dog, in a park setting. This dog owner looks at his dog, so there's a relationship there; he's not just staring straight ahead into space, as he was doing when he was walking without purpose.

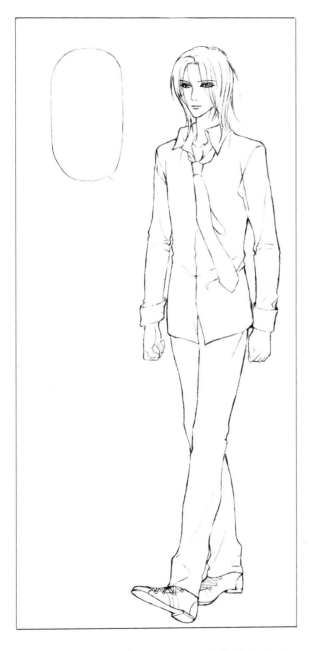

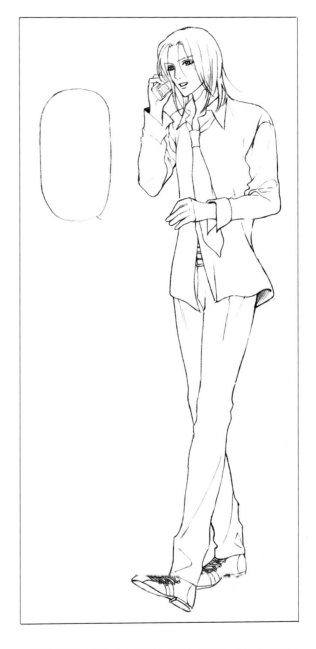

PRIMARY ACTION: WALKING CASUALLY

This character may be out for a stroll, but frankly, his pose is putting me to sleep! The problem with this drawing is typical not only for beginning artists but even for some pros: The drawing itself is excellently rendered but static. The hands are down by the sides, doing nothing. Why not make use of them to liven up the scene?

SECONDARY ACTION: TALKING ON A CELL

Something as basic as talking on a cell phone animates a character significantly. We now imagine that he's on his way to meet whomever he is speaking to on the phone (his girlfriend, perhaps). The walk takes on more urgency not because the gait is drawn differently, which it's not, but because he's speaking in an engaged manner. We want to know what's being said, and this draws us into the scene, unlike the previous image.

SITTING

Sitting is an inactive pose by definition, so it's not wrong for a character to sit without a secondary action. It works, but it's subdued. However, if you want to show a perky character, one with a bubbly personality, you need to give her a secondary action.

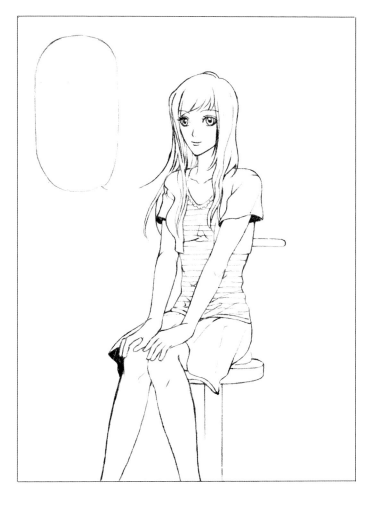

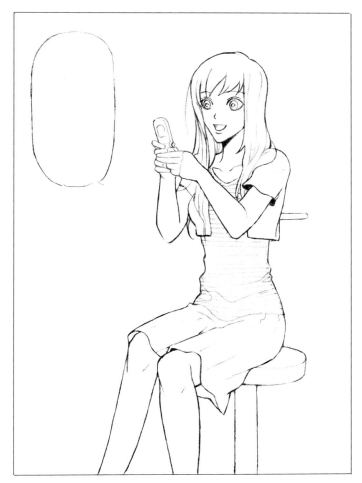

PRIMARY ACTION: SITTING

This character is very closed up, with her knees together and hands on her knees. There's a lot of tension in the pose.

SECONDARY ACTION: TEXTING

People text while they do everything—talking, shopping, eating. In this way, you quickly define your character as a typical high-voltage teenager with a type A personality, which is an appealing character to watch and quite different than the previous, restrained type.

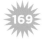

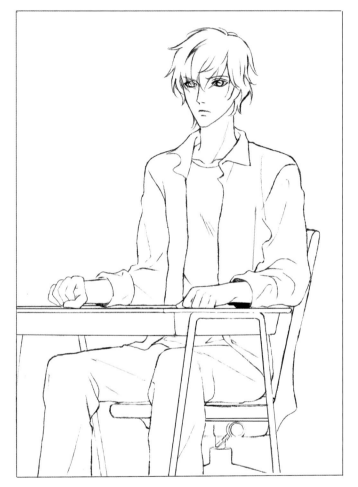

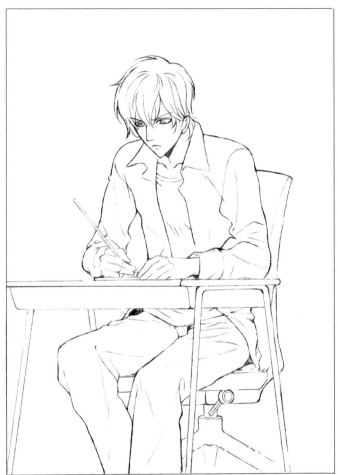

PRIMARY ACTION: SITTING AT A DESK

Sitting stiffly at a desk, back straight, listening attentively to a lecture in class may be what a teacher wants you to do, but it's not the best look for a manga character. Not relaxed enough. Not active enough. Not interesting enough.

SECONDARY ACTION: TAKING NOTES

Now he's hunched over his paper, taking notes furiously as his teacher (who's off-panel) gives her talk. Note that his back leans forward off the chair. This is a much more engaging scene. Now we feel the pressure and know we're in a classroom!

PRIMARY ACTION: SITTING (WHILE TALKING)

This is a good pose as it is. She's pretty, with an open face and appealing looks. She gestures nicely with her hand. And yet, if you want to do your very best work, you always have to ask yourself that one nagging question: Can I do more with it? In this case, the pose could be a little more fun, don't you agree? It sort of sits there, like plain vanilla. It functions but doesn't inspire. And we want to inspire the reader. So let's compare it to the next example.

SECONDARY ACTION: TYING HER SHOE

What does it mean that she's tying her shoe? It means that she's getting ready to go. She's an on-the-go gal, active, whereas before she appeared inactive. And that wink at the reader also helps, adding a touch of flirty humor. Other similar actions could be zipping up a vest, putting on her boots (easier to draw than tying laces), tying a hood into place, or putting on mittens.

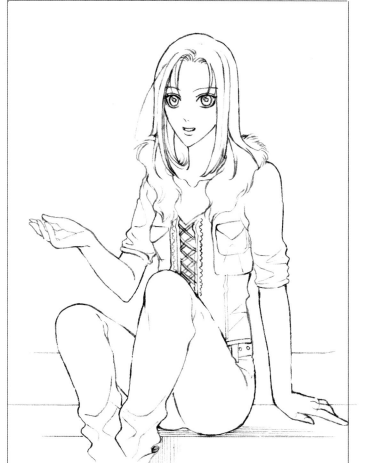

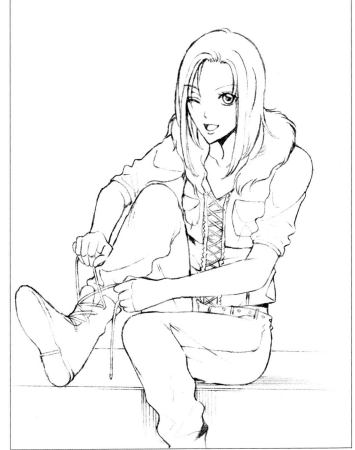

KNEELING

Sitting on the knees is a feminine pose, which shows passivity. Here's an example of a situation where we may not want to add a secondary action because it may make the character appear too lively. After all, she's sweet and quiet, and meant to be that way. Still . . .

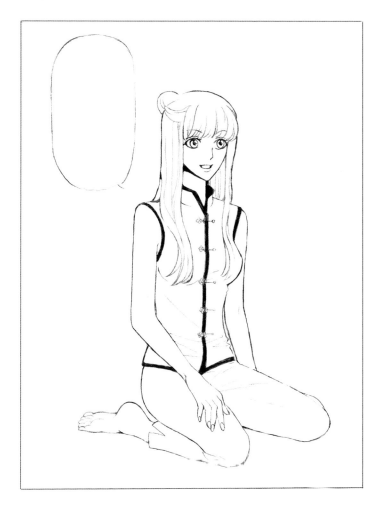

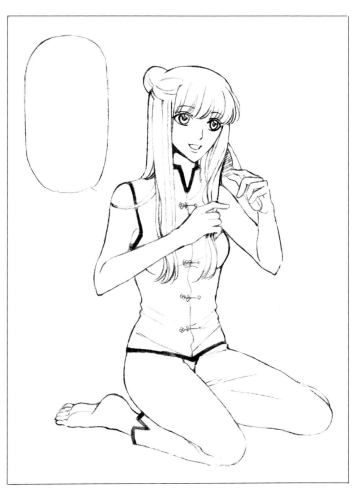

PRIMARY ACTION: KNEELING (WHILE TALKING)

If you can find a secondary action that will reinforce a kneeling character's femininity, as well as give her something to do with her hands, then it will be a positive addition to what is otherwise a static scene.

SECONDARY ACTION: BRUSHING HAIR

The lesson here is that no matter how routine the secondary action is, whether it's brushing hair or putting away clothes, doing something is more interesting than doing nothing.

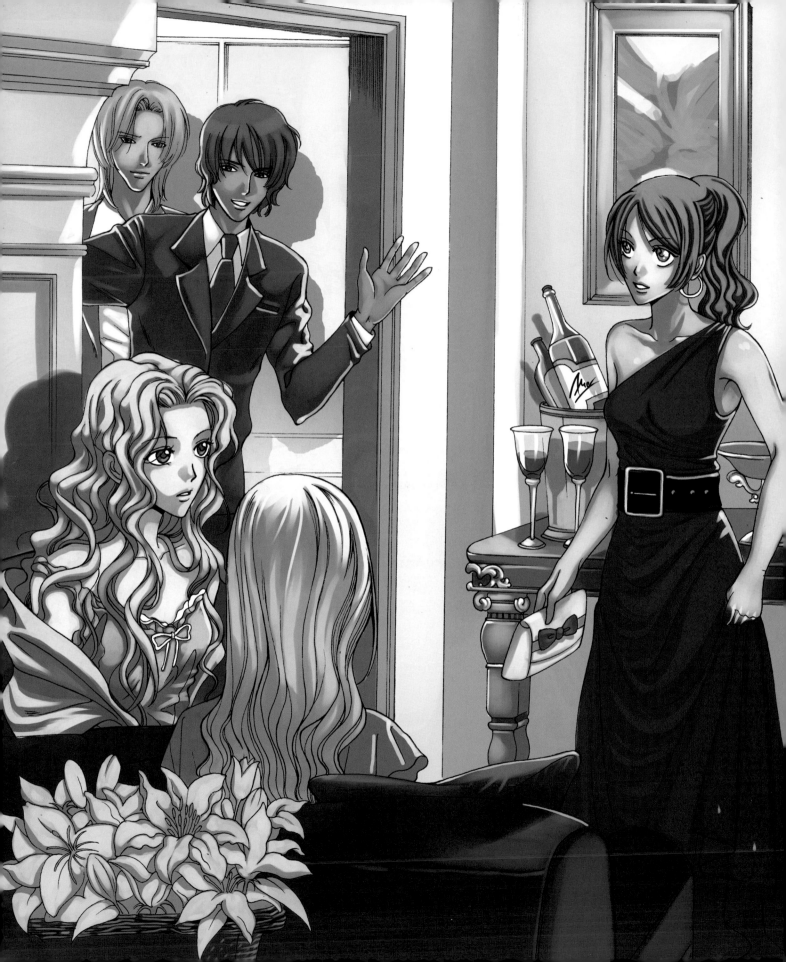

Putting It All Together

WE'RE NOW AT THE POINT in the book when we've made much progress. We've drawn and designed characters and poses of all different types. Now we'll get a chance to put two or more characters together in a scene. The beginner draws two figures in a scene by simply sticking them stiffly in a panel. But as you may have guessed, there's more to it than that. To bring a scene to life, the characters have to interrelate visually. That requires some staging, posing, and layout. Here's the chapter that will give you the tips you need to get started.

173

CHARACTER INTERACTION

We'll explore how to create energy between characters with something simple and fun: introducing a cuddly, little pal into the picture. Two personalities together, interacting, create a scene. Plus, introducing a pet is a surefire way to win readers' hearts;

their presence always adds a welcome element of comic cuteness. And because the animals are small and simple to draw, the composition of the scenes is going to be easy. We won't even worry about backgrounds at this stage.

DIRECT EYE CONTACT

Ah, that's it, a little more to the left—perfect! Now the puppy is in heaven having his head scratched. A "scratch" is done with the fingertips; a "pet" is done with the palm. Note the direct eye contract between the two characters, which communicates the sense of love. Also notice that by placing the two characters at different levels—one on the bed, one on the ground—you add more visual interest than if both were on the floor together, but we'll get to that more on page 178.

The Eyes Have It

Eye contact is important, whether your two characters look at each other or not. One option besides mutual eye contact is to have one character look at the other, while that character looks at something else. Another is to have one character look at readers, engaging them and drawing them into the scene.

NO EYE CONTACT

Here we have only one character looking at the other; the girl looks at her pet, while the dog is busy doing his own thing—sniffing out that special treat. It's a cute moment; the girl takes on the point of view of the reader as someone who's observing the dog, who is, in turn, transfixed on the bone. The dog takes on a quasi-hunting posture, which is comedic, because after all, he's hunting an inanimate bone! He's probably a reckless hunter, but don't tell him that. The girl's back is positioned toward the dog to show that he has circled his way around her to track down his prize. Her position also allows for a cute over-the-shoulder glance at her friend.

EYE CONTACT WITH THE READER

Wrong idea, puppy! Not the skirt, the ball! Grab the ball! Here we have the classic tug-of-war with a dog. Unfortunately, he was supposed to play fetch, instead! Note how the girl looks out at readers, drawing them into the scene playfully. Position the pup low to the ground, so he really looks like he's giving a good yank. The type of dog you choose for the scene is also important. Some toy dogs are delicate looking and don't appear to be able to tug hard. So better make it a terrier. They may be small, but they're chesty and tough. Place the ball in the foreground and make it large, or the reader may miss the point of the joke.

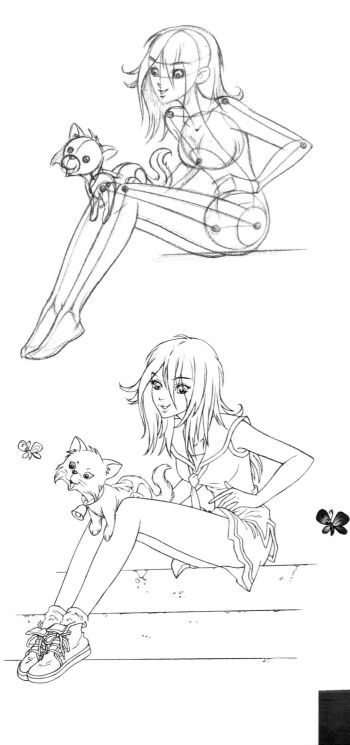

LOOKING IN THE SAME DIRECTION

Cats have no compunction about walking on anything, even their owners. Here, the girl's legs act as a plank to let the kitten get closer to the butterfly that has captured its imagination. Cats have an amazing ability to follow anything with their eyes. Put something that's moving in front of them, and they will become fixated on it like a radar system. This butterfly has the cat hypnotized and is staying just out of reach, teasingly. A tilt of the cat's head reads as a happy, inquisitive gaze. The classic head tilt also works for dogs. The two main characters (the girl and the cat) share the same eye line, which is transfixed on the butterfly.

Playful Poses

Having an animal roll over and flop around on its back is the universal way to communicate a playful mood. It works whether the character is a dog, cat—or even a girl! Here, the girl holds the kitten as if it were a cuddly baby. On the facing page, the playfulness comes from the "stubbornness" of the cat.

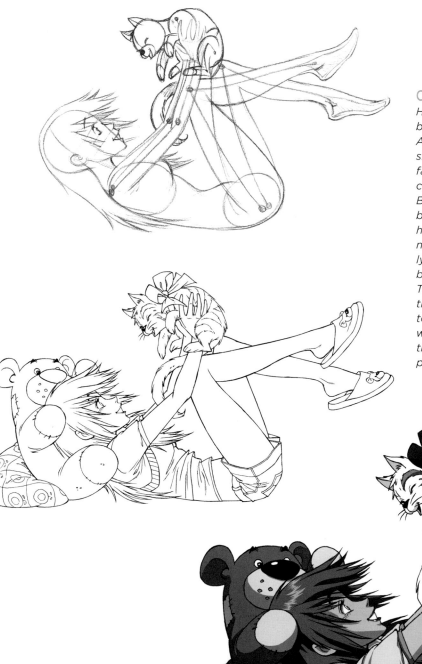

ONE CHARACTER LIFTING ANOTHER

Here, you'll want to show the communication between the characters in this shared moment. A good way to do that is to make use of the side view, in which you can draw them both face to face in profile. Having the girl raise her cat above her gives the pose a very active feel. But there's still a strong sense of connection between the characters, since the girl lifts her head up toward her pet. This connection would not be as pronounced if the girl's head were lying flat on the ground. So the artist lifts it up by placing a huge teddy bear underneath it. The reader thinks the stuffed animal is a prop that belongs there, but it's a device put there to get her head up so that the composition works better. Artists make choices like this all the time, without the reader realizing why the props have been added.

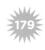

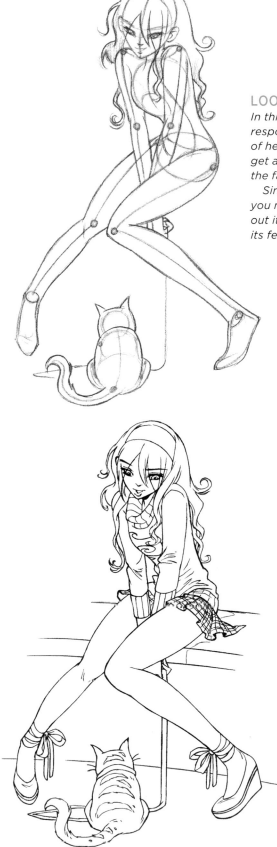

LOOKING UP AND DOWN

In this simple setup, the girl looks down, trying to elicit a response from her portly feline, while the cat sits in front of her, content just to watch her try. Who hasn't tried to get a cat to "do" something but to no avail? The fun lies in the fact that the little one of the pair is the "boss."

Since the cat is only seen from the back at this angle, you must make it extra-round and pudgy. That will bring out its cuteness and compensate for the fact that none of its features are visible.

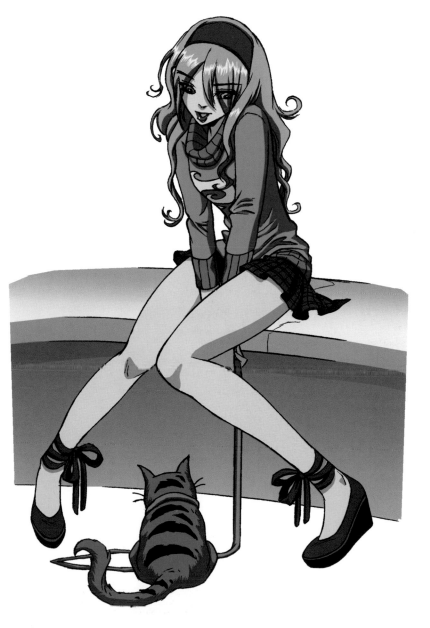

PINUPS

Now we'll take all of the principles we've learned throughout the book and combine them to create ministories in the form of full scenes, called pinups. Used in graphic novels, pinups are giant panels that each take up an entire page. They add visual excitement to a story by breaking up the continuous stream of smaller sequential panels that can get mundane after a number of uninterrupted pages. For artists, pinups are fun to draw, because they allow you to focus all of your energies into creating a single, finished piece of work. As a result, you get to really sink into the creative process. However, for these pinups to become scenes rather than merely pretty drawings, they require certain elements:

- Generally, multiple characters interacting with one another.
- An identifiable location, even if it's a fantasy or more abstract location.
- An activity. The characters must be doing something; they can't just be posing purposelessly.
- Character development; for example, are they cute, evil, good, jealous, and so on.
- A point to the scene.

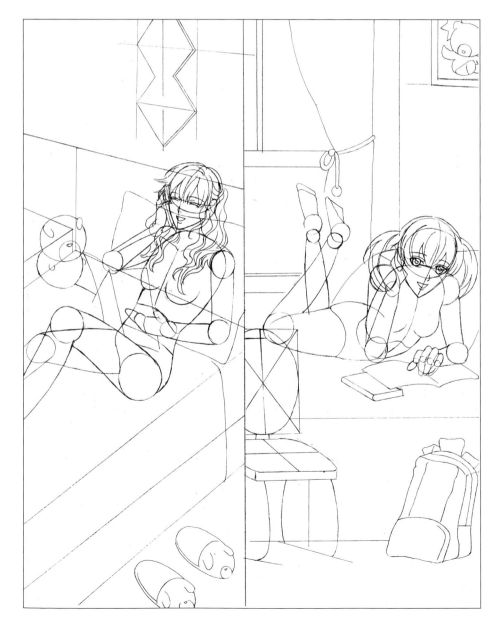

Chatting on the Phone

Here's a picture of two shoujo girls chatting away on their cell phones. Should it be a regular panel, or does it qualify as a scene that warrants the full-sized, pinup treatment? Let's see if it fits our requirements:

• Does it have more than one character? Check. (There are two girls who interact with each other.)
• Does it have an identifiable location? Check. (There are two bedrooms.)

• Are the characters doing something? Check. (They're talking on the phone to each other.)
• Is there good character development? Check. (The girls are chatty, cute teens.)
• Does the scene have a point? Check. (The girls are friends who are having an animated conversation.)
• Affirmative on all five counts. Yep, it's a scene with a story all right, and that makes it a good pinup panel—you can give it a full page.

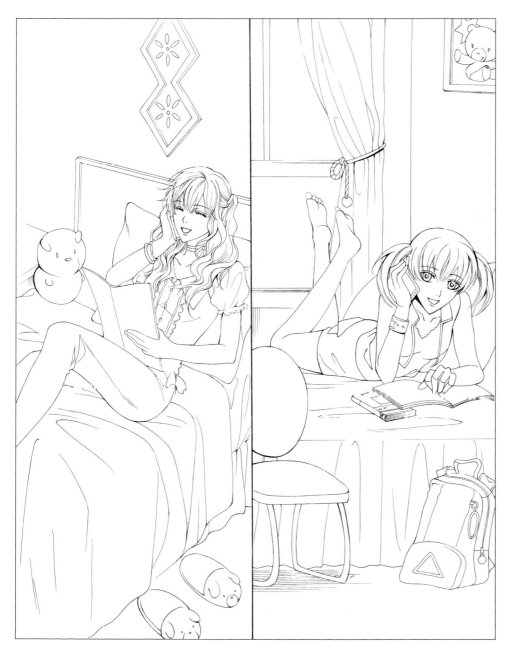

INKED VERSION

This is the stage in the process when the clothing is added and any drapery in the background gets its fabrics and folds. All of the details come in. The step is also when the pencil drawing gets inked. The inked drawing is then ready for reproduction in the manga graphic novel. Some artists ink over their pencils; others use a light box to trace their drawings in ink onto a separate piece of paper and that way preserve the original pencil drawing underneath.

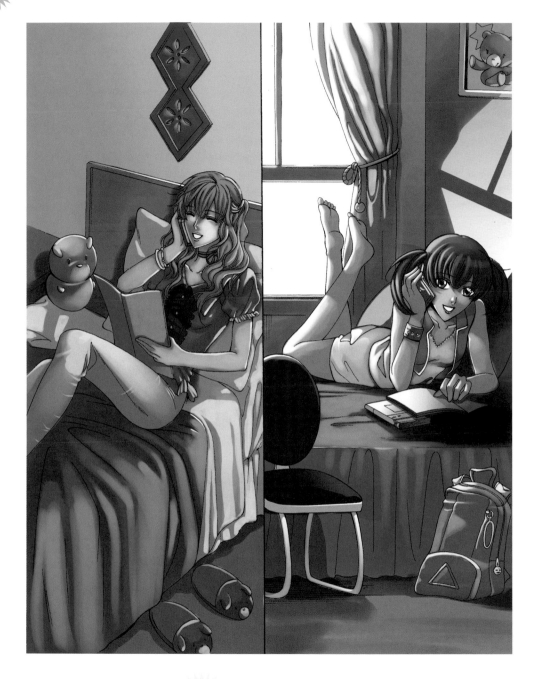

COLOR SUGGESTION

Western audiences (particularly in America) prefer anime-style coloring, also known as cel shading, which results in hard edges of color. They see this primarily in TV animation. But they generally haven't been exposed to the other style of shoujo coloring, popularly seen in Japan, that is a softer type of coloring, without the hard edges where one color ends and another begins. This section provides you with examples of this soft shoujo coloring style. It's good to familiarize yourself with both approaches.

HOW TO USE THESE PINUP EXAMPLES

Like the step-by-step characters in this book, all of the scenes here are provided in a step-by-step fashion. In the initial steps, the lines of the backgrounds have been "drawn through" the characters so that you can see exactly where they go in relation to the figures. Note that these are very complete backgrounds. You can leave out much of the detail and still have a very good scene. How much detail you want to incorporate is entirely up to you. But it's all included here (like the shadows on the wall), in case you want to go for a totally professional look.

Fighting over the Girl

Two guys. One girl. This could spell trouble. This picture is drawn on a slight diagonal: The vertical lines of the building are slanted, as are the people. This is called a *tilted frame* and is typically used to heighten the dramatic tension within a scene.

In addition, the entire scene is drawn in a predominantly vertical fashion. Notice how the characters and building are positioned vertically—there's nothing going on horizontally. This type of composition allows you to place numerous characters in a small space within in a fairly close shot, without making it look like a tight squeeze.

INKED VERSION

Unless the perspective is purposely warped, which is sometimes the case in wide panoramas, buildings must be drawn ruler-straight. If they're hand-drawn and a bit on the wiggly side, they'll draw attention to themselves. You don't want that! What you actually want is for the buildings to recede into the background and become unnoticed so that the focus remains on the characters in the foreground. Therefore, in addition to ruler-straight lines, keep the buildings fairly simple. This means no fancy windows with people's silhouettes in them and no gargoyles or individually drawn bricks. Nothing to make the background pop. Use thin lines, not thick ones, for backgrounds. The thinner, the better.

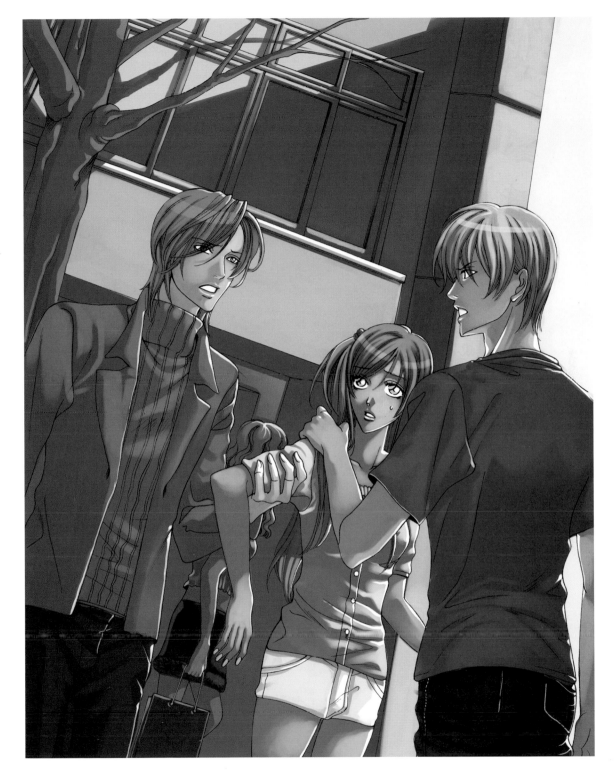

COLOR SUGGESTION

Here, the skin color is reflecting the emotional state of the characters, which is getting hotter. The skin tone has more orange in it, making it fiery, dialing up the degrees of the scene a notch or two. Likewise, the building is yellowish and purple, giving it a baked look. Temperatures are rising, and soon something is going to explode. In this way, colors can reflect the tension of a scene.

Having a Party

We're having a party . . . and who invited those guys? These friendly party crashers don't take no for an answer. They simply flash their smiles and hope their charm does the rest. Notice how the eye moves from the boys counterclockwise to the girls on the couch, then to the girl standing by herself, and then back to the boys again. In other words, the placement of the figures encourages the eye to make a continuous loop, which keeps your eye within the panel.

In addition, there's a lot of overlapping that occurs here, which creates a sense of depth: The girls on the couch overlap the two boys entering the room, and the girl on the right overlaps the table. All of this creates a nice foreground/background dynamic.

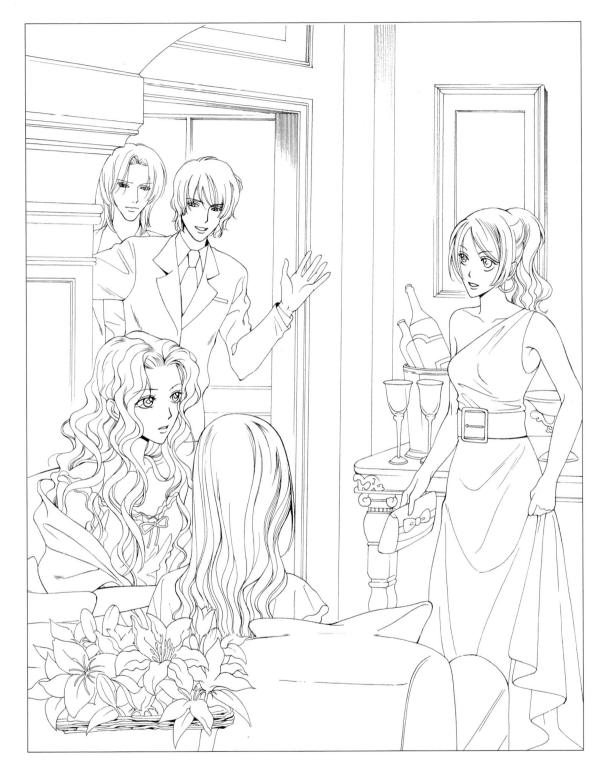

INKED VERSION

"Dress up" is part of the fun of shoujo manga, and readers love to see it.
It's a world filled with fancy clothes and stunning locations. Readers thrill
to live vicariously through their favorite characters. Whether they drive a
million-dollar exotic car, wear outrageously expensive clothes, or jet-set to
exotic resorts, our characters live the lives about which we can only dream.

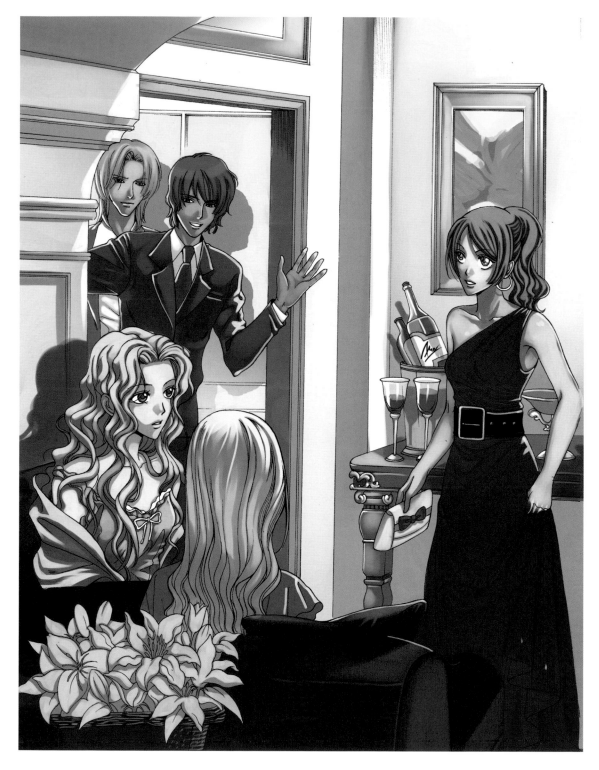

COLOR SUGGESTION

Which girl's party is it? The brunette, of course. Why? Because she's the one wearing the red dress. The bold primary color, instead of a muted or pastel tone, makes her stand apart from the other girls, and even the guys. The vibrant red color underlines her role as the main figure on the page.

Fighting Magical Girl and Boy

In this exciting scene, a magical girl fights a magical boy (another type of shoujo character). But although the magical boy has significant powers, the magical girl's arsenal trumps the boy's: She has a dragon for a protector-friend! Hard to beat that. What's important to note here is that there's a great deal going on in this scene, which is why the characters have been placed on opposite corners of the panel. There's actually too much action going on to put them together in the middle. That would cause what is known in artistic terms as *eye fatigue*. This way, there's a visual pause in the center.

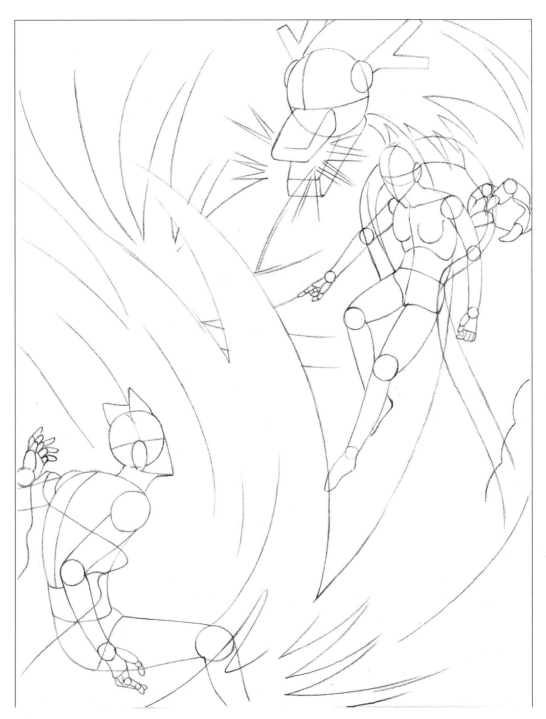

INKED VERSION

Even at a distance, both figures appear to interact. With her finger pointing at the magical boy and the dragon leaning forward to spew fire at him, the girl takes on the role of the attacker. The boy, who is leaning back, is the defender. So their postures show one playing off the other.
Note the lack of horizontal and vertical backgrounds. This is typical of the abstract fantasy scenes, which have more organic, curved designs for the environment.

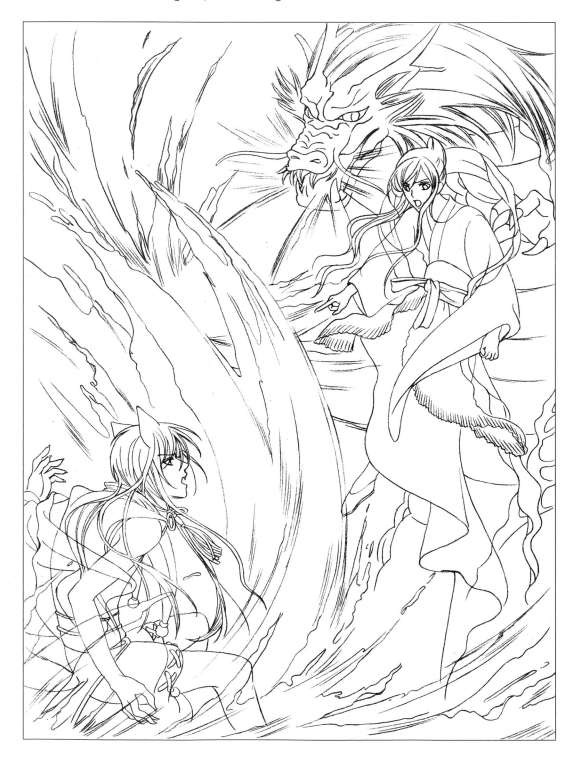

COLOR SUGGESTION

It's always tempting to go for the stereotype, which in this case would mean coloring the dragon green. But that would turn the dragon into something a little more pedestrian, like a medieval lizard. Ho hum. In addition, a blue magical boy and a green dragon wouldn't have such different color values, and the elements of the picture would start to blend. You don't want that, especially because those characters are on opposite sides, storywise (they are each other's nemesis). This way, the colors clash, which underscores the theme of a fight scene.

INDEX